the new color photography

the new color photography

sally eauclaire

abbeville press • publishers • new york

for Peter

On the cover:
A photograph by Langdon Clay
See Plate 52 and Chapter 3

On the title page:
A photograph by Mitch Epstein
See Plate 135 and Chapter 7

Designer: Roy Winkler
Editor: Mark Greenberg

Library of Congress catalog card number: 80-70940

ISBN: 0-89659-190-5 (cloth)
0-89659-196-4 (paper)

CONTENTS

ACKNOWLEDGMENTS

Without the provocative and often profound writings of John Szarkowski, Max Kozloff, and Ben Lifson, my own comprehension of photography might never have developed. The formidable standards inherent in their efforts continually inform my concepts of critical and curatorial practice.

No project of this scope could have succeeded without the cooperation from many artists who allowed me to view their work, answered my questions, and volunteered their insights. Of the many critics, curators, dealers, and photographers who showed me work and referred me to additional sources, I would like to offer special thanks to Phil Block, Janet Borden, Caldecot Chubb, Van Deren Coke, Charles Desmarais, Chris Enos, David Fahey, Andy Grundberg, Marvin Heiferman, Mark Hobson, Peter MacGill, Don Peterson, Tennyson Schad, Michael A. Smith, and Charles Stainback.

Without numerous constructive suggestions and personal support from Marilyn McCray, this project would surely have lost its way.

I am indebted to Warner Communications, Inc. and the National Endowment for the Arts for generously funding the 200-work exhibition based on this book. I also wish to thank Ronald A. Kuchta, director of the Everson Museum of Art in Syracuse, N.Y. under whose auspices I organized the exhibition. The faith he demonstrated in my project when it was still in embryonic outline encouraged its successful culmination.

For their confidence in me and in this book, I would like to thank Robert Abrams, Mark Magowan, and Mark Greenberg—all of Abbeville Press.

Most of all I thank Peter R. Berg, who took time away from his paintings and suffered through the manuscript at every stage, making inflammatory and irreverent comments that were always relevant. His thoroughly original insights invested this book with a depth it would otherwise have lacked.

Sally Euclaire

INTRODUCTION

Color photography, the medium once consigned to ama-teurs and advertisers, has been embraced by an increasing number of artists since the late 1960s. The explosion of exhibitions, publications, course enrollments, museum acquisitions, symposiums, and grants attests to the view that color is *the* issue in contemporary photography.

The color phenomenon piques and puzzles. Proponents have been hard pressed to articulate why they find certain works potent, suggestive, and complex. Detractors are wont to speak of museum curators "conning the public." Photo-graphs that seem "perfect" to one critic are "perfectly banal" to the next. Meanwhile, so many color photographs by so many different photographers have been exhibited in museums and galleries that the scene resembles Andy Warhol's prediction of a future in which every self-proclaimed artist enjoys the limelight for fifteen minutes.

Rather than indiscriminately promote this pluralism, I have attempted in *The New Color Photography* to elucidate color photography's unique visual syntax and to focus on those color photographers who best exploit the medium's assets and overcome or minimize its deficiencies. *The New Color Photography* is not a survey, nor a history of color photography of the 1970s, but a critical text that argues for and endeavors to articulate visual and conceptual stan-dards.

Although many relatively unknown color photographers are included, the majority of the book is devoted to key images by major photographers who have contributed to the maturation of this new art-making medium.

The New Color Photography suggests reasons why John Szarkowski has written that most earlier color photography has been "puerile"[1] and why Max Kozloff has suggested that color photography "came of age"[2] around 1970. In discussing frequently reproduced images by the most famous color photographers from the earlier generations, I have attempted to illuminate the limitations that Szarkowski, Kozloff, and numerous others have instinctively understood. This was necessary not to elevate the new color photographers through denigration of the old, but for a greater understanding of why the predecessors have not been influential. Instead, the most instructive impressions were made by black-and-white photographs, modern paintings in which color is used as a structural force, and to a lesser extent, the prolific critical discourse that has accompanied minimal and conceptual art. Many analysts speculate that color television, movies, and magazines saturated the consciousness of contemporary color photographers during their formative years, but most of these artists decisively reject such models in favor of more qualitative visual statements. Nor can full credit for the color phenomenon be accorded to the technical advances and home processes that offer the same personal control over printing that has long been the standard for black-and-white printing. The convenience certainly made possible an easier and less expensive realization of vision, but it hardly helped to define that vision.

The photographs included in *The New Color Photography* establish that the medium's intrinsic quality stems from the photographers' thorough sensitivity to the full color spectrum with its myriad subtleties of gradation. No works included are of the type often described as "about color"—a critical catch phrase frequently used to justify many photographs in which concentrations of primary or secondary hues screech for attention. Rather, the new color photographers consider color's role in a formal, descriptive, and symbolic totality. Their visually and conceptually full-bodied works have prompted color photography's emergence in the 1970s as a distinct and distinguished art form.

CHAPTER 1: **THE PROBLEMATIC PRECEDENTS**

Although the history of color photography goes back more than a hundred years and modern film has been on the market since 1936, color photography did not come of age as an art form until the late 1960s.

This time lag is startling, considering that the world exists in full color and photography has been valued since its invention for its mimetic powers. Yet the colors unique to color photography produced what once seemed insurmountable problems. Color film's exaggeration of subject hue and the concurrent difficulty of formally organizing the visible world's raucous color combinations gave the medium an aura of vulgarity.

Colors of the same value, such as red and green, which convert to compatibly similar gray tones in a black-and-white photograph, pulsate violently when represented adjacently in a color print. According to optical principles, hues advance and retreat from the picture plane with often disconcerting results. It is not at all unusual in color photographs to find red war paint leaping off the face of an Indian, blue sky sitting on the surface like a collaged fragment, and sunrays on water like applied gold leaf. When color photographs are taken in bright illumination, dark shadows often obtrude like silhouettes. The result: disjunctive compositions with prominent spatial discrepancies.

Amateurs were (and are) by no means aggrieved. The first advertisements for color film promised "vivid" photographs, and however cacophonous the compositions might seem to sensitive viewers, the photographs exuberantly testified to births, weddings, holidays—what Kodak ecstatically called "all the wonders of awakening life."[1]

Artists sought subtlety and formal resolution to little avail. Laszlo Moholy-Nagy observed that color photographers attempting naturalism were "back where realistic painters started in the Renaissance—the imitation of nature with inadequate means."[2] Walker Evans deemed color a "vulgar" medium and stated that many "color photographers confuse color with noise" and that they "(blow) you down with screeching hues alone . . . a bebop of electric blues, furious reds and poison greens."[3] Even Edward Steichen, a photographer by no means immune to the lure of instantaneous impact, found the medium too "coloriferous."[4] The best results Edward Weston seems to have achieved are simplistic color tableaux. Minor White, Ansel Adams, Harry Callahan, and other black-and-white photographers similarly made color photographs that now seem far more curious than cogent. That these works have been consigned to history is less the result of a conspiracy to downgrade color photography for its impure commercial and amateur applications than recognition that they singularly lack the authority of more solid images in black and white.

Color photograpy's poor reputation, however, derives less from the black-and-white photographers' relatively unknown failures than from a school of slick, sensationalized "creative" photography that has saturated the public (and artists') consciousness of the medium for the past quarter century. Although the many photographers who consider visual and/or sentimental excesses as keys to expressivity have been generally slighted by museums, they have been lucratively rewarded by advertisers and lauded in popular photographic publications.

Their lust for effect is everywhere apparent. Technical wizardry amplifies rather than recreates on-site observa-

tions. Playing to the multitude of viewers who salivate at the sight of nature (in the belief that good and God are immanent), such photographers often choose such picturesque subject matter as prodigious crags, rippling sands, or flaming sunsets. Drawing upon the Hudson River School's legacy in painting, they burden it with ever coarser effects. Rather than humbly seek out the "spirit of fact," they assume the role of God's art director making His immanence unequivocal and protrusive.

In the advertising world, where "message impact" is vital, photographers routinely saturate colors to the limits of credibility and simplify forms into catchily rhythmic semi-abstractions. The graphic impact of such effects can be striking. But when photographers blatantly graft on high-art allusions, they risk entering the realm of kitsch. Compositions borrowed from Adolph Gottlieb do not automatically accord cosmic significance, and tiers of luminous color alone cannot recreate the spirituality of Mark Rothko's paintings. Chiaroscuro effects fail to match the depth and dignity of the old master paintings from which they are borrowed.

Popular photographers can dazzle us with pyrotechnics and ingenious improvisations. Of these, Ernst Haas has so virtuosically perceived the world's protean possibilities that Max Kozloff has titled him the "Paganini of Kodachrome."[5] Haas's photographs invariably show an optimistic, dynamic world where blossoming meadows festively flutter in celebration of spring, where cities from Venice to New York vibrate with pattern, and where the Himalayans and other exotic peoples theatrically celebrate utopian lives. In Haas's world sunstruck tree tops suggest a river of gold; an abalone shell becomes a vista; a crushed can, a Buddha; and an oil

stain, the cosmos. For his book *The Creation*, Haas was unmistakably The Creator, a role he has often assumed during the course of his career. Scores of imitators and Haas's ongoing work in the same vein have made such solutions seem cliched. More bothersome to the majority of the new color photographers, however, is Haas's preference for transformation over truth, for drama over restraint, and for what Kozloff has identified as Haas's exploration of "not the sensations, but the sensationalizing of color."[6]

Eliot Porter, Philip Hyde, and other Sierra Club photographers are far more self-effacing. Considering the great outdoors a holy temple, they avoid deliberate transformations and distortions. Each photograph encapsulates a reverent observation, a vignette of a larger truth. These photographers refrain from artful obtrusiveness in order to safeguard the primacy of the subject. But because color film overreacts to certain colors and intensities of illumination, and because nature itself often provides jolting color effects, their photographs may contain visually disruptive occurrences. This rarely disturbs the many photographers and viewers who consider two-dimensional formalism irrelevant to their transcendental reportorial priorities.

But as Eliot Porter has sometimes shown (most consistently in the group of photographs chosen for *Intimate Landscapes*), reverence for the given does not preclude waiting for moments—or choosing vantage points—in which nature accommodates itself to the rectangular corral. Cliffs and horizons can form frames within the frame. Light can project geometric patterns on mesas. Trees, cropped and centered, can supply vertical axes.

Porter's devotion to the organic tapestry of natural sub-

ject matter virtually precludes a solid visual architecture tailored to the demands of the rectangle. When he fills his frame with instances of nature's tactility, there may be baroque tumult or color-field meshing, but rarely are there controlled pictorial tensions or graphic correspondences. Movements throughout the frame are simple repetitions and alternations, which do not supply the variety that calculated pictorial inversions, transformations, or correlations might provide. While of enormous interest to nature lovers, his results have led the new color photographers to seek combinations of man-made and natural subject matter that might offer a broader selection of observed motifs for formal orchestration.

Dean Brown, between 1969 and his death in 1973, extended the "wilderness untrammeled by man" genre in a manner that predicted the work of contemporary color photographers. Pattern-on-pattern textural occurrences link diverse spatial zones, transforming the world into spectacularly woven color fields. On occasion, Brown even toyed with irony: Feathery cloud tufts seem stuck on a blue surface; cresting waves form white lines so regular that they seem the marks of a design-conscious conceptualist manipulating string, tape, or paint. Although largely unacknowledged by contemporary photographers, his work ought to have convinced them that imposing, nostalgic, and sublime subject matter was amenable to treatment.

Black-and-white photography figures so predominantly in the documentary tradition that we might be conditioned to expect the news in tones, not chromes. However, the principal impediment to color film's credibility has been its inclination to alter rather than duplicate the world's colors, producing extravagantly lush, festive hues from less flamboyant sources. Now that magazines and even some newspapers rely so heavily on color reproduction, chillingly ironic paradoxes often result. The jaunty abstraction in pinks, purples, and other pastels that graced *Time* magazine's cover on December 4, 1978 was David Hume Kennerly's unintentionally joyful translation of the Guyana tragedy.

Informed opinion has been so convinced that serious, sober subjects could not be truthfully represented in color that in 1975 Max Kozloff asked the rhetorical question, "Is there even a single photograph of the Depression in color?"[7] Sally Stein's discovery of a cache of 700 Kodachromes (compared to 100,000 black-and-white negatives) shocked just about everyone. FSA color photographs by Russell Lee, Marion Post Wolcott, and Jack Delano argue persuasively that as far back as the 1930s the medium was used directly, subtlety, and without disruptive spatial contexts or saccharine enrichment. However, this work foreshadows the best of recent imagery primarily in its chromatic restraint and descriptive clarity, the color is not used structurally.

In any case, the FSA color photographs affected no one for they were not seen. Stein speculates why: "The innate sense of propriety in the way they handled color probably explains why none of it succeeded in being used at that time—their descriptions were too uninsistent to conform to the already stereotyped editorial ideas about what kind of imagery merited the cost of color printing."[8]

Advertisers then and now enlisted color to grab viewers' attention. Color photography's "more is more" visual character made it the ideal purveyor of conspicuous consumption. Color photographic advertising pioneers such as Paul

Outerbridge, Anton Bruehl, and Nickolas Muray have been followed by scores of advertising photographers able and anxious to serve up dramatic, audacious, and alluring fantasies. Adroitly adapting art from Cubism to Constructivism to Surrealism, they remained au courant while pandering to the mass ideals of the moment.

However many noncommercial works Outerbridge and others produced in color, the idea persisted that color photography was mainly entertainment. Irving Penn and Richard Avedon, both of whom have mastered color, choose black and white when working for posterity and not for profit.

In 1940 Paul Outerbridge wrote that still life offered the greatest possibilities "for purely creative work in color photography."[9] Although Outerbridge accomplished many curiosities and a few near misses in somewhat simplistic, Cubist style, most still-life photographers, like most portrait photographers, have chosen to emulate the effects of old master paintings of the Caravaggist-Northern European painting tradition. Such works have suffered more severe critical evaluation than the often gaudy, giddy, and dated advertising tableaux, which over the years have acquired a nostalgic patina.

But simply to dismiss well-varnished photographic "paintings" as soupy, sentimental, and still-born is a moral judgment, and it does not explain why these photographs fail visually. The painter's infinite prerogatives to include, exclude, accentuate, and minimize are not extended to the color photographer. Compared to paint, brush, and canvas, the camera is a rigid tool with which to attempt premodernist imagemaking.[10]

To photographic imagery of pictorial unity and quality, a strategy of total, manipulative control prior to exposure must be applied. For years commercial photographers accumulated arsenals of technique and equipment with which they might authoritatively ration visual nuances and control the informative pace of their images. Because their photographs aim for the impact so necessary to successful advertising, they rarely produced contemplative, time-released compositional arrangements. Most of the photographic artists who might otherwise have applied the technical knowledge and manipulative strategies of their commercial brethren subscribed, instead, to Stieglitz's and Strand's proscription against directorial photography, or else believed that the artist must remain a solitary figure, free from the ministrations of technicians and other retainers. Because of the belief that art not born of its own time is still-born, most art photographers then and now shun a wholesale exploration of premodernist pictorial impulses.

That task fell to Marie Cosindas, who stands apart as an artist creating highly qualitative visual effects in a genre and style out of date and out of vogue. Much of the imagery she has produced since 1962 with Polacolor sheets and a Linhof box camera demonstrates the results obtainable through maximum directorial control. If a subject's arrangement, color, texture, and illumination are fastidiously chosen and then manipulated prior to exposure, and if the technical variables—such as room temperature, colored lens filters, exposure time, aperture setting, Polacolor film development time—are applied, evaluated, readjusted, then applied again until precise control of result is attained, it is possible for a photographer to exert a dominating influence over every resultant visual effect.

Because Cosindas's photographs seem more painterly than photographic, they are often disparaged or dismissed. Yet to say that she violates the "truth to material" imperative is to ignore the fact that she, more than anyone, has cultivated the rich color effects of her medium, and to the greatest extent she has enlarged the control over color photography's mimetic potential.

Her images, with their decorative pile-ups of flowers, plumes, fabrics, bow-tied asparagus spears, and other gew-gaws and contrivances, are undeniably decadent. The tiny spaces—so drunk with color and packed with textures—exude an ambience that seems tense, cloying, precious, and claustrophobic. The portraits of actors, couturiers, personalities, and friends are court portraits lacking either restraint or surprising insight. The belatedly appropriated painting styles—ranging from the baroque to the Nabis and the Vienna Secession—now seem empty forms, lacking the meaning attached during those earlier eras. These manifold weaknesses blind many diehard modernists to what she can teach. Her anxious commitment to test the full potential of Polaroid products, her desire and increasing success in controlling every aspect of the photographic act, could serve stylistic and ideological ends alien to her own.

Working out in the world, where directorial control over illumination, object color, and relative physical position is obviously difficult if not impossible to attain, color photographers mainly fumbled and floundered until around 1970 when they modified their traditional naturalistic priorities. Although adopting a modernist position, they avoided the simple-minded approach, which regarded a patinated wall or some already two-dimensional forms as "modern art-like" and worthy of recognition. Instead, their photographs revealed the purely visual, two-dimensional viability of the three-dimensional world. By careful framing of a selected section of the world, they learned to anticipate and enlist color film's hue exaggerations and the spatial codifications imposed by all lenses.

Since many of the distinctively photographic tendencies conscripted for this end seemed suspiciously similar to the unintentional, unwanted by-products of careless snap-shooting (such as overexposure or accidental cropping) some critics perceived this approach as a wholesale indulgence in chance. To the contrary, the most capable photographers applying such deliberate methods employ fastidious tactics intelligently designed to stress, extend, and extract qualities unique to their medium. Though often inspired by an amateur's accidents, their works are as similar to snapshots as Abstract Expressionist paintings are to oil spills. They are hardly the same photographs that Uncle Harry returns to Fotomat.

Writing for the *New Yorker*, Janet Malcolm has theorized that photo-realist painting was the catalyst by which snapshots traveled in style from albums to art galleries. Calling this a "ludicrous" demonstration of photography's perennially mimetic relationship to painting, she wrote that no photographer has acknowledged photo-realism as the progenitor of the new color photography because "one of the unwritten laws of contemporary photography is that no photographer shall ever publicly admit to any painterly influence."[11]

Malcolm's contentions stem from narrow assumptions about the strageqies, priorities, and goals of the new color photographers whom she calls "photo-Photo-Realists." In fact, the only common denominator that links them with Photo-Realist painting is the use of color photography as a mechanical transcriber of the contemporary landscape. That photographers and Photo-Realist painters employ both process and subject matter for wholly different purposes, with dramatically different results, seems to elude Malcolm.

She defines "Photo-Realist country" by the presence of "recently made structures, machines and objects; by people dressed in clothes of the cheap, synthetic and democratic sort; by the signs and the leavings of fast food, fast gas, fast obsolescence; by the inclusion of the very parts of the landscape that photographers used to try to eliminate. . ." With such pervasive criteria, it would be difficult for any contemporary color photographer to address the modern landscape and its inhabitants without provoking Malcolm's accusations of mimicry.

Two major trends in Photo-Realist painting contain the traits that provoke Malcolm's conclusions. In the first, the painter selects a conspicuously mundane contemporary subject, like Robert Bechtle's sedans in suburban shopping-center parking lots. The subject is then photographed with unexceptional skill so that the resultant snapshot replicates the blandness of the average amateur photograph. The subject and its photographic transcription thus combine to form a cultural artifact that provides the form and content of the painting.

This strategy renders both the subject and its snapshot transcription a single object. Instead of revealing visually or narratively transcendent meanings, this method submerges any such potentials by turning the represented view into an emotionally opaque, material symbol of itself.

Malcolm implicates this mode of Photo-Realism as the precedent for photographs by William Eggleston which appeared at the Museum of Modern Art in 1976. Yet Eggleston's pictures—and those of many other color photographers to whom she indirectly refers—distinguish themselves from typically Photo-Realist representations of the mundane. Where many of the Photo-Realists traffic in narratively impotent, specimenlike typologies, Eggleston and other color photographers like him orchestrate contemporary subject matter into subtler, more precisely tuned chromatic arrangements. Eggleston's photographs in particular often intimate that substantial significances underlie the presentation of subject.

In the second Photo-Realist trend, which a greater number of painters embrace, subjects are chosen for their spatial and volumetric complexity and general technological sleekness. If painters of the first trend regard their subjects with mute, dutiful ambivalence, painters of the second exalt their motorcycles, pickup trucks, fast-food restaurants and airplanes, choreographing such glittering gadgetry into dazzlingly slick visual arrangements. Enthusiastically intensifying the color saturations and tonal contrasts in their source photographs, they deliberately dramatize the fluidity of high-tech forms and surfaces.

These Photo-Realist painters seem less concerned with visions of rare formal sensitivity than with producing visual extravaganzas that rival Abstract Expressionist painting in

sheer scale and visual impact. If the Pop artists chose to entertain us with prefabricated graphics from the labels and signs of our world, many Photo-Realists choose predetermined, crowd-pleasing subjects that extoll the emotively neutral, epicurean visual excesses of modern civilization.

Such imagery embraces the same quantitative concentrations of visual sensuousness found in full-color advertising photographs, which use lavish displays of color and texture to hype commodities from fashion to pocket calculators. No wonder, then, that these Photo-Realist paintings project such a strutting, muscular charisma when exhibited on museum walls.

Among the Photo Realist painters, only Richard Estes endeavors to paint imagery that enlists and evokes the most visually sublime aspects of color photography's potential. Working from several 4 × 5″ color contact prints of his subject matter, he is able to compensate for the informative deficiencies (such as parallax, burn-outs, fill-ins, and out-of-focus zones) that limit many single photographs. His results, painted with formidable technical sureness, represent a sparkling, clear, vibrant conception that is ideally "photographic," yet is not technically attainable through photography alone.

The new color photographs, though larger than snapshots, rarely approach the size of photo-realist paintings. Malcolm thinks this makes them "slouch" and look "dejected" on museum walls (as if in awareness of their inferiority to their counterparts in paint), but in fact, the size suits photography's own unique capacities. As a precious print that people must move up to and peer into, these photographs contain their own special attributes of immaculate transitions of tone and hue, rich color idiosyncracies, crisp delineation of textural detail, and omniverously recorded information.

Color photography came of age during the decade of the 1970s, when many of its practitioners energetically probed its special capabilities, determining to overcome its deficiencies and exploit its assets. No longer confined to the Procrustean bed of painting styles, living or dead, it emerged as a distinct art form with a unique visual syntax.

CHAPTER 2: **COLOR PHOTOGRAPHIC FORMALISM**

Through most of art history, formalists have been idealists in search of optimum pictorial structures. Content and materials were subordinated to that end. In recent years, formalism's scope has narrowed to an almost exclusive preoccupation with medium and process. As Ad Reinhardt insisted, Only 'art as art' is normal for art.

Some color photographic formalists follow this ideological prescription. Others, who do not flaunt medium and process, have devised a language from color photography's descriptive capacities and chromatic tendencies that is no less "photographic." Typically, their nonhierarchical compositions reflect many of the same visual principles that govern nonrepresentational painting. Yet photography's unseverable connection to optical reality makes the modernist ideal of the autonomous artwork elusive, if not impossible.

Unlike those contemporary painters and critics who denigrate subject matter as an adulteration of the art-about-art imperative, the most resourceful photographic formalists regard the complexion of the given environment as potentially articulate aesthetic material. They consider the subject and its visual essence as indivisible.

These formalists perceive real objects and intervening spaces as interanimating segments of a total visual presentation. They test every edge, tone, color, and texture for its expressive potential and structural function. Each photograph represents a delicately adjusted equilibrium in which a section of the world is coopted for its visual possibilities, yet delineated with the utmost specificity. The resultant image exists simultaneously as a continuous visual plane on which every space and object are interlocking pieces of a carefully constructed jig-saw puzzle and a window through which the viewer can discern navigable space and recognizable subject matter.

These two contexts of the image coexist in conflict, producing a visual tension that transcends pure design. This approach revives aspects of early Renaissance pictorial presentation, where visual sections of a three-dimensional scene functioned both as representations of such recognizable entities as ocean, sky, shrubbery, and figures, and as carefully arranged and chromatically coordinated two-dimensional shapes, which comprised a unified, decorative design. The strategy harks back to the era of Jan van Eyck, when painters sought a divine reconciliation of illusion and decoration.

The purely visual structure of such images seems invisible to many who prefer what normally passes for "abstract" color photography. The new color photographers assiduously avoid "painterly" polymorphous fuzz, "minimal" monochromatic marinations, "abstract expressionist" peeling walls, and high-tech graphics derived from derrieres impersonating "S" curves.

Conspicuous design is not instantaneously apparent, and so some viewers search in vain for an obvious message. Since the subject matter has not been bullied into exaggerated angles or supersaturated colors, many viewers find the works lacking in impact. Because the new formalists eschew the *grand jeté* in favor of a strategy that carefully coordinates all components, many viewers are bored. Those receptive to the subtle, sequenced impact of a multilayered image are far outnumbered by the audience who believes a good photograph must be instantly accessible. When the

Plate 1 William Eggleston

Plate 2 William Eggleston

subject seems missing altogether, the photographer may be accused of pulling the wool over the eyes of critics, curators, and the public.

Since so many viewers, and even critics, contend that these recent color photographs reflect an absence of method and intent, a discussion of basic pictorial strategies is imperative. The most sophisticated practitioners do not work with glib formulas, but combine various tactics in response to the particular demands of each image-making situation.

Frequently, color photographers enlist man-made or organic entities to establish an underlying geometric order. Although such images often include overlayers of subtle and variegated elements, the geometry of the compositional skeleton remains prominent. *(plates 2, 3, 5, 12)* This format has often become slick; consider the thousands of photographs produced during the past decade in which a building façade, ground, and sky each provide simple planes of light-inflected color. Although now a cliché, its frequent use in the early 1970s at least demonstrated that two-dimensional design need not derive from the photographing of already flat surfaces.

Most formalists now embrace more complicated arrangements, wherein balance is more intuitively attained and strategy less obviously revealed. However, certain devices do recur. A conspicuous motif or element is frequently positioned near the center of the image in order to perform a "push-pin" function, overlapping and thus riveting together various compositional elements. *(plate 2)*

Photographers who use view cameras often compensate for their equipment's cumbersome bulk and weight by composing with such stationary, stabilizing devices as porches, windows, fences, and building façades. The world is thus made to function like the backdrop of a shooting gallery, against which figurative targets or even light can move. *(plates 20, 24, 28)*

The acute constructive motivation fundamental to the formalist impulse is less apparent when geometry seems absent. Photographers sometimes subsume discrete facts in an overall field. In such images, compositional structure depends upon interwoven networks of recurring motifs, hues, textures, and tonalities. Except when viewed at extreme close range, individual components optically blend together, fusing into communal visual passages. *(plates 15, 78, 109)* Precedents for most of such field strategies exist in Eliot Porter's photographs, but his successors typically choose mixtures of man-made and organic material, incorporating a wider variety of patterns, rhythms, and densities.

Such photographers often exploit their film's reaction to certain color and light sources, applying such phenomena in the manner of the oscillating colored discs in Larry Poons's best-known paintings. *(plates 122, 126, 127)* When recorded on film, broad expanses of similar hues or values superfically resemble color-field paintings. *(plates 22, 23)*

As Eliot Porter's imagery demonstrates, the field strategy adapts readily to the photographing of organic subject matter. The material might first appear as incoherent commotion or an unfocused "mass image" (to use George MacNeil's term for Abstract Expressionist painting). *(plates 4, 115)* If foliage is set against a wall or mirror, the flora will become the warp, the shadows or reflections the weft.

(plate 71) Although such a weave directs our attention across the picture surface, the illusion is not one of flatness but of ampleness and springy resilience.

Field strategies often evoke characteristic passages of Abstract Expressionist painting, but the visual texture of the photographs derives from an optical mix of steadfastly articulate, recorded facts that have been presented in a manner calculated to emphasize the subject matter's cumulative rather than individual visual appearance.

A photograph need not employ complete, unmitigated meshing or unending repetitions of elements in order to apply principles of field strategy. Motifs must recur with just enough frequency to create correspondences that reconcile unruly chromatic, textural, and spatial elements to fixed and functioning positions within the rectangular scheme of the image.

Another approach incorporates a motif (or motifs) that repeats, inverts, augments, diminishes, aligns, and/or overlaps to unify the composition. Unlike in the field strategy, the crucial elements in such visual fugues do not blend together but remain conspicuously discrete. Each configuration remains clearly visible amidst the contrapuntal texture, distinguished by its local color and visible contours. No optical mixing confuses the identification of such motifs. *(plates 6, 7)*

Images organized in fuguelike fashion never achieve emphasis through the kind of sweeping movements attained in Mitch Epstein's photograph of Pohkara, Nepal *(plate 135)* where interconnecting fields of color and texture converge from disparate spatial locations in the scene. Fugal methodology dictates a more precise, ascetic means of achieving pictorial climaxes, one that might be compared to the terraced phrasing by which baroque musicians simulate a change of register on a baroque organ.

John Szarkowski has been widely criticized for writing that **William Eggleston** "invented" color photography. Yet Eggleston seems to have been the first photographer consistently to employ sophisticated formal strategies by which the medium could be controlled and from which its unique visual syntax developed.

By 1971, the year by which all the images in *William Eggelston's Guide* and many of those in Eggleston's 1976 exhibition at the Museum of Modern Art had been created, he had applied almost every visual idea and structuring device in current photographic parlance. Other photographers have refined Eggleston's strategies, but he paved the way.

Eggleston's adroit application of various formalist approaches produces narratively potent, poetic photographs; a focused examination of his extra-pictorial interests is offered in Chapter 6. However, his control of the plastic aspects of color photographic processes provides lucid demonstrations of pure visual strategy, and so it is important to consider him here as well.

In "Southern Environs of Memphis" *(plate 2)*, Eggleston overlays color and texture upon a stable geometric scheme. He bisects the frame along a central horizon, creating equal sections of land and sky. In turn, the ground divides into two segments of almost identical size on opposite sides of the nearly vertical strip of gutter, which retreats until it disappears under the wheel of an old black Buick. Like the axial

Plate 3 William Eggleston

Plate 4 William Eggleston

button of a giant pinwheel, the car occupies the precise location where the expansive shapes of the photograph's lower half seem to converge.

Such stolid symmetry could easily deaden an image's plastic power and emotive energy. But Eggleston fleshes out this balanced skeleton with juxtapositions of color, value, texture, and size contained within similar shapes. Although the sidewalk and gravel road sweep with parallel grace toward a common vanishing point, the walk glows warmly with rosy light, while the gravel glowers with cooler hues and deeper values, expanding tediously without conspicuous incident. Distant and shadowed, the house at the right remains remote, but its nearer counterpart at the left sparkles with sunlit detail. Patches of groomed grass pattern the sidewalk, countered by shady clusters of sprawling undergrowth bordering the road.

In the careless cropping, negligent alignments, and imprecise exposures of amateur snapshots, Eggleston recognized potent effects that under his direction could produce mesmerizing contrasts and shifts of conventional emphases. In his photograph "Memphis" *(plate 1)* large portions of a figure and car have been amputated at the frame's lateral edges. Brilliant patches of sunlight obscure the complexion of recorded surfaces. The horizon and several other prominent edges careen along disquieting diagonal trajectories. This list of effects reads like an inventory of flaws cited in many technical manuals, yet a forceful deliberateness guides Eggleston's display of objects, governing its visual arrangement and informing its narrative implications. Although this image avoids the more measurable schematic symmetry of plate 2, it attains its equilibrium through careful rationing of contrasting values, simple and complex textures, complementary shapes, and intense color. Asymmetrical sections of discrete color, value, and shape divide the rectangle into zones of dark and light, neutral and saturated hues. Reflecting metallic surfaces, dappled sunlight patterns, flames, and selected instances of chromatic intensity obscure many of the contours that help define individual objects, creating sparkling repetitions and correspondences. The crimson hand, orange fire, and red reflections on the car surface describe a constellation that spans the image's full width. The bleaching swatches of sunlight further subvert the intelligibility of many of the subjects' actual planes and volumes.

Such phenomena transform the three dimensions of the actual scene into crazy-quilt fragments and effects. Eggleston achieves pictorial cohesion and emphases through contiguous visual relationships that are more specific to his photograph than to the scene itself. In real space, the gray slab and car hood do not touch. But in Eggleston's presentation, they lock together within the pliant, shallow space of the image. Illusionistic sensations persist, but clear transcription of actual depth and volume is not essential.

In "Memphis" *(plate 4)* Eggleston exploits his medium's capacity to create connecting, nearly continuous visual fields from subject matter placed at varying distances from his lens. While definitions of the scene's actual spatial relationships wander into repeated ambiguites, foliage located throughout the frame unites into a network of related texture and hue. Weaving behind and in front of the prominent blue pickup truck, near and distant trees, grass clumps, discrete branches, and pink blossoms diffuse the

24

Plate 5 William Eggleston

salient power of the vehicle's solidity, transforming it into a lurking shape of blue that radiantly engages the pinks, greens, and browns that dissect it.

These examples, like many of the photographs in *William Eggleston's Guide*, portend poetic and potent possibilities for the medium. Yet most color photographic formalists do not follow Eggleston's lead. Before his work was published or exhibited to any extent , these photographers were also developing color photography's potential. Some pursue the process, strategically applying technical flaws and snap-shooters' accidents. Their conspicuously photographic works will be discussed in the next chapter.

Stephen Shore, Joel Meyerowitz, and others, however, seek sublime fusions of illusion and decoration. In this pursuit, they appear to hold much in common with Walker Evans and Eugene Atget, and certainly must benefit from the substantial legacies of those two great practitioners of black-and-white photography. Because those two masters provide no high quality models of work in full color, modern painting—where color is a fundamental, structural force—contains the most significant precedents for the strategies employed by the best contemporary color photographic formalists. Unlike premodernist paintings, which retain much of their spatial intelligibility and decorative cohesion when reproduced in black and white, these new color photographs share with modern painting a heavy dependency on color. When translated into monochrome, they lose their formal and metaphorical meanings.

Of the principal color photographic formalists, **Stephen Shore** has most successfully adapted Evans's objectivity and aesthetic autonomy. Yet unlike Evans, who so ably absorbed the significance and sensuousness of his subjects, recognizing the potent ambiguities in the real, Shore avoids mythic possibilities for purely pictorial meaning.

Whether photographing deserted intersections, dirt roads, parking lots, esplanades, or Monet's gardens, Shore's paradigms are order, balance, and serenity. Objects, shadows, and intervening spaces provide Shore with vital components of co-equal visual significance.

Shore likens the visual tension of his best photographs to the "constant pressure" maintained by trout fishermen.

> When you're casting you have to time your cast so that the fly on the end of your line settles gently onto the water, thus giving the trout the impression that it's biting at the real fly. It's a tricky procedure to master, and the key to it, the way experts explain it, is constant pressure. It's a feeling of the line on the rod tip that is always there. Without constant pressure the timing falters, and so does the fly line, leaving the caster with a disconnected, where-did-it-go feeling. Of course, it's very possible to take pictures without constantly paying attention to every decision that needs to be made, but my experience was that when my attention wandered and I started making decisions automatically, there was something missing in the pictures and I was left with that where-did-it-go feeling?[1]

By adjusting and readjusting his framing, Shore strives to eliminate every visual loophole and inconsistency. Nonetheless, he avoids obvious solutions. Inexplicable, instincive adjustments guide Shore's works.

Shore's fugal tactics are evident in plate 6. The basic motif is the chevron shape, which appears twice in the

forked tree branches; once in cast shadows; in the perspective retreat of white lines in the walkway; in the legs of the pedestrian; and so forth. Other repeating elements appear, such as the instances of yellow-orange, which inhabit various spatial regions of the composition. Unlike many less sensitive photographers who appropriate a conspicuous item and seek one or two recurrences of it, Shore's application of fugal methodology is less obtrusive and more thorough. The almost spiritual sense of balance and quiet harmony that his best photographs contain derives from the sensuous effects of cumulative, rhythmic motifs that remain well integrated, even camouflaged within the continuum of recorded data. Close examination may reveal fugal relationships between various elements, but the individuality of any motif is superseded by its role in the pictorial whole. Consequently, the effect, not the technique, predominates.

Shore constantly strives to keep the edges "alive."[2] In plate 7 sections of sky vibrate when pinched between poles or signs and the picture's edges. Such compositional precision maintains the identities of the objects and the spatial coherence of the scene. Closer pruning would have threatened both. Shore's method charges the photograph with the dual tension of two-dimensional design and three-dimensional illusionism.

For Shore, light is always an expressive force. Carol Squiers writes:

For Evans a clear cystalline light reiterated the spare simplicity of his compositions (and therefore his subjects), concentrating attention on broad forms or specific situations in an emphatically direct, unfettered presentation. When Shore uses this clean, direct light,

it serves basically an instrumental function. And his most expressive use of light, again, appears in his representations of distance.

Normal daylight illumination is provided by a mixture of sunlight and skylight, the latter being composed of short wavelength light that appears to be blue. As objects recede into the distance the progressively denser blue atmosphere mutes tone and shape, an effect traditionally known as atmospheric perspective. Especially in his finely detailed vistas, Shore favors a palette that stresses the blue end of the spectrum. By doing so he exaggerates the effect of skylight overall, and the effect of atmospheric incidence in particular, producing cool tonalities across the field . . . Cold tonalities express the inert, deadpan beauty of these images.[3]

Shore's goal, like that of Evans, appears to be a "reticent, understated and impersonal art."[4] Viewers immune to his subtle, sensuous visual intelligence often describe his works as "dry" and "detached" because they only see lucidly described facts. Kandinsky's metaphor of the burning flame within the ice comes to mind. "If people perceive only the ice and not the flame, that is just too bad. But a few are beginning to grasp."[5]

Shore does not use cliched pictorial packages to carry readymade meanings. In one sense, his subject matter is what it appears to be—a scrupulous inventory of visible facts. But Shore maneuvers his facts to reveal epiphanic visual interdependencies. Pictorial priorities supersede a devotion to what might constitute the subject's truth. He is engaged not with any place's knowable identity, but with

Plate 6 Stephen Shore

28

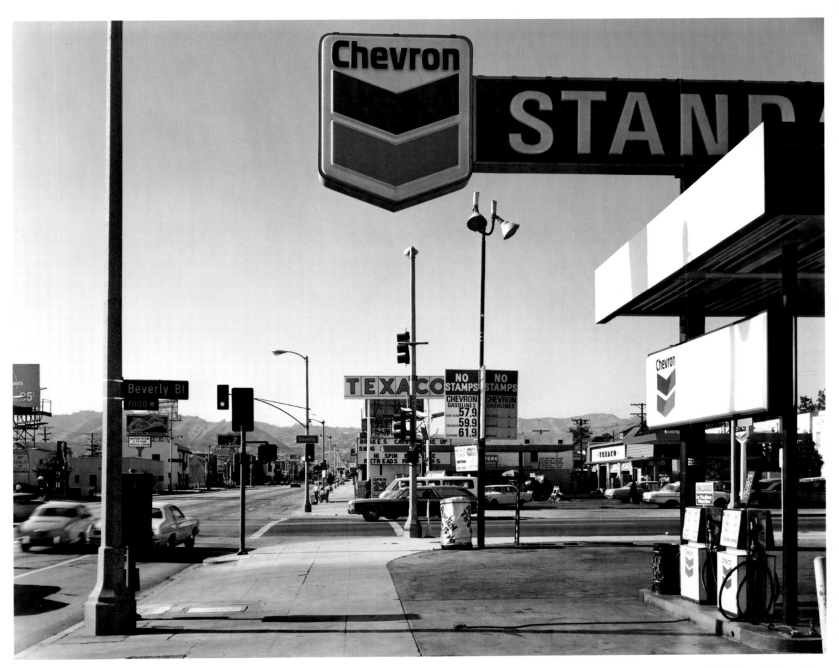

Plate 7 Stephen Shore

its visual mystique, its potential for being turned into a picture.

Rocky Thies's imagery shares the more rigorous and austere aspects of Shore's aesthetic. His work is highly valued by those who consider visual charisma to be decadently decorative and indulgent. Operating within the terse limitations defined by his minimalist sensibility, he accounts for every visual event and avoids any occurrence that might undermine the taut consistency of his intentions.

Photographing "purple mountains' majesty," Thies assumes a vantage point that includes gray scrub brush in the foreground to neutralize the purples of the picturesque peaks and the postcard blue of the sky. In most images he concentrates on the plains. *(plate 13)* His deliberate inclusion of assorted telephone wires, tire marks, and sprays of water from irrigation spigots thwarts any possibility of idealizing his subject, while providing graphic devices that subdivide and order his schemes into calculated sections. Thies thus transforms nature's sprawling displays into minimalist statements of almost mathematical precision.

Like Rocky Thies, **Allen Hess**'s aesthetic seems to coincide with the more restrained polarity of Shore's art. He usually selects earth-colored subjects whose chroma is predominantly pale. The wharves of New Orleans offer ample displays of weathered vessels, bleached boathouses, and dull brown dock pilings. Hess permits only occasional passages of verdant foliage and allows diminutive instances of red or yellow into his images with even less frequency. The primary distinction that separates his imagery from work by those with whom he seems to share aesthetic allegiance is his sense of balance, which completely dominates pictures that conspicuously lack the uniplanar tension that so characterizes formalist color photographic imagery.

A salient demonstration occurs in plate 16 where extreme contrasts disrupt the spatial articulation of the scene and thwart attempts to categorize Hess as one more practitioner making the world flat. What remains—and what is most forcefully, if politely, asserted in this image—is the hushed application of visual weights and measures. Hess's sky disappears. Shadows under the wharf engulf the pilings in black. Except for small instances, the whole bottom half of the scene is dark while the upper section is light. This contrast is much too radical to allow both halves the appearance of existing on one plane. Hess's great gift seems to be the capacity to envision and present concrete evocations of near-perfect balance and harmony through unwieldy vehicles of extreme value contrasts, arranged in combinations of geometric and irregular shapes.

Much of the black-and-white and color photographs in **Emmet Gowin**'s "Working Landscapes" of 1978 reflect a high vantage point, which eclipses or nearly eliminates the horizon line. Earth, fences, cottages, gardens, and groves alike are subsumed into pictorial fields. *(plates 14, 15)*

Except when regarded at extreme close range, the works read like miniature painterly abstractions with short linear strokes of white bordering splayed colors. Under intimate examination, the delicate passages of texture and color convert to meticulous factual detail; lines become clearly defined tree trunks, fences, poles, roads; the pastel-like

smudges are foliage; the watercolorlike washes, expanses of pasture.

The muted quality of Gowin's hues and tones derives directly from his preference for overcast lighting conditions that do not fragment the field of vision into segregated territories of extreme light and shadow. The sober hues are frequently diluted versions of complementary colors that animate each other delicately in the soft, overcast illumination, serving his priorities of subtlety and containment.

Nonformal meaning may accrue from Gowin's approach, but he presents his inventory of discrete facts in a manner that is direct, precise, and denotative, refusing to spell out meanings. Gowin may detect important secrets in the vague tracks and whorls of light, even interpret them as the world's pentimenti, but his technique rejects emphases. Like his aesthetic predecessor, the surrealist Frederick Sommer, any and all subjects are grist for psychic revelation.

Gowin's framing seems to blanket an existing scene without tampering with the inherent equality of all the facts included within it. But while his direct manipulation of the appearance of any individual part is minimal, his particular selective inclinations unobtrusively adjust the scene to the formal demands of the frame, revealing pictorial priorities at least equal to his desire to transmit unmolested facts or to offer surrealist possibility.

Joel Meyerowtiz and the more romantic of the contemporary color photographic formalists attempt to integrate Eugene Atget's accomplishments into their own full-color conceptions. Atget's dense, mysterious, and deceptively simple photographs exude an extraordinary poignancy. As Colin L. Westerbeck, Jr. has pointed out, this poignancy never degenerates into nostalgia or sentiment but rather becomes a "genuine wound in the heart." Atget's photographs "imply the remorseless perishability of the world with a grace so subtle that we do not at first realize the force of what is revealed."[6]

Meyerowitz acknowledges Atget's effect on his own search for an intense, pure vision. But his sensibility is so responsive to the sensory experience of seeing pure color that modern painters clearly provide him with equally provocative stimulation. Referring to a rubber raft leaning against a Cape Cod cottage, Meyerowitz recalls that he saw "blueness itself. It was radiant. It had depth. It had everything I might possibly compress in my whole being about blue."[7]

Meyerowitz perceives sun-bathed sections of buildings, fences, lampposts and the St. Louis arch as dynamic color forces that will thrust against or dramatically recoil from the surfaces of his images (plate 24). Far from appearing gaudily gilded, his recordings retain every subtle tonal and chromatic shift on the sunstruck surface of his subjects.

By selecting specifically desired moments of illumination and through careful printing, Meyerowitz effects quiet, beautifully measured transitions that sensuously and emotively animate meticulously defined and orchestrated visual facts. He would probably affirm Kenneth Clark's statement that tones "close together have a spectacular beauty —they are often like the faintly shadowed vowel sounds so, often a source of magic in verse. 'La verité est dans une nuance.'"[8]

In giving pictorial realization to epiphanies experienced at the site, Meyerowitz is always cognizant of the rectang-

Plate 8 Stephen Shore

32

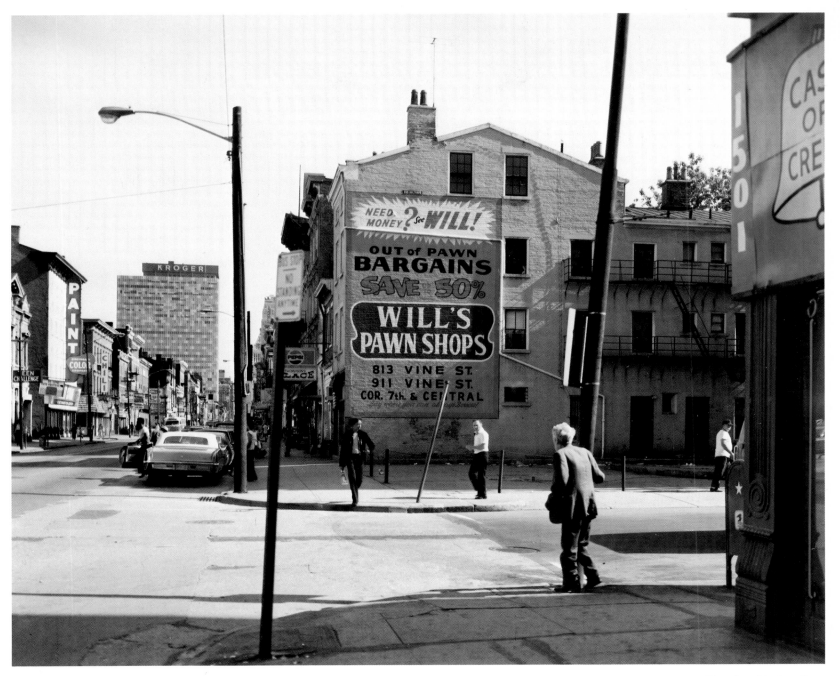

Plate 9 Stephen Shore

33

ular frame. No subject is suitable unless he can choreograph it to align in an aesthetically desirable way with the edge. Man-made elements, to be avoided according to traditional photographic priorities, are incorporated for their geometry and color. Porches, piers, and Eero Saarinen's arch provide geometric clarity that shapes fluctuating fields of sky and water.

Meyerowitz's switch from a 35mm camera to a 45-pound, 8 × 10″ view camera altered his stalking, rapid-fire attitudes without preventing snared, coincidental confluences of color and choreography. He often establishes sea, sky, sand, piers, and buildings as graphic fields—theater sets within which figures, but most often light, provide animation.

Typically, human presence is confined to such minute scale that narrative is nearly eliminated and incidental gesture has little influence on the formal character of the pictures. As figurative action diminishes, movement in the photographs derives mainly from subtle modulations of light across every surface. The climactic moment is rooted in the climatic; Meyerowitz waits for those times when light significantly alters color expectations.

The many variations in the "Bay/Sky" and "Provincetown Porch" series from his *Cape Light* works depend less upon changed vantage points than upon light-caused transformations of sand, sea, and sky, harmonizing anew in each picture. Unlike Claude Monet's studiously painted transpositions of a wide range of typical luminous effects on haystacks and cathedrals, Meyerowitz selects only the most visually extraordinary and epiphanic moments. He might wait for days before the requisite illumination manifests itself.

The twilight hours, when harsh shadows disappear and surprising colors emerge, prove especially potent. A column in waning, orange sunlight shimmers because adjacent shadows are tinged with green. If photographed in brilliant midday sunlight, the harsh contrasts of light against shadow would have transformed the column into a domineering pictorial protrusion. *(plate 20)*

In the "Bay/Sky" photographs, man-made elements provide minute concentrations of rich, often complementary hues that punctuate the fields of natural texture and color. The pink of a diminutive figure on a sand spit sparkles among surrounding browns and violets, simultaneously linking the land to the rosy sky. *(plate 22)* Through precise allocations of sky and the unit of water and sand, Meyerowitz creates pictorial structures that acknowledge and engage the rectangular precedent of the frame while avoiding static, layered stratifications. Land and water may be woven together by inclusion of a diagonal sand spit; a sailboat, patterned in pinks and reds, geometrically corresponds to the clouds above.

Even more subtle devices may be used. The bay at dusk is seen as a narrow-toned, almost achromatic visual field in which ochre sand and gray sky merge into the gray-violet horizon of the ocean. It is a hushed sweep of interlacing sand and water in which barely distinguishable tinges of mauve in the ochre contribute to its seething, simmering quality.

Although Meyerowitz's selection of light obviates the extreme or abrupt contrasts typically associated with the rendering of clearly defined space, precise readable detail extends throughout each picture. The illusion of spatial

depth thus afforded preserves pictorial tensions. Indeed, it is the texture provided by Meyerowitz's omniverous description that becomes the unifying fabric of his compositions. By realizing the subtlest light modulations, Meyerowitz's visual passages gently oscillate in the manner of color-field painting.

Meyerowitz's color-field photographs function like windows opening onto navigable realms. The minute chromatic shifts across lounge chairs, concrete, sand, water, and sky generate the vibrations. Peach and blue-gray hues—diluted versions of complements in the color spectrum—hum quietly. No zone is out of focus or diffuse. The ineffable color effects arise from the immaculate presence of apparent visual facts. Meyerowitz thus implicitly rebuts the painter Mark Rothko's notion that "the familiar identity of things has to be pulverized in order to destroy the finite associations with which our society increasingly enshrouds every aspect of our environment."[9]

For Meyerowitz certain places, like the pool, become *other*. "The place resonates a quality that you respond to. You feel your *self* in relation to its otherness. . . . Whether you're making images, poetry, painting, music, or love, you should be totally enraptured by that, by the experience itself. That's what it is about—the location of subject, it's about passage of the experience itself, in its wholeness, through you, back into the world, selected out by your native instincts. That's what artists do. They separate their experience from the totality, from raw experience, and it's the quality of their experience that makes *them* visible to the world."[10]

In their response to the sensation of seeing, **Larry Babis** and **Joanne Mulberg** seem to be Meyerowitz's kindred spirits. Babis favors creamy chromatic schemes, balancing commensurate quantities of blue and warm hues with interspersals of gray. Transitions, such as the progression from red to peach on the sign in "Colorado" *(plate 29)*, create visual movement within and between the image's subdivisions. Wires pattern the sky's vast expanse, and elements intruding from one field into another prevent monotonous symmetry. Here a projecting sporting goods sign commands the image, extending a green arm in a gesture complementary to the thrust of the store's eve.

Joanne Mulberg's square format imposes a perfect stasis upon her composition, stymying attenuation and movement. *(plate 17)* Although shadows pattern the foreground and branches scribe the wedge shape of sky into visually complex stanzas, the square and the interior verticals tend to convey a state of waiting or being, rather than the suggestion of any visual or narrative action unfolding.

Mulberg carefully coordinates her scheme with the square's proportions, supplying mildly varied quantities of dark, medium, and light tonalities, which remain chromatically subdued. Within such stabilizing confines, Mulberg derives rhythmic repetitions of horizontal, vertical, and complementary diagonals from the contours of walls and angled roofs. Despite the decided warmth of the illumination, the image's ambience seems mildly detached, its emotive power implosively contained.

For **Jan Groover**, "formalism is everything."[11] Always prone to exercise the maximum directional control over form, space, and color, she first worked analytically—as-

Plate 10 Stephen Shore

sembling modular works from several photographs—and since 1977 has worked synthetically, fabricating still lifes in her studio.

Of her composite images, Groover wrote, "For me, the rules are how things go together."[12] She photographed cars, trucks, buildings, streets, houses, and foliage, not for their referential possibilities but for their forms. Placed side by side, the three-dimensionality of each image evaporated, leaving planes of color. Viewers could compare and contrast the changes in time or motion, but more significant were the visual tensions and interlockings created by placing the separate panels together. Light posts and trees in the center of some photographs—and the mats marking the division between component images—served as metronomic markers, governing the eye's movement across the pictorial space. (plate 33)

Effects vary from the festive primary colors of trucks, caught clearly or in blur, to fluctuating textural foliage, flowers, and stone walls. Views of lower Manhattan buildings (plate 34) are to Max Kozloff "dark soaked visions" of going "dramatically blind in broad daylight."

These meditative highly personalized studies of stony and highly transparent surfaces depend all the more on color the scarcer it is. It's as if the pupil has to dilate in order to penetrate spaces grown irrational because they have been reduced into long, deep shards of tonal nothingness. (Her shutter has been gauged only for the light.) The human desolation of these locales serves all the more to concentrate one's own gaze, drawn, as if in communion, to the inanimate solids of the street. Umbers hold the glance, provide intimacy, and even-

tual credence. Still, her triptych sequences compound enigma, for even though shaded areas abut each other across the frames, suggesting a common place, differing perspectives wrench it apart.[13]

Of other works, Kozloff asks, "Does one see at slightly different times of the day three views of a New Jersey apartment with a tree placed in a corner, or is it three different apartment buildings, that only suggest the one, seen three different ways? Such doubts, which arise from the shared typology of streets and scenes, are played upon with a guile that is aware of surrealism." But to Kozloff, "Groover's systems speak to internal dissolution, not of it."[16]

Groover's use of modules to make abstractions was a contrivance that unavoidably provoked interpretations as rich and allusive as Kozloff's. This invariably drew attention away from Groover's formalist priorities. In her single-image still lifes, begun in 1977, extra pictorial references remain but distract little from her primary interest—choreographing space.

Working in the venerable tradition of product photography, Groover arranges knives, forks, spatulas, whisks, pyrex bowls, brioche tins, aspic molds, and other household objects. She reaches beyond two-dimensional formalism with its elements of color, shape, and line, to incorporate the sculptural elements of tonal transition, weight, and depth. Though these works superficially invoke Paul Outerbridge's still-life constructions of the late 1920s and 1930s, Groover's dramatic manipulations of depth and volume nod only to Paul Cézanne's late still lifes with their spatial twists and turns.

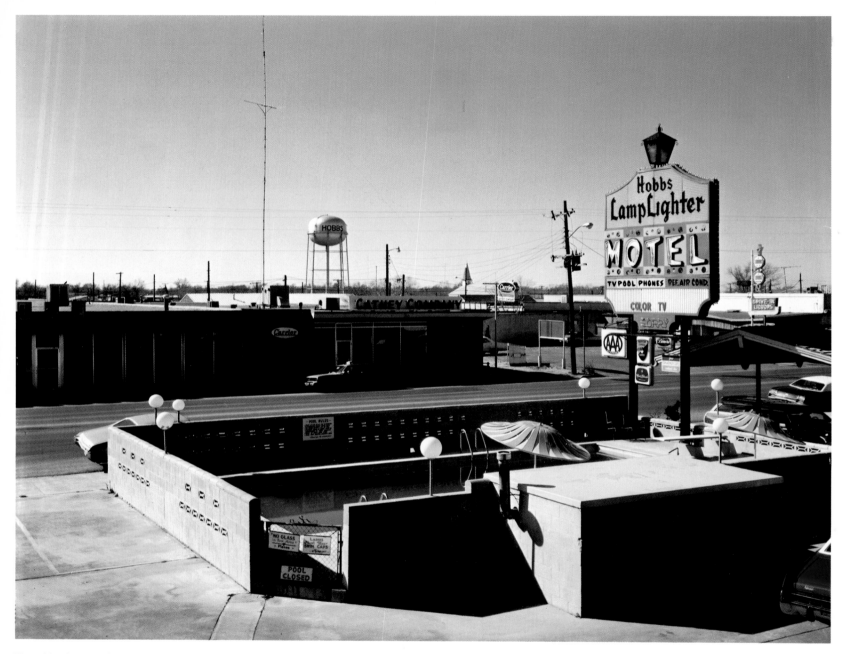

Plate 11 Stephen Shore

38

Plate 12 Stephen Shore

Groover reaches beyond two-dimensional formalism, with its elements of color, shape, and line, to incorporate the sculptural elements of tonal transition, weight, and depth. The result has so few precedents in photography that viewers often exclaim that the pictures must be paintings. But they would be unique to painting as well. Such perceptual sensations of spatial illusion do not typically occur without accompanying spatial legibility, in paintings or photography.

To view Groover's still lifes of knives, forks, spatulas, and snake plants is to be caught up in swirling movement. The eye latches onto one object, then another, and yet another. It may swish along the curve of a bowl, bounce across the tines of a fork, slide down the slope of a leaf, even be thrown outward by the oscillating wires of a whisk. The spaces between the objects seem like chiseled clefts, equal partners in an interlocking that goes beyond the tranquil tensions of modernism.

Groover exploits rather than elucidates three-dimensional space. The depth between objects is virtually unmeasurable. It is often difficult to differentiate foreground, middleground, and background. When a leaf touches a fork in one of these pictures, the tangency may well be an illusion—the result of the camera's foreshortening.

Additional ambiguities arise in reflections and transparencies. Objects with reflective surfaces may themselves be reflected, or seen through glass or under water. Objects outside the frame may be included in the picture as reflections. Unseen undersides of leaves may cast their colors onto aluminum foil or stainless steel. Objects submerged in water produce rippling and jagged breakdowns of forms refracting upon immersion.

Nervous energy generates from the presence of chatty objects, particularly forks, which add a charge like a painterly painter's aggravated brushwork as they sweep through Groover's compositional space.

The still lifes would be riotously chromatic had not Groover chosen so many metallic, silvery, and otherwise neutral hues. Color film gives a heightened conspicuousness to the mottled pinks and yellow-greens of calladium and coleus plants and to the deep green of peppers. *(plates 30, 31)*

Colors appear at full saturation, as well as in etherealized diffusion when they half-dissolve in reflections. The neutral half-tones of Groover's shadows provide more than sculptural definition; they supply moderating intervals that induce richer colors to glow rather than blare out from high-contrast surroundings. The hues are integral, not provisional. Their interaction contributes to the illusions of spatial progression and recession.

Groover's images range from sensational spatial displays *(plate 30)* to somber, eerily ambient arrangements *(plates 32, 35, 37)* about the vitality and subdued expressivity of neutral hues. To Ben Lifson, a "disturbed spirit inhabits this work" unlike her "first versions of *le dérèglement de tous sens*. The colors have narrowed to dark mineral blues, browns and silver; shadows impinge on objects; stainless steel mixing bowls recede into darkness like maelstroms; green and red peppers seem on the verge of shriveling; conical horns and cylindrical molds often seem about to tip and fall; vertigo, flaccidity, and darkness threaten."[15]

The 16 × 20″ size of Groover's prints causes her slightly enlarged objects to assume a sculptural identity barely evident in real life. The scale makes the photographs declarative and accessible from across the room. Clearly, Groover does not subscribe to the notion of the photograph as a precious print that viewers must press up against and peer into.

Although Groover consistently capitalizes on the camera's distortions, she never makes process the message. Where many contemporary photographers are inclined to build pictures around single instances of the camera's quirky vision, Groover devises entire symphonies of objects aligning and overlapping or appearing to do so. Her props would

Plate 13 Rocky Thies

probably seem helter-skelter to the naked eye, but filtered through the camera's lens they become cohesive pictorial units.

Groover's early modular works were in part critically self-conscious, but a gifted visual sense reigns in her still lifes. And while they possess the obvious, radical newness prized by so many advocates of modernist ideology, Groover's photographs are predominantly empirical, visual, and sensual—images rife with mystery, movement, and intrigue.

41

Plate 14 Emmet Gowin

42

Plate 15 Emmet Gowin

43

Plate 16 Allan Hess

Plate 17 Joanne Mulberg

Plate 18 Joel Sternfeld

Plate 19 Joel Meyerowitz

Plate 20 Joel Meyerowitz

Plate 21 Joel Meyerowitz

Plate 22 Joel Meyerowitz

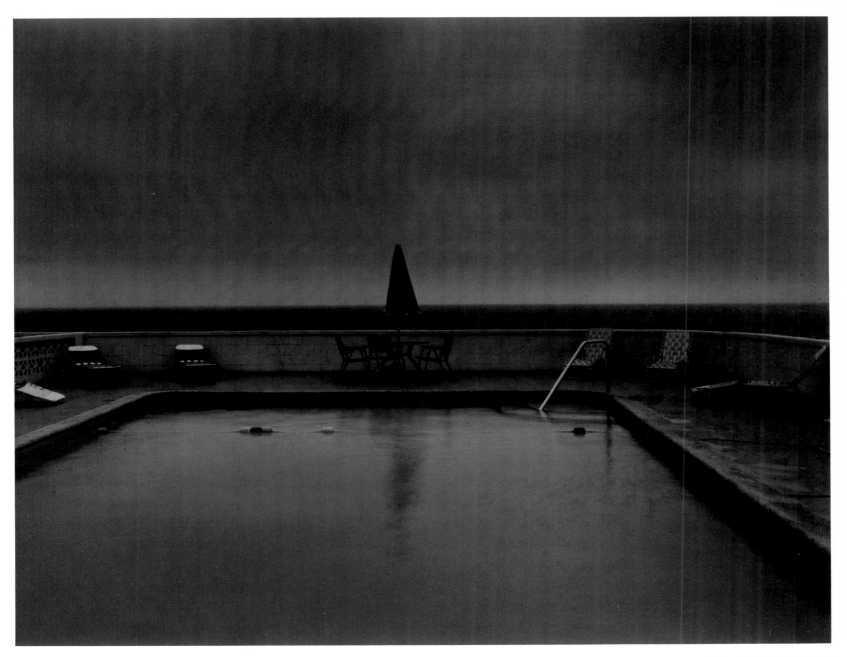

Plate 23 Joel Meyerowitz

51

Plate 24 Joel Meyerowitz

52

Plate 25 Joel Meyerowitz

53

Plate 26 Joel Meyerowitz

54

Plate 27 Joel Meyerowitz

Plate 28 Joel Meyerowitz

56

Plate 29 Larry Babis

Plate 30 Jan Groover

Plate 31 Jan Groover

Plate 32 Jan Groover

Plate 33 (triptych) Jan Groover

Plate 34 (triptych) Jan Groover

Plate 35 Jan Groover

Plate 36 Jan Groover

Plate 37 Jan Groover

Plate 38 Mark Cohen

CHAPTER 3: **THE VIVID VERNACULAR**

Clement Greenberg's dictate that each art ought to "determine through the operations peculiar to itself, the effects peculiar and exclusive to itself"[1] has filtered into the world of photography. Numerous photographers have made photographs about photography—enlisting, even embracing, the visual peculiarities of the medium that capable professionals once avoided or only implicitly or indirectly acknowledged.

The formalists already discussed, who primarily exploit color photography's special descriptive powers, do not typically produce images that seem obtrusively photographic. But others purposefully court and coax the perceptual ambiguities and accidental visual excesses typically found in unselfconscious amateur snapshots. When imaginatively enlisted to achieve fastidiously formal and/or provocatively narrative images, such effects become crucial elements of a vivid and vital vernacular art.

Whether working in black-and-white or color, **Mark Cohen** draws out the anomalies of photographic seeing, expanding notions of what might constitute photographic form. He is the best-known exemplar of the photographer-as-trigger-happy-gunslinger approach. People are often shot from such close range that they seem virtually assaulted, their heads and limbs cropped from the picture. *(plate 38)* Flash-bombed subjects frequently appear as bright, jutting shapes separated from a flat, fuzzy, monochromatic, and mural-like background.

Shooting frame after frame on impulse, Cohen captures confluences too fleeting for the conscious eye to perceive. He would agree with Garry Winogrand, who has said he photographs "to see what something looks like when photographed,[2] and Eugene Ionesco who has written, "If lucidity is required a priori, it is as though one shut the floodgates. We must first let the torrent rush in and only then comes control, grasp, comprehension."[3]

Because it is not possible to consider philosophical ramifications or formal balances in a fraction of a second, Cohen verifies his initial impulse while editing his negatives. Then he discovers that, yes, there is something strange and interesting about the way a woman's bra strap parallels poles, a tilted plane, and her own tail bone *(plate 40)*; the way the crotch of a woman's form-fitting shorts is inverted and repeated in the V-shaped tops of picket fence posts; or how the smoke from a cigarette looks uncannily like the out-of-focus zone of the photograph. *(plate 39)*

The Candid Camera aspect is obvious. People are caught unexpectedly and rarely represented as they presumably would wish to be seen. But aggressive as his method is, Cohen's intention does not appear to be cruelty or wit. He merely appropriates people, radically distorting their forms to make formal pictures primarily about the process of photography itself—pictures whose visual character results from consciously seeking the accidents and distortions most professionals attempt to avoid.

Cohen's methods preclude definitive formal images. By the mid 70s he was increasingly attempting the expressive rendering of immediate observations, not in the romantic sense of transforming the ordinary into the ideal, but for the purpose of making the ordinary vividly apparent. An old woman with pursed lips is flash-lit so that she is expressionistically thrust forward out of a surrounding, exaggerated

Plate 39 Mark Cohen

Plate 40 Mark Cohen

71

darkness. Flash-induced accidental color effects turn a grove of trees eerily green, as though a supernatural appearance is immanent.

Cohen's cropping often creates perceptual enigmas that reveal their origins reluctantly. A woman, seated cross-legged in front of a red-and-blue draped platform, initially appears as a series of colorful patterns that hide her identity as a human figure. Her vivid white gloves, black handbag, and blue-green pants interact as areas of pure color long before they confess their utilitarian identities. Eventually, her wizened face becomes visible in the upper right-hand corner of the frame, placing the pictorial elements back into context. *(plate 42)*

What most viewers would assume to be the undesired consequences of dust-defiled negatives are likely to be insects spot-lit by the flash and magnified in the print. *(plate 41)* Because Cohen blows 35mm film up to $16 \times 20''$ the grain appears coarse and diffuses references; insect forms almost disappear into the grain, which also provides a visual correlative to the pores of flesh or textures of stone. Dust motes normally disturb our reading of a photograph, but Cohen's motelike photographic revelations create intrigue. As Stuart Liebman noted, "Whether left on the negative or caught in the world, the indistinct blurs of emulsion can be read in depth as part of the photographed objects or as hugging the surface of the photograph itself. The eye shuttles back and forth uncomfortably between two readings, neither of which is decisive."[4]

George Bernard Shaw's comment that a photographer is like a cod, which must lay a million eggs so one will hatch, fits no one better than Cohen. Not surprisingly, his images are unhomogenized and even chaotic. He seems quite willing to obey his impulses when shooting, rather than seek subjects offering familiar or preconceived schemes. He would rather investigate process than seek a formalized presentation, and he succeeds in producing varied, often unexpected images that incorporate numerous levels of potential significance.

Cohen's entire oeuvre is based on what Max Kozloff has called photograpy's "tripping" of our "loose ideas on what has a right to be there at any given instant."[5] **Joel Meyerowitz**'s street photographs only seem less idiosyncratic than Cohen's. In fact, they, too, are based on process and depend equally on openness and alertness to sudden possibility.

Unlike Cohen, Meyerowitz attempts to insert himself into teeming crowds without "bruising the situation."[6] He operates energetically, experiencing things in a continuous way. "That's part of what small-camera photography is about, keeping your experience sensation alive as you move," he says. Photographing on the street produces what Meyerowitz calls "new compositions. Awkward ones, chancy ones, radical ones. Things are all slamming into the frame on the oblique. They're all crashing and colliding. They suit the place very well."[7]

But compared to black-and-white film, color film speeds are slow. This fact has influenced Meyerowitz's decision to step back from his subject. "You can't work at 1/1000 second at f/11 on Fifth Avenue. I'd have to work at 1/250 second at f/3.5, or f/2.8. And at that point you begin to give up the description that you're getting with that film. So then you slow down even more. I found myself being forced to

behave differently on the street. I was being directed by the limitations of the material to look at things differently."[8]

Meyerowitz's shutter-speed options forced him to slow down, and his aperture options forced him to step back. Over the past decade he has moved away from a "decisive moment," such as the fallen horse (plate 43), to seek scenes that fill the frame from edge to edge with no obvious center of interest. Henri Cartier-Bresson's isolation of the the significant moment captures an event that would probably have passed too rapidly for the human eye to perceive. The fallen horse seems as eternally still as a stone statue, though, it was probably all flailing legs and movement.

From photographing events that would have been significant to any spectator at the scene, Meyerowitz moved to photographing scenes that only became events when framed and frozen by the camera. This strategy may include capturing unauthored gestures—freezing people in transit between their last and next deliberate action, like out-of-context quotes. A Puerto Rican man points at a woman bending down to adjust her absurdly high-heeled shoe while the feet of people to the left seem lined up in formation. (plate 44) What narratives can be construed here exist only in the picture, not in the situation.

Other works exclude such potentially narrative subjects, making apparent Meyerowitz's more significant formal concern for framing scenes in order to disperse bold color accents throughout his composition. The "catches" of these photographs are the colors, choreographed hedonistically and spread across the picture surface. Max Kozloff writes of this: "What a revealing challenge it must be to the photographer who now not only juggles the dynamic ratios of space and time in terms of values, but also must clock the escaping and impinging energies of color as well."[9]

In a Meyerowitz photograph of pedestrians in New York City (plate 45), a pink triangular portion of a skirt flashes from under a brown coat, crackling in the late afternoon gloom like the similar reds of a nearby rope and flag that mark a construction site. The light of a "don't walk" sign and tail lights of cars sprinkle more red across the image. Meyerowitz describes his composing as "centripetal,"[10] moving inward from the edges rather than out from the center. The technique prevents any tendency to envision a center of interest.

Meyerowitz has been packing more and more information into his frames. (plate 46) Inspired by the organized chaos of Federico Fellini films, he invites increased quantities of color and texture into his lens. Tantalizing possibilities interest him more than sensational catches. Engaging what is peripheral in the eye as well as what is central, he presents picaresque adventures, caught in the moment of their unfolding, their meaning open.

Harry Callahan is so identified with austere, subtle black-and-white work that his 1977 color photographs (plates 47, 48) had an "initial effect comparable to the physical jolt experienced when switching to AM after listening for a while to FM."[11] Sally Stein's comment reflects knowledge that, at the same time he was producing his full-color pictures, Callahan had conscientiously decided to abandon Beethoven and start listening to "as much Rock 'n Roll as he could stand."[12]

While color photographs produced with relatively conven-

73

Plate 41 Mark Cohen

Plate 42 Mark Cohen

75

tional lenses feature flattened spaces, Callahan's extreme wide-angle lens imposes the reverse, so exaggerating near/far disparities that buildings lean away diagonally, gesturing anthropomorphically.

Callahan compensates for the extremity of lenticular distortions with infusions of deep color and strong contrasts. The hue saturations of the dye-transfer process allow him to infuse his skies with so much rich color that the natural void is filled with a presence as solid as the edifices themselves. Because the disorienting diagonals obviate stability and tranquillity, Callahan has devised a spatial choreography in which rollicking voids and solids are equal, counteractive compositional partners. The results: photographs that burst into view, the color-dense sections discharging energy as they collide, giving the images a peculiarly photographic verve and pizazz.

In a time when it is fashionable to be understated, unengaged, and dry, many process formalists revel in ecstatic or expressionistic excess. The color in **Joe Maloney**'s pictures is incontrovertibly artificial, the consequence of film balanced for tungsten light exposed in daylight, then adjusted during printing. This technique produces grasses as green as astroturf and foliage like the candy apple green of a 1950s hotrod. Maloney is not obsessed with technique but understands and cares about formal concentration and coordination.

In plate 50, he punctuates sumptuous congestion with charged instances of nearly electric color. With the general saturation level of the scene already quite intense, Maloney pumps still greater energy into it with hot yellow-gold and red accents that provoke the green of the grass and exagger-

ate the hints of blue in the overcast sky. Discrete hues consequently stimulate each other into competitive activity, filling Maloney's frame with selected segments that press forward against the picture plane. The shapes, textures, and locations of chromatic sections forge horizontal, diagonal, and a subtle vertical axis amidst the bustling textural plays of grass, hedges, trees, clouds, and chain-link fence.

At the opposite extreme of Maloney's aesthetic are photographs in which the only ostensible process-induced traces are slightly blurred notes of color caused by the wind blowing during a lengthy exposure—a phenomenon that has affected view camera photographs of every era. Maloney's landscape in plate 51 is perhaps slightly more chromatically intense than real life, but he has refrained from ostentatious manipulation, recognizing sufficient eventfulness in the road's rush toward the tumultuous sky.

Unlike the human eye, which adjusts to alternately read information in both lit and shaded portions of the world, the camera must seek some compromise between the polarities of light and dark. In a photograph of a brightly lit object and a deep shadow, the illuminated surface may appear bleached to an uninformative, brilliant smoothness called "burn-out." The details within the shadow may be lost in a dark void called "fill-in." Filters and added lights alter and modify these extremes, but equivalencies of human vision are almost impossible to reconstruct.

Some photographers anticipate distorted extremes of dark and light, planning photographs in which these effects function as important visual events. The brilliant patch of sunlight streaming in the window of a **Langdon Clay** photo-

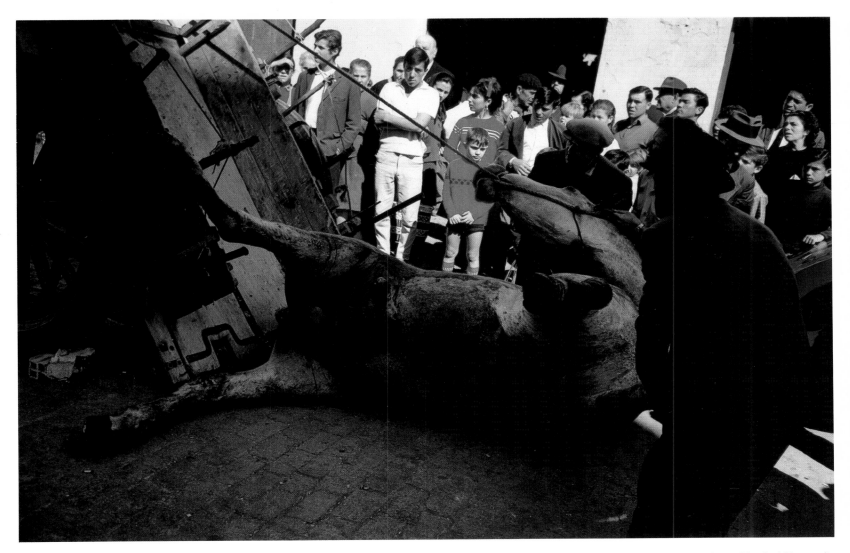

Plate 43 Joel Meyerowitz

77

graph *(plate 52)* cleaves a bright gash in a couch, dissolving portions of brown velvet upholstery into bleached, glowing tan and transforming a red telephone into a ghostly, red-tinged apparition. An aura of scintillating red borders the zone overrun by the intruding ray of light.

Dramatic fill-in occurs in a Polacolor photograph by **Roger Mertin** *(plate 53)* where a sink's gleaming whiteness is heightened by a deep, flawless murk of black shadow. Exposure time adequate to reveal the sink (a long exposure, as evidenced by the Polacolor film's blue-tinged overreaction to the daylight on the bathtub) was apparently not of sufficient length to render detail in the shadow. Burn-out, too, figures in Mertin's composing. Overexposure of the top center of the scene causes a black cord to turn red and the blue wall to turn white.

In his Type C prints, Mertin continues his interest in such photographic effects, shooting a series of rooms decorated for Christmas—a subject rich with potential for producing chance light effects. Mertin uses indoor film, which has a heightened blue tone to screen out the yellows and reds of incandescent light, but which consequently overreacts to daylight: thus the blue cast on walls, white burn-out in the window, and overexposures with halos around every lit bulb on the trees. *(plates 54 and 55)*

Mertin's Christmas rooms function less as evocations of holiday spirit than as round-ups of emotive subject matter and photographic effects in which he discerns the simultaneously curious and delicate relationships that serve his striking sense of order. These images derive some momentum from the recognizably recorded affectations of holiday ritual, but they do not exalt the Christmas spirit as much as freeze its trappings for anthropological study. In this sense, these pictures are very much part of the larger body of Mertin's predominantly black-and-white work. In each medium Mertin's disciplined eye isolates sociologically interesting nooks and crannies of the real world, preserving such views as artifacts but simultaneously coopting the shapes, textures, angles, and colors they contain into expressions of pictorial value. His color work extends his earlier concerns. By providing chromatic and tonal radicalizations of things that he actually sees, the color process challenges Mertin to anticipate and control those effects that show up only after the exposure is history—and rewards him when such anticipations are both accurate and inspired.

Barbara Karant is best known for her blue-tinged photographs of interiors. In plate 56 the cool daylight from the room's two windows balances the warmth of the beige walls, transforming the color-keyed bedspread into a chromatically neutralized plateau. In similar fashion, the eccentric gestures of the two chrome tensor lamps, combined with the undulating leaves of the seven potted snake plants, serve to offset the otherwise staid geometric regularity of the compositional scheme. A sense of classical stability results through measured applications of visually conflicting elements.

Color film's exaggerated response to the presence of two or more kinds of light can easily become nightmarish during the twilight hours when neon, tungsten, fluorescent, and natural light may occur simultaneously. Furthermore, the long exposure necessitated by less intense illumination is likely to result in reciprocity failure, when the film responds unpredictably and unequally to each color of the spectrum.

It is easy enough to amplify such effects to delerious extremes, using color photographic technology's flaws to represent the world as if it were comprised of psychedelic memorabilia. It is far more challenging to maintain a semblance of descriptive credibility in situations where the subject matter and the medium threaten to overwhelm any attempt to produce moderated results.

Although **William Eggleston** often exploits the color photographic process to the utmost to attain his lurid views of the South, he always retains a semblance of fact. The flesh tones of children out on Halloween are natural, although ground and sky seem costumed in the bizarre colors that only arise in color photographs. *(plate 57)* Likewise there is a truthful aspect to his garishly lit courthouse *(plate 58)* and the "burned-out" sink of a kitchen. *(plate 59)* Notably, Eggleston never uses process for its own sake, only to amplify content.

Joel Meyerowitz frequently photographs at dusk, during the time the French call *entre chien et loup* ("between dog and wolf"). His images become enticingly alien when color film's reaction to various light sources produces surprising, unnatural hues that somehow retain credibility as phenomenal facts. The process does not invent but exaggerates what can actually be seen by the naked eye. Meyerowitz rarely abandons a fact to produce a fiction.

Throughout his photograph of a Dairy Land drive-in at dusk *(plate 21)*, Meyerowitz magnanimously accepts the acidic chromatic effects of various sources of artificial illumination. His seamless unification of fluorescent, tungsten, and waning sunlight on sky, asphalt, and a multitude of synthetic surfaces avoids the havoc such disruptive stimuli might create under the supervision of a less expert photographer. Meyerowitz not only melds the strident hues and surfaces into a creamy, continuous display of masterfully arranged visual elements, but also conveys a thoroughly persuasive description of time, place, and atmosphere.

In another work *(plate 26)*, "alpine glow" from the sunset behind Meyerowitz turns the far side of the St. Louis Arch so red that it moves forward pictorially, departing from its actual spatial position in the scene. Lights pattern the blue asphalt expanse with greens and lavenders, imparting an aura of mystery throughout. Such characteristic filmic responses to illumination, which have raised countless questions about color photography's capacity to produce controlled, soberly accurate, and intimate imagery, are anticipated and assimilated in Meyerowitz's handling of them. Indeed, many of his images are based upon them.

Most incursions into the realm of photo-process result in a faked mania that is mistaken for emotion. In truth, many of today's color photographic "artworks," legitimized under the aegis of "exploring the medium" are very similar—in both their effects and in the actual, rather than the proclaimed, priorities of their makers—to the glib, gimmick-oriented pictures that for years harmed color photography's artistic reputation. It is ironic that the medium's maturation as an art form has allowed it inadvertently to reverse its own course, turning back to the realm of technomany, which at one time convinced critics, curators, and potential practitioners of its futility as a sophisticated medium.

Plate 44　Joel Meyerowitz

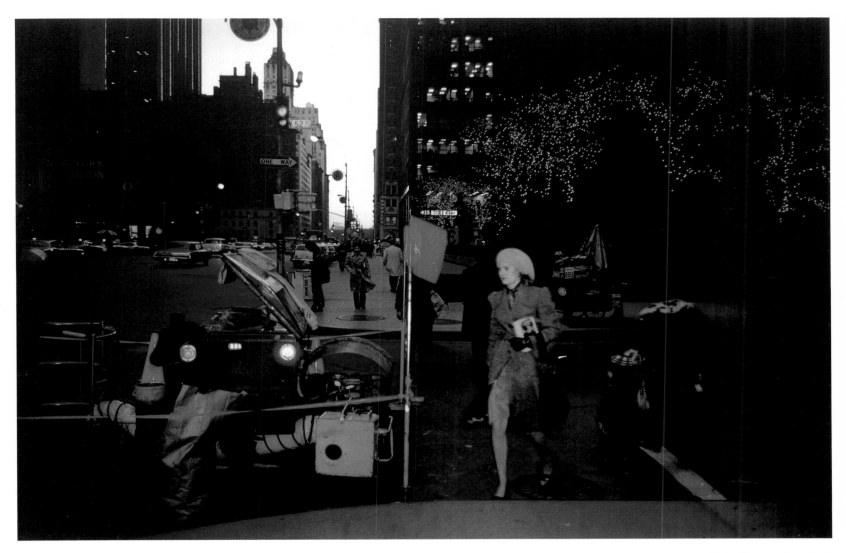

Plate 45 Joel Meyerowitz

81

Plate 46 Joel Meyerowitz

Plate 47 Harry Callahan

Plate 48 Harry Callahan

84

Plate 49 Joe Maloney

Plate 50 Joe Maloney

Plate 51 Joe Maloney

Plate 52 Langdon Clay

Plate 53 Roger Mertin

Plate 54 Roger Mertin

90

Plate 55 Roger Mertin

Plate 56 Barbara Karant

92

Plate 57 William Eggleston

Plate 58 William Eggleston

Plate 59 William Eggleston

Plate 60 Michael Bishop

96

CHAPTER 4: **SELF-REFLECTIONS**

Self-reflective photographers actively grapple with the intellectual questions of the medium, challenging assumptions, subverting expectations, and combating defined frontiers. Uniquely photographic effects are not incorporated as means to an end but elevated as the primary content of the art.

To many viewers, such self-scrutiny seems a way of avoiding authentic experience. Others, weary of art-theoretical discourse, agree with the writer in John Barth's "Life Story" who muses:

> Another story about a writer writing a story! Another regressus in infinitum! Who doesn't prefer art that at least overtly imitates something other than its own processes? That doesn't continually proclaim "Don't forget that I'm an artifice!" That takes for granted its mimetic nature instead of asserting it in order (not so slyly after all) to deny it or vice versa?[1]

The most cynical viewers carp that the frenzy of such art-about-art inquirers compares to the pointless desperation of Samuel Beckett's Malloy, who is thwarted in his desire to suck sixteen stones in precisely the same sequence because he has only four pockets in which to order them.

No one has elucidated the task of easing the world onto the uniplanar surface of the print more thoroughly than **Michael Bishop**. Using a perspective control lens—not to correct distortions as an architectural photographer would, but to exaggerate them further for pictorial ends—Bishop deliberately exacerbates the constricting of space that is the natural result of the lens's monocular vision. A section of the world becomes a photographically compressed image of itself, its objects and spaces converted into elements of a taut design. Objects that actually exist at varying distances from the cameras are forged into strategic visual alignments and overlappings.

Bishop's subject matter—typically street signs, saw horses, guard rails, oil drums, fences, and other disreputable, dismissable, or expendable objects—is more tractable than objects encrusted with allusive associations. Certainly an absence of familiar associations makes it easier for the viewer to accept Bishop's subversion of the closure and autonomy of an individual item. The gray of a generator merges with the gray of cement steps in the distance so that, combined, they appear as a bizarre, stepped machine, a new, photographically created entity. Bishop often relates such dissimilar objects in terms of observed scale, size, and color. Merging, they camouflage each other, parts unexpectedly disappearing according to the same principles by which butterflies elude toads.

Bishop may be belaboring the point that the generator and the steps have a different existence when photographed than in life—that he has given them a new gestalt in relation to the medium and the viewer. But though modern artists generally consider it impossible to both present and represent, photography's persistent connection to subject matter produces countless visually and intellectually engaging ambiguities.

A yellow pole mates with the yellow façade of a house far in the distance. *(plate 61)* A red fence joins with the red barn far behind it. *(plate 64)* A stop sign, photographed from behind, seems pinned down flat to the curb beyond it. *(plate 60)* A cloud becomes a puff of smoke rising from the barrel of a cannon. *(plate 63)* Such examples extend, expand, and more self-consciously elucidate Walker Evans's

Plate 61 Michael Bishop

Plate 62 Michael Bishop

precedents in black and white.

Bishop constantly traffics in perceptual confusions, unsure significations, or at the very least, data only marginally truthful. Consequently, his works raise doubts about the photograph's repute as a document. Other strategies, too, stimulate such questions. Like painter Richard Hamilton and filmmaker Michelangelo Antonioni, who enlarged photographs to the limits of legibility in the 1960s, Bishop forces us to recognize that photography is less a system that duplicates reality than a process that codifies it. His frequent enlargements of 35mm negatives to 20 × 24" prints cause partial dematerialization of the illusion and asserts the materiality of the process itself. Enlarging the scale of the negative's granular matrix diffuses the seamless, immaculate clarity of the print, inducing consideration of it as material to look at, challenging the inclination to regard a photograph exclusively as a window through which the world is visible.

Bishop's occasional use of vignetted edges, produced by inserting a flexible lens hood in front of portions of the lens during exposure, recalls work in black and white by Walker Evans, Eugene Atget, and others whose equipment sometimes imposed similar but unwanted effects upon their images. Bishop's affectation functions as a formal device, balancing otherwise unreconciled, disruptive elements in certain of his pictorial schemes. (plate 60)

Though it would be logical to assume that Bishop's facts would not signify or symbolize but just be, they can be interpreted. Charles Hagen finds a "consistent, slightly ominous feeling to them." He sees dramas taking place "based on the implied relationship between two objects whose details suggest a connection of some sort."[2] Smears of red paint on wooden latticework near a red fence suggest that the two objects, now so resigned to each other, had once done battle. (plate 64)

Bishop's pronounced preoccupation with photography's contradictions does not preclude dedication to producing images of striking visual quality. His shooting philosophy, coined after hearing Jackson Browne's lyric "I was taken by a photograph" is "Photography, take me."[3] Bishop has been increasingly "taken" with the spatial magic and chromatic charisma that emerge when the world's deep spaces and solid volumes become flattened and realigned.

Consider the precise allocation of visual events in Bishop's 1980 photograph of a fireman. (plate 66) Grass and sky function as solid chromatic fields which provide complementary hues that activate the orange flames, the red of the fireman's suspenders, and the yellow of his pants. The cluttered construction zone at left combines with rising brown smoke to offset the visual weight of the house. The diagonal lean of fence posts reverses in the angle of the streaming flame while repeating instances of white from the clouds above to the fence below rhythmically variegate the entire image. The fireman's dark helmet and body eclipse any direct perspectival retreat into deep space. Overlapping crucial intersections between foreground, middleground, and infinity, his precisely positioned presence pins down the composition.

Bishop's selection of subjects for mutual compatibility of hue, shape, texture, and tone; his deliberate inclusion of information from several spatial locations; and his exclusion of visual clues that might clarify contexts lead to coherent, surprising, even stunning two-dimensional schemes. Although tenaciously photographic, such works offer more

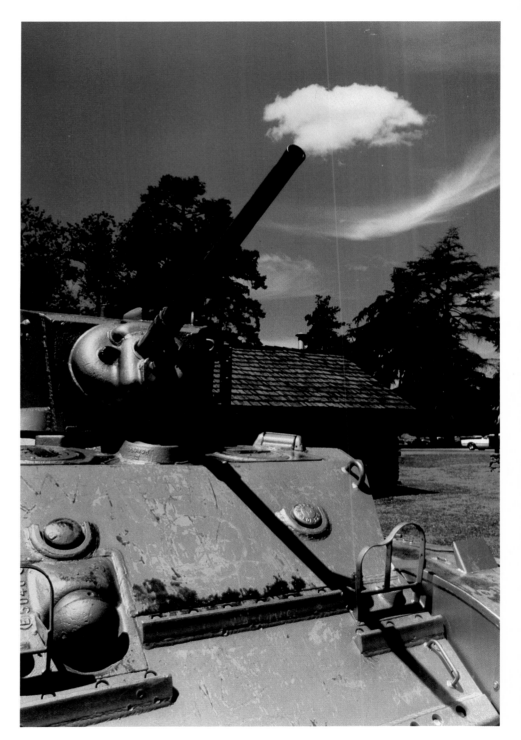

Plate 63 Michael Bishop

than meditations upon the medium. Irony, perceptual duplicity, narrative, and abstraction arise directly from the dialectics of process—through Bishop's presentation, not the representation.

John Pfahl extends and often diverts the implications of traditional picturesque imagery. Carefully skirting cliched strategies, he appropriates tactics and allusions from sources as diverse as the trompe l'oeil painting tradition, recent conceptual art, earthworks, current photographic theory, and the whole of photographic history. Photographers of the picturesque, from Timothy H. O'Sullivan to Eliot Porter, provide Pfahl with a legacy abundant with opportunities and strewn with pitfalls.

Pfahl's delicate, skillful color prints sensuously inform the crisp, clear description they contain. Although they often brush the boundaries of soft prettiness, Pfahl's extraordinarily precise arrangements infuse his images with a distinct detachment. His entrancement with ambiguity and irony directs his efforts. Through visual commentary, his photographs exercise some of the didactic points typically found in written criticism.

In his most widely reproduced and exhibited photographs, Pfahl has modified nature through carefully calculated installations of string, rope, tape, or other materials. Spending from two to eight hours in preparation for each exposure, Pfahl manipulates these unnatural substances so that they will appear as lines, arrows, or other markings drawn on the surface of the photographic print.

Pfahl's "fool the eye" markings cohere only from the exact vantage point occupied by the lens of his 4 × 5" view camera; from any other position, they would be a jumble. Unlike conceptual artists and sculptors trafficking in questions of location or the limits of perception, Pfahl doesn't force viewers to search for the proper spot or angle for decipherment.

In addition to solving the Modernist dilemma of how to translate the scene onto the uniplanar support, Pfahl's markings form directional clues that aid our navigation through the scene. Pegs that anchor lengths of tape can occasionally be detected; dots bend to follow the forms of rocks or other nonflat surfaces; vertical lines that would be of consistent width if actually drawn on the print surface taper and grow pale as they approach the distant horizon. In short, Pfahl's markings function in a fashion similar to the staffage figures placed in works by Timothy H. O'Sullivan, William Henry Jackson, and other early photographers of the Great West.

Obeying his formalist impulse, Pfahl gently subjugates nature by extending, mimicking, and completing shapes suggested by the information before him. A horizon may be lengthened or a mountain reflected, as if in water, by a repetition of its shape in string. Sensitive to the interactions and dependencies of color, Pfahl spices his chromatic schemes with carefully located hints of specific hues that engage and often contradict expanses of natural color.

In one of his most minimal works, Pfahl placed a gossamer blue thread across a field of green grass punctuated with yellow and white blossoms. The strand is so slim that its presence is not readily apparent, yet its color is immediately felt; where it passes the yellow blossoms, vibrations occur. In another image (plate 78), orange strings continue

the striations of a palisade and transform a scene of browns, tans, and rust into a shimmering tapestry. Measured bands of aluminum foil, selected for their textural and reflective qualities, wrap a row of pine trees precisely at the point where they visually overlap a horizon of water. A checkerboard results in which "tiles" of sand, foil, and sky alternate with those of tree trunk, water, and tree trunk, creating spatial ambiguities and rhythmic alternations in a scene that would ordinarily be static. *(plate 80)*

No matter how formal their placement, such strings, tapes, or whatnot appear incongruous amidst the natural scenery. To those who regard nature as inviolable, the additions are irreverent. To most everyone else, they are amusing. Not surprisingly, Pfahl's manipulations frequently flirt with comedy. A pile of hay becomes a scoop of ice cream on a cone of string. "Rays" of yellow string complete a needlepoint calendar sunset.

Toying with lines and grids, Pfahl conjures maps, diagrams, and photographs of geologic concretions and lunar landscapes. Arrows accentuate the directional force of soaring natural arches. Dashes playfully indicate where it is proper to cut or fold. A rock off the Bermuda coast is the apex of Pfahl's version of the Bermuda Triangle. *(plate 79)* He calls it "Triangle, Bermuda" lest its proper name cause him to disappear.[4]

Pfahl's physical manipulation sometimes involves only a single act. The pair of diagonally projecting sticks that reflect in the smooth water in "Great Salt Angles" *(plate 81)* seem like abandoned sign posts or obscure totems in a bizarre unearthly scape. Only one of the staffs was placed by Pfahl, and this in response to his discovery of the initial stick, driven into the lake bottom by some stranger. It would appear to have influenced Pfahl's developing recognition that usable ironies and inconsistencies already exist in the visible world.

Pfahl's "readymades," his "Pfound Pfahls," in Andy Grundberg's words, "make explicit the culture's arrogation of the landscape just as his earlier pictures made explicit Pfahl's arrogation of the same."[5] A pink Portosan *(plate 82)* provides a smooth, regular shape to offset and define the prickly variegations of nature; its white inscription "women" corresponding with the white cliff dwellings in the distance. Ironically, the Portosan's pictorial richness cannot obviate its nonheroic, everyday function, which is so contrary to the grand values of the picturesque tradition.

From scenic roadside "picture spots," Pfahl moved inside to photograph scenes through "picture windows." Rather than accurately record the "view" as chosen by some homesteader, Pfahl reconstitutes it through the photographic process. The mullions, smears, and reflections on the glass that we normally attempt to ignore are recorded with as much fidelity as the scenic sight beyond. Consequently, the three dimensions of the scene are always compressed onto the two dimensions of the window, and it sometimes becomes difficult to discern whether objects like sills, plants, and parrots are inside or outside.

Shimmering reflections on louvered windows fragment one view, transforming it into a pulsating, woven abstraction. *(plate 83)* On another window, rain smears resemble stalactites—as if the cliffs beyond conjoined with caverns for the ultimate tourist ambush.

In plate 84 Pfahl includes one of his Polaroid test shots

Plate 64 Michael Bishop

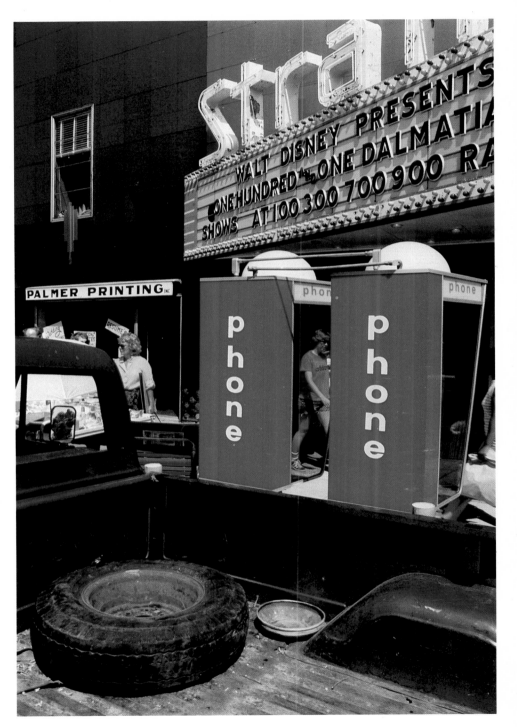

Plate 65 Michael Bishop

resting on a table below the window. The table shimmers in the gloom, hit by blue and orange hues reflected from sky and sunkissed mountain top. Because the black and white Polaroid has picked up a full reflection of the scenic view, it literally becomes, as photographs first were called, "a mirror with a memory." Emblematic of all color photographs, it will "fade" back to black and white.

Pfahl's decision to submerge most of the interior in opaque black shadow heightens the color intensity of the "image" in the window, which glows like a slide projected on the wall of a dark room. The words *room* and *camera* have common etymologies, suggesting that each room might function as an enormous camera, perpetually focused on the window view. Having moved *in camera*, ("into private quarters"), Pfahl projects his own photographic preoccupations. The inky blackness alerts us to the subjective shape of each particular transcript of reality. The view "on camera" assumes a new context. Out of the blackness, that metaphor for blindness, emerges "the view," more brilliant and more "true" because its new format has not been depleted through years of overuse and trivialization on picture postcards.

Eve Sonneman didactically draws attention to photographic choices and dilemmas, forcing viewers to consider the whole process of perception. Use of the diptych format offers referential alternatives. Two views, often of the same subject, remind the viewer of the infinite number of vantage points possible by which the photographer edits the world and removes it from its natural context. The diptych furthermore prevents the stasis or resolution that the single

image or triptych offers, forcing a dialogue between the two images. As the pairings are rarely formally related, they can only be explained conceptually. Clearly, Sonneman is not primarily concerned with the purely visual; indeed it might be said that beauty has been supplanted by an "antibeauty."

Cibachrome's glossy surface is itself a gloss; it invokes the age of plastics and parodies the laminated picturesque placemats available at any souvenir shop. Contrasts are so harsh that the informative middle values are partially eliminated; supersaturated colors surrounded by black "filledin" areas read as strident patterns. The black border and base sometimes make formal sense as extensions of the shadow areas, but with equal frequency they interrupt and dominate the picture. Where the traditional white border would enforce picture-window illusionism, the black makes the colors seem to float on its surface. In her demonstrations that no subject need preclude pithy, or at least provocative, treatment, she has eliminated every value held dear by the hobbyists, advertisers, and nature lovers. Ideology dominates.

In Sonneman's book *Real Time*, which includes black-and-white photographs taken from 1968–74, she paired images from consecutively exposed negatives. This practice of coupling each photograph with the image produced from the very next exposure on the film demonstrated drastic shifts of perception that resulted from taking a second look a moment later from a different vantage point. The truth told by the single photograph is thus proved incomplete. Lovers caught in bliss from one angle seem estranged from another; a dandy, smoking in perfect poise, forgets

composure in the second instant.

As Ben Lifson observed of *Real Time*:

The black line between Sonneman's frames is thus like a semi-colon in a sentence dividing an initial statement from an afterthought . . . Since we know that in each diptych the images were juxtaposed in real time—not in the darkroom at some later stage—we imagine the photographer when we look at the pictures. Sonneman thus creates a fiction of the photographer as well as the world. The illusion of her rapid shooting implies a sensibility attuned to small but significant changes in common life.[6]

Since switching to color, Sonneman has stopped exhibiting consecutive exposures. Pairings are now made at her leisure. The photographs still represent split-second decisions made at the site, but the images paired may have been exposed a few seconds or a few months apart. Though Sonneman's individual photographs still look more raw than finished, as if testimony to the "authentic" immediacy of her response, the couplings derive from subsequent cerebration. Less conjunctive than disjunctive, the forced sequencing invokes Heinrich Wolfflin's opening up of lines of thought through comparative juxtapositions. Relationships may be visual but are always conceptual. The second photograph need not be predicated upon the first; it might instead represent an alternative, equally valid view.

Points may be simple. Clouds (which we, conditioned by the precedent of Eadweard Muybridge's motion studies, would assume to have moved) have changed positions in the second photograph because of the photographer's change of vantage point.

Often there are multiple meanings. A view of the "timeless" Parthenon *(plate 67)* surrounded by meandering tourists ought to contrast with a train station where determined people rush to meet the train "on time." But the cropping of the train station resembles the foreshortening of the Parthenon and people take their time at both sites. Sonneman printed the grays of the street and station pink, a decision that makes them move forward pictorially in contrast to the figures "quick-frozen" by the camera. The pretty pink that initially seems so jarringly out of context has another purpose as well: it offsets the blue sky backing the Parthenon, reminding us that such blues often disrupt the pictorial unity of scenic postcards.

Some of the images could only have been made photographically. Looming silhouettes of figures *(plate 69)*, seemingly tattooed upon the New York City sky above and overlapping tiny tourists on the observation desk of the World Trade Center, can only be explained if Sonneman had photographed through the glass of an atrium. Though human vision typically can focus alternately on the reflections on a window, the glass itself, or the scene beyond it, Sonneman's camera has recorded all three. Her own shadow and reflection, besides providing intriguing abstractions, remind us of her irrefutable presence.

In Samos, Greece, Sonneman photographed a boat under construction early one morning, then photographed it again a month later in evening light. *(plate 68)* The pairing of the two images produces visual reactions that would not occur if each were displayed alone. Their proximity causes visual sections to advance and retreat in ways independent of the spatial coherence of either image alone. The more distant

Plate 66 Michael Bishop

Plate 67 (diptych) Eve Sonneman

Plate 68 (diptych) Eve Sonneman

sky and ocean, visible in the morning scene, thrusts forward as if it were a mural that Sonneman photographed. The shadowed wall in the same image more closely resembles the black sky of the evening view than the bright planar surface of an evening wall. These perceptual reversals are abetted by Cibachrome's absorption of half-tones into its dense, dark, liquid tonalities. Spatial pulls and pushes occur on the basis of primary laws of color. Subtle modulations in tonality are rare and therefore offer little assistance in solving spatial mysteries.

Traveling out west in 1977, Sonneman used her moving car as an observation deck, snapping a photograph in which nearby scenery was recorded out of focus, while distant mountains were sharply rendered. *(plate 70)* This phenomenon of both natural and camera vision was paired with a "picturesque" moment that exists only in a photograph: a road sign, blurred by the car's movement, becomes transformed into a black cloud poised between two clearly focused, stationary clouds in the sky. Ironically, the camera-recorded blur dematerialized the sign's substance at the same time it seemed to solidify the vaporous clouds.

Sonneman never pretends the photograph is a window on the world. The glossy surface, high contrasts, and acidic colors of the Cibachrome process taint illusion with technological artificiality. Her choice of a black border and a wider black base for every photograph, whether or not the black disrupts the formal structure, recalls Bertolt Brecht's insistence on the proscenium arch in order to underscore the artifice of the stage play. Although logically photography would seem to be the medium in which the artwork and the referent ineluctably entwine, Sonneman's pairings refer primarily to each other, challenging us to complete the dramas that are extracted from the world but staged anew for the viewer.

Photographs within photographs may also alert us to intellectual self-consciousness. The method need not be direct, however. **Stephanie Torbert**'s ingenious recordings of painted and photographic illusions in combination with actual deep spaces and solid objects persuasively reverse, mingle, and deliberately confuse the distinctions between reality and illusion, authenticity and artificiality. Torbert's results both demonstrate photography's reportorial undependability and elucidate its sensual, expressive capacities.

Each Torbert photograph abounds with spatial ambiguities, offering numerous tantalizing clues that often lead to contradictory conclusions. Viewers are likely to find themselves drawn into a visual journey akin to the viewing of an M.C. Escher print—climbing three flights of stairs only to find themselves back at step one.

In one photograph *(plate 71)*, the edges of an opening in what seems to be the exterior wall of a building frame a view into apparent deep space. The illusion of depth derives, in part, from a tapering column of smoke such as would be seen from a disappearing train. The first impression dissolves as one notices that the wide end of the column continues cleanly onto edges of the opening and surface of the wall. A detectable seam along the base of the opening offers additional evidence that the ostensible recession is actually a flat surface located parallel to and a short distance beyond the wall. Perhaps it is a painted mural, but a reflecting surface is also a possibility since the image closely resembles a mirrored montage of elements. Crevices, reflecting lines, color changes, and a dark, shadowed area where the photographer could be standing conform to such a deduction. Yet it is erroneous because the colors of the reflecting lines would be more diffuse, not brighter, in a reflection. The rendering finally coalesces into a representation of a warehouselike interior painted on the outside of a

door so that the door appears to be open, even when it is shut.

Often elements appear out of context in works that otherwise might make sense. A Torbert photograph of a green exterior wall includes a pigeon nestling on a ledge and a display case with a blue interior. The blue surrounds the white silhouettes of a glider, making it seem caught in the deep infinity of some nocturnal sky. Does the case contain the cleverly illusionistic backdrop of blue, disguised as sky? Did Torbert (or some prankster before her) cut the glider shape out of paper and mount it on the pane? Did she actually capture that improbable glider in flight, reflected on a sheet of glass?

Another image presents the diminutive form of a nearly nude man resting supine on a vast rectangular expanse of mottled tile. *(plate 72)* His tiny size, the aerial angle of vision, and the comparatively Brobdingnagian scale of the surrounding margin of bar-shaped tiles contribute to a sense of vantage point that is both elevated and remote. However, a continuous plane of wood planks runs from the tiled border to the edge of the tiles supporting the man. Close examination reveals that the slight visual irregularity that occurs at the edge of each plank seems visible even under the mottled tile, suggesting that the man and his immediate surroundings are, themselves, a photographic reproduction mounted over the plane of wooden planks.

Although all color photographs heighten the illusionism of prefabricated images, like paintings or preexisting photographs, the Cibachrome process imparts to such representations a mysterious, powerful three-dimensionality that often seems more real than photographic recordings of actual volumes and spatial depth. In her deliberate deceptions, Torbert exploits this aspect of Cibachrome.

Far from seeming ideological, Torbert's photographs first coalesce into sparkling surfaces of lush color, intricate patterns, and vibrant rhythms that simultaneously connote a deep, dreamy space. Like many urban landscape photographers, she has discovered that flashing lights, mirrored walls, reflective glass, and burnished metal produce dissolving forms, fractured images, multiple projections and condensations. Her decision to exacerbate such natural perceptual confusion is a comment on the elusive nature of context—an idea fundamental to the evaluation of photography itself.

Those who photograph color for its own sake—the salmon of an adobe wall against the bright blue sky, a red barn against verdant green—rarely transcend slick, decorative design. Few makers of such images share **Arthur Taussig**'s entrancement with conceptual ironies.

Taussig's color passages are always delineated with such precision that careful framing reveals all the mars and scars of the man-made environment. Purity's origins in impurity are readily evident. What first appear to be the photographic equivalents of overly lush Minimalist paintings actually relate more directly to 1970s abstract paintings, in which artists pit impulse and intuition against cold rationality by ripping, gouging, and scarring otherwise immaculate surfaces. Taussig's carefully recorded wires or shadows, traced across building surfaces, resemble conceptual artworks documented in photographs. When he photographs three-dimensional scenes so that they appear flat, he obviously intends to create abstractions. When he does the reverse, the results are witty. Indeed, the second impression derived from many of these photographs seems tongue-in-cheek enough to recall Harold Rosenberg's characterization of Minimal Art as "Dada in which the art critic has got into the act."[7]

Taussig has increasingly chosen subjects possessing

Plate 69 (diptych) Eve Sonneman

Plate 70 (diptych) Eve Sonneman

Plate 71 Stephanie Torbert

greater complexity and visual eventfulness. Photographing foliage and shrubs, he juggles two echelons of information. In conjunction with their shadows, palms and bushes carve building walls into sculptural reliefs. When the wall is faced with an expanse of reflective glass *(plate 73)*, the foliage repeats in slightly diffused duplication, transforming the building side into a deep atmosphere containing solid objects.

Most recently, Taussig has produced diptychs of plants photographed in Mexican jungles. In each pairing, Taussig alters the vantage point slightly from one view to the other. Though the form is reminiscent of nineteenth-century stereo cards, Taussig's intention is contrary to the stereoscopic pursuit of maximum depth. His passion for what Tom Wolfe calls the god "whose name was Flat"[8] is equalled only by his amused warping of Euclidean space. The result induces acknowledgment of the object nature of the photograph. Pictorially, Taussig's framing mat serves as a rhythmic marker. Formal correspondence often connect the two images, which consequently develop into a discourse about interval and incident. *(plate 74)*

The occasional bursts of blue that appear on the prints result from the reaction of Taussig's film to 110° jungle temperatures. Though not contrived, Taussig says he accepted them, believing Minor White's advice that there are no accidents, only gifts.[9]

David Haxton has been called "a cooly modern cinematic magician."[10] In his films he creates spatial illusions that deliberately collapse before the viewer's eyes, directing attention to the plane of the projection screen. In his photographic diptychs and single images, Haxton incorporates leftover rolls and pieces of backdrop paper, fluorescent and flood lights, staple guns, nails and lumber, transforming them into dazzlingly luminous displays of space and color that demonstrate how variations in lighting can significantly alter a scene.

Like most process artists, he acknowledges his materials and methods. But his lights do not articulate the form of his three-dimensional constructions as much as produce pictorial illusions that tease our comprehension. Light shines through holes in backdrop paper, transforming spatial voids into pictorially protuberant areas of color. Brilliant illumination bleaches the walls of Haxton's studio so completely that they often disappear from the print. Flaps and curls of paper become solid cylinders when photographed in chiaroscuro. When including layers of paper in several different hues, Haxton's placement of lights before, between, or behind the stratifications transforms the identity of numerous areas of color.

Haxton's most recent photographs are pseudodiptychs, divided by a central piece of backdrop paper that separates each single image into two distinct sections. The paper may appear as a slim boundary line. *(plate 76)* When viewed obliquely, it frequently casts wedges of shadow, producing vivid spatial clefts in the image's surface. *(plate 75)* In either case, spatial perception is manipulated. The unidentical twin sections provide Haxton with arenas for his inventive, contrasting constructions and light plays.

In plate 76, the left picture is a minimalist monochrome of blue-white paper and fluorescent light, while the right rectangle contains a riot of multicolored paper strips, some hanging in clusters, others fallen like relics from some unexplained festivity. In plate 75, ruptured sheets of paper testify to a more violent deconstructive impulse. Yet Haxton's application of light affords pictorial reconstruction. How-

ever "photographic" his process and materials may be, his pictorial syntax recalls Abstract Expressionist painting. The colorful light-struck paper produces violent spatial convulsions, while ripped fragments suggest licking flames and bursts of passion. Occasional appearances of distorted faces even recall the mythic preoccupations of Abstract Expressionism's formative years. These "photographs about photography" purposefully exclude references to the world, yet indirectly acknowledge it through allusions to the world of art.

These ideological photographers effectively argue against the traditional expectation that photography be a handmaiden to everyday experience, insisting instead that photographic artworks be recognized and studied for themselves. To them, the world in front of the lens is not subject matter to which medium and method are subservient, but—to use Barnett Newman's phrase—"object matter" for artistic appropriation.

Yet such exclusive self-scrutiny is an arbitrary decision that accepts alienation as the human condition. More and more contemporary photographers recognize the validity of alternative concepts. They believe that they can generate visual systems embracing more expansive concerns, which might more directly address the human desire to exist in harmony with the cosmos. These photographers eschew the ideologist's self-reflection because of its narcissistic avoidance of a greater mission. But they are fully convinced of the incontrovertible advances made by the ideologists, and they apply many such innovations in manifesting their own photographic visions of human problems and aspirations.

Plate 72 Stephanie Torbet

116

Plate 73 Arthur Taussig

Plate 74 Arthur Taussig (diptych)

Plate 75 David Haxton

120

Plate 76 David Haxton

121

Plate 77 Joel Sternfeld

Plate 78 John Pfahl

123

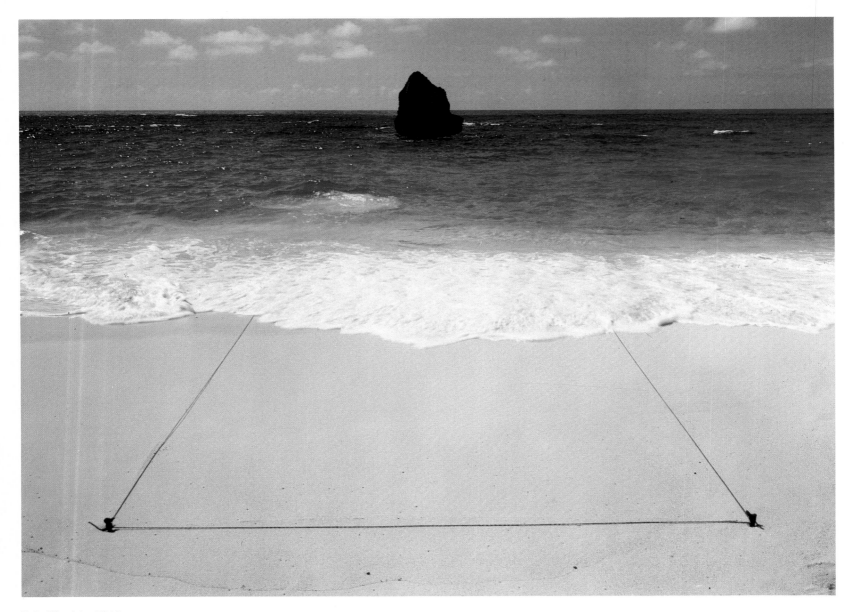

Plate 79 John Pfahl

124

Plate 80 John Pfahl

125

Plate 81 John Pfahl

126

Plate 82 John Pfahl

Plate 83 John Pfahl

Plate 84 John Pfahl

Plate 85 William E. Smith

130

Plate 86 William E. Smith

131

Plate 87 Neal Slavin

CHAPTER 5: **DOCUMENTATION**

Although in the popular mind the photograph serves as a surrogate slice of reality, the relationship between any subject and a photograph of that subject is highly unstable. Photographic codification invariably creates some degree of alteration, exaggeration, and/or ambiguity. Framing removes the subject from its larger, more informative context, automatically—and sometimes capriciously or even deceitfully—nullifying the subject's surrounding makeup.

The experienced viewer regards all photographs suspiciously. The problem is not that photography is inherently untruthful, but that its illusion of veracity makes it such a perfect means for a lie. Even when a photograph is not taken with the intent to mislead, its captions can alter our interpretation. Although it routinely functions as incontrovertable evidence in court, the single photograph often requires either the aid of words or of additional photographs, whose alternative vantage points clarify its message.

Such reservations notwithstanding, the camera that is equipped with color film represents the ultimate mimetic tool. Certainly no more efficient method of transcribing the world exists. Furthermore, the camera's capacity to record facts that the human eye doesn't even notice gives the medium its unique aura of disinterested objectivity. In conceptual art quarters, what Max Kozloff calls the medium's "alertness without mind,"[1] promises nothing short of an impartial collection of unadulterated facts.

The camera's information-gathering proficiency seems to override any musings that its transcriptions might be idiosyncratic and that the machine, far from being immune to the variables of human personality, is programmed by a human being even when not directly operated by one.

As Jeff Peronne said, "The normal effect of the photographer is to deny any recognition of the record-taking activity itself. We get this funny feeling, the feeling of 'unreality' when we see the photographer unexpectedly acknowledge his presence (his shadow, a finger near the lens, his reflection). The viewer is supposed to 'tune out' the knowledge, edit out the fact of the photographer's interaction or alienation from the subject. We expect transparency."[2]

The degree to which the illusion of transparency exists depends heavily on the viewer's practice and facility at reading photographs. Just about everyone, however, would agree with Max Kozloff that "the print offers such an overwhelming quantity of finished data that our disbelief in their evidence is nipped by gratitude."[3] Thus though some Postmodernist photographers (Michael Bishop most successfully) make ironic salutes to the photograph's powers of untruth, many more hope to retain its value as a repository of information.

For the documentary photographer today, telling the truth about the subject is not enough. The truth must be told in a manner that instills the viewer's confidence in the truth of the depiction. Lewis Baltz has stated the dilemma well:

There is something paradoxical in the way that documentary photographs interact with our notions of reality. To function as documents at all they must first persuade us that they describe their subject accurately and objectively; in fact, their initial task is to convince their audience that they are truly documents, that the photographer has fully exercised his powers of observation and description and has set aside his imaginings and prejudices. The ideal photographic

Plate 88 Bill Ravanesi

134

Plate 89 Bill Ravanesi

135

Plate 90 Wayne Sorce

document would appear to be without author or art. Yet of course photographs, despite their verisimilitude, are abstractions; their information is selective and incomplete.[4]

Baltz's perceptive understanding of the photographic document's dual character seems lost on the many critics and curators who label any work that does not obviously trumpet aesthetic frills as anthropological and scientific. Indeed, the obsession with detachment is so acute today that a concept of the "passive frame" has been promulgated.[5]

Unlike "active framing," by which the photographer clarifies, reveals, distorts, turns into symbols, or otherwise comments on the world, the passive frame purportedly sections off a segment of reality with such immaculate objectivity that the subject's photographed significance and its real-life function are interchangeable—i.e., the subject passes through its photographic transposition completely intact, in form and content, with no trace of bias or reconstruction.

The absurdity of this "passive frame" ought to be obvious. The act of framing represents a conscious choice, even when the subject is represented by a multitude of views from various vantage points, through different lenses, types of films, and so forth. Even such multiple presentations present only relative, fractional objectivity, for an infinite number of points of view are possible.

The color photographer most often invoked as a "passive framer" is **Stephen Shore**. Yet only the most hard-headed empiricist, insensitive to the subtleties of purely visual phrasing, could contend that Shore's worthiest photographs are deadpan "take it or leave it" views of the essential subject. Although Shore acknowledges that he uses the "nonjudgmental part" of his mind[6] and so can be considered "passive" in terms of extrapictorial content, his visual, formal priorities are highly judgmental and elitist.

Shore comes closest to fulfilling the unkind assessments most often attributed to the entire body of his work in the handful of close-up portraits he made of the New York Yankees. His representations of Ron Guidry, Lou Panella, Catfish Hunter, and others seem to impose a deadening circumstance—the act of posing for a photograph—and an equally deadening, arbitrary purpose—the desire not to heroicize these celebrated champion athletes—upon both his subjects and himself. In these portraits, Shore strayed from the sensitive, intuitive, visually conscientious "nonjudgmental" procedures that produced most of his best and best-known imagery. Rather than choose subjects for their capacity to inspire visual solutions to image-making problems, Shore found subjects whose renown and significance to the public and to himself make them conspicuous within the larger context of visual orchestration. That they were regarded as such by Shore is evident in his decision to isolate and record them. He strips them of their mythical, sports hero personalities through a strategy of subtraction; what he allows to remain fails to reveal any large meaning. These men appear patient but put upon, compressed into arrangements that broadcast the contrivances of Shore's approach to them. Simple, solid color backgrounds and pervasive illumination fail to reveal the ordinary in the extraordinary, or the extraordinary in the concise; instead, the forced "factuality" of Shore's frontal portraits inadvertently illustrates the futility of searching for special

Plate 91 Wayne Sorce

Plate 92 Douglas Hill

significance with laboratory techniques under laboratory conditions.

When most effective, Shore's style is distinct and inimitable, a nearly absolute integration of imaginative vision and methodical observation. Still, artifice undeniably remains. To astute observers, this has seemed inevitable and obvious, as it did to Susan Sontag more than a decade ago when she wrote:

> Of course, as everyone knows or claims to know, there is no neutral, absolutely transparent style. Sartre has shown, in his excellent review of *The Stranger*, how the celebrated 'white style' of Camus' novel—impersonal, expository, lucid, flat—is itself the vehicle of Meursault's image of the world (as made up of absurd, fortuitous moments) . . . What Roland Barthes calls 'the zero degree of writing' is precisely, by being antimetaphorical and dehumanized, as selective and artificial as any traditional style of writing. Nevertheless, the notion of a styleless transparent art is one of the most tenacious fantasies of modern culture.[7]

The documentary mode does not, by definition, exclude formalist priorities. Much of the best work accomplished today marries journalistic and formal concerns in the belief that the truth seems more potent and legible when presented in a coherent fashion. But the documentary photographer ought to be influenced by the subject, rather than represent the subject so that it complies with formalist preconceptions. Far from aspiring to an inactive role, the photographer must earnestly probe for the personality of the subject, and then employ the photographic process with utmost skill in order to reveal what has been discovered.

Yet the term "documentary" has been applied to just about anything that seems at once restrained and factual, and numerous Modernist and Postmodernist photographers with track records of eloquent or ironic meditations on the medium have been commissioned to make documentary surveys. The *Court House* project in which 24 photographers photographed 1,300 of the nation's courthouses as a Bicentennial project, is a case in point. The results exhibited as well as distributed in book form, reveal less about architecture and social history than about the curatorial preferences in contemporary photography. Of another commissioned survey, Mark Power wrote: "The photographers didn't document Washington; instead, they used it as a handball court, playing off it variations, repetitions, and, in some cases extensions of the games played in their previous work."[8]

For Allan Sekula the confusion of formalism and documentation in such surveys has had an insidious effect and he argues that we "understand the extent to which art *redeems* a repressive social order by offering a wholly imaginary transcendence, a false harmony, to docile and isolated spectators."[9] James Hugunin, expanding some of Sekula's opinions on the black-and-white photographs of Lewis Baltz from *The New Industrial Parks* series, wrote that "Baltz conceals the factory aspect of such spaces with the minimalist abstraction ploy of a strategist aiming at elite attention in the gallery/museum circuit. Here the objectivity of the lens actually hides the objective social meaning of the factories. Expression nudges aside referentiality, real dialogue is shut out by the formalist ploy."[10]

Formalism does indeed avoid such questioning. The formal photographer carefully extracts anything in the way of referents that would, to use John Szarkowski's phrase, leave

a "gritty precipitate" extraneous to the interior requirements and rhythms of the artwork.[11]

"My propaganda is on behalf of the eye,"[12] says black-and-white photographer David Freund, summing up the formalist position. The contention that formalists are aestheticized recluses is understandable. Much of photography's documentary function arose with nineteenth-century positivism, which held that reality was the highest form of knowledge and truth could be found with simple descriptions of sensory phenomena. In our time, with hopes of attaining truth abandoned, notions of the real have become mere beliefs.

Suspicious of the photograph's ability to express the complexities and incongruities of day-to-day affairs, many photographers accept Normal Mailer's testimony that "the facts are nothing, sir, without their nuances."[13] Afraid to overlook the nuances, most photographers use the medium in an introverted, ironic, alienated, and formalized fashion.

Assertions of unequivocal exactitude and certainty seem simplistic, lacking credibility. The era when clear answers to social problems were forthcoming has passed. Contemporary documentarians provide descriptions rather than prescriptions. Their works attempt to encompass contradictions, to provide facts that might produce theories, but which do not, in themselves, proclaim hypotheses.

Such evasiveness might, in part, represent a reaction against the aggressive, manipulative tactics of the New Journalist photographers of the 1960s and early 1970s who cleverly and caustically continued the cynical subjectivity heralded by Robert Frank in *The Americans*. Though Garry Winogrand's black-and-white photographs brilliantly sum up a decade of bombast, pretention, and simple-minded slogans, he captures his "victims" at fortuitously coincident, but not necessarily truthful moments. His peculiarly photographic fast freezing and flash bombing frequently snare unauthored gestures that only seem to be revelations of character and content. Consequently, the sharp scalpel of apparent truth can often be a tool for the blatant intrusion of Winogrand's own opinions and personality. Few would demean his hawk's eye for the comic, characteristic, and convergent. But his revelations result from a nosy, noisy style, no longer as acceptable now that most of us believe any value judgments are best left unmade.

Likewise, Diane Arbus's style is increasingly perceived as judgmental and auteuristic. Shelley Rice writes, "By perceiving outcasts as aristocrats and the bourgeoisie as a sideshow of oddities, Arbus created new standards which were as shallow and stereotypic as those that she despised."[14] Though it was once widely thought that Arbus "unveiled" an alienated, atomized world, her truth often coincided with our own worst fears and prejudices. In fact, her technique seems to transform all her subjects into oddities from the same litter. Arbus herself said that she felt "kind of two-faced" vacillating between ingratiating her sitters and asserting control over them.[15]

Numerous street photographers still caricature people and many have sought to transpose the more superficial aspects of Winogrand's and Arbus's strategies into color with blatantly exploitive results. Drawing attention almost entirely to the freakish color confluences on human subjects hardly constitutes justification for photographing, yet the cheap attraction persists.

The most effective color street photographers eschew

Plate 93 Douglas Hill

Plate 94 Neal Slavin

satire. **Joel Meyerowitz** steels brilliant bursts of color with sophisticated aesthetic strategies. *(plates 43-46)* **Mark Cohen** intently investigates process for its formal and emotional effects; *(plates 38-42)* **Helen Levitt** reaches for mythic significance. *(plates 103, 104)*

Joel Sternfeld seems motivated by the documenter's goal of investigating a predetermined subject—pedestrians during rush hours—and allowing his perception to dictate presentation. Photographic effects, derived from flash, conspire to detail the anxieties of people in a hurry. *(plate 77)*

The harsh flash assaults corporeal security, creating visual evocations of presumed spiritual deprivation. Sternfeld shoots people who are in too great a hurry either to reveal the full depth of their character or maintain a composed, public persona. The spatial dislocation produced by flash-blitzed foregrounds and naturally illuminated backgrounds paraphrases an illogical universe. The film's garish exaggeration of the characteristic colors of the plastic, polyester present manifests a brazen, brassy ambience with shameless insistence. These photographs truly seem to capture the aching acceleration and resultant grimace of our age.

Although Sternfeld obviously exploits his subjects, insofar as they would probably not prefer to be recorded in the context that he has selected, his images emanate a sympathetic undercurrent. It is as if during his dutiful documentation of reality's undisguised features, he experienced a certain compassionate sadness that somehow seeped into his pictures.

If sympathy has reactionary associations, it is nonetheless a quietly resurging attitude in contemporary photography. But many photographers continue to strive to incorporate cynicism, apathy, and alienation in order to demonstrate their detachment—thus supposedly validating the unemotional, scientific objectivity of their pictures.

Bill Ravanesi's photographs of farmworkers—predominantly Filipino migrants laboring in California—offer a mixed presentation of factual reportage, candid sympathy, and pictorial formalism. Some of his individual portraits reveal a deeply humanistic reverence for individual dignity and value, and a specimen collector's obsession with detailed description of his human subjects' possessions and immediate environment. In one image, unusual for its depopulation, Ravanesi records the bizarre, totemic displays with which a worker has decorated his temporary homestead. Although the laborer is not visible, his presence seems to reside in haunting, sculptural assemblages. Bicycle handlebars, disfunctioning television sets, old buckets and automobile parts adorn the fence outside his shack, transforming its material rudeness into something akin to a postapocalyptic shrine or the house of a primitive medicine man. Ravanesi's fascination—and ours—fastens as much upon the exotic fact of this ramshackle conglomeration's uncontrived actuality as on its mystical, emotive evocations.

More typical of Ravanesi's tightrope walk between social conscience and formalist distance is his photograph of an irrigated field in California's Mojave Desert. *(plate 88)* The late afternoon sun renders the solitary figure with a conspicuous glow, but the richness of that illumination, the formal compositional stratifications, and the vastness of the image's visual scope distract attention from the signifi-

144

cance of the worker's role in Ravanesi's overall statement. The closer proximity of the tobacco workers in the group portrait *(plate 89)* allows greater opportunity to reveal character or contact our sympathy through direct, intimate appeal. Yet here, too, the people appear components of, as much as the reasons for, the formal scheme.

Wayne Sorce commemorates the Chicago home of Aldo Piacenza, a naive artist who eccentrically painted and decorated his home from basement to attic. Where a formalist would seek a subject more likely to submit passively to treatment, Sorce concerns himself with representing the qualities of Piacenza's own beguilingly innocent, intense, and idiosyncratic art. Brightly painted, patterned rooms are framed into compellingly patterned and colored photographs. *(plate 90)* Objects of interest are presented with descriptive directness, allowing their eccentric personalities to speak with apparent autonomy. *(plate 91)*

Douglas Hill catalogs zealous examples of the type of Pop architecture celebrated by Robert Venturi *(plates 92, 93)* He represents each specimen in a presentation that utilizes its colors, values, shapes, and angles as visual elements in a carefully constructed pictorial scheme. As the eye savors every formalist nuance, it assimilates each quirky detail of the subject's structure and surroundings, from its cornball caricature to gratuitous visual exuberance.

William E. Smith's photographs of a weatherworn, 1940s amusement park in Québec revivify documentary concerns through formal means spiced with spatial anomaly. The principal subjects are the park's picture boards, which contain holes through which people once inserted their heads so they could be photographed atop witty, painted bodies of concupiscent courtesans, valiant soldiers, sweethearts caught *in flagrante delicto*, and organ grinders' monkeys.

Smith enlists these now unoccupied openings in the painted boards, creating photographed vignettes from scenery viewed through them. Scenes of actual grass, shrubbery and buildings framed by the openings often appear more vivid in texture and color than the faded paint on the worn panels. Consequently, many such vignettes seem to advance as if they are precisely focused images mounted on the façade of the weathered boards. *(plate 85)*

Though crudely rendered, the paintings occasionally offer very convincing illusions of three-dimensional space. *(plate 86)* The illustration of the adulterous couple in bed, painted on a panel positioned in a diagonal relationship to the picture plane, seems volumetric, while the real space around the board appears as flat as a magazine page. This reversal of spatial reality frequently occurs in photography, which typically flattens three-dimensions but as often transposes ready-made representations with more vivid illusionism than they might possess in real life.

In Smith's images, photographic illusion and painted illusion play off one another like elements in a collage. A visual *non sequitur* occurs whenever the two idioms of representation coincide.

Neal Slavin calls groups "the American icon."[16] His 1976 book, *When Two or More Are Gathered Together*, represents the imagery accumulated during three years of informal, anthropological exploration during which he

Plate 95 Neal Slavin

Plate 96 Neal Slavin

traveled the country photographing groups that ranged in size from two to thousands. Togetherness on the basis of birth, jobs, disabilities, and interests has always been an American phenomenon. Slavin attempts to evoke both the group ideal and familiar conceptions of it in visual terms. Like an advertising photographer, he heightens identifiable, unequivocal situations through striking presentation and unexpected frissons.

Color separates the gold trophy from the silver, yet Slavin seems to use color less for descriptive purposes than to produce emotive ambience. Neither crystalline nor restrained, his hues are densely saturated. Information emerges as though from beneath a layer of tinted cellophane. He deliberately enlists such "heavy" color to help convey his perception of the character of each group.

An anglers' club *(plate 87)* poses by a fish tank in a photograph whose every hue seems tinted with aquamarine. This time-honored strategy of advertising gospel long ago spread among hobbyists, too. Scores of technical manuals induce amateurs to allow the pink of petals to seep into the cheeks of children frolicking among the flowers, advising that such effects will manifest visions of sweetness and harmony with nature. Clearly, Slavin jeopardizes his credibility by pulling such treadworn stunts.

Yet such obvious tactics need not produce cliched solutions. Depicting the Associated Blind *(plate 94)*, he expresses the frightening remoteness of a life without light by dimming the foreground into inky shadow, placing his subjects against dark backdrops that produce stridently disconcerting contrasts, and directing bright light into their faces, emphasizing the absence of focus in their sightless gazes. The hues seem somewhat dingy, as in certain hand-tinted photographs, as if paraphrasing the absence of chromatic richness from the lives of the group's members.

Slavin's most distinguished art-historical precedent is the group portraiture of Dutch baroque painters like Rembrandt and Frans Hals. When Slavin applies chiaroscuro lighting in his photography, his subjects burst melodramatically from the gloom. When the location is a theater, Slavin induces his film to react as randomly and exuberantly as it can, thus alluding to the theatrical aura of magic and surprise.

With equal frequency, Slavin creates formal images in which all recorded detail, texture, and pattern form a continuous visual field along the print surface. Cheerleaders are so numerous that their heads and costumes combine to form a huge shag rug, incongruously carpeting a gymnasium floor. *(plate 96)* Although Slavin hoped viewers might decipher the field of faces as if it were a map, color film does not record with the pinprick clarity of black and white, so the distant, minute faces in his images bleed into each other.

The less populous groups provide more informative minutae and the richest surprises. A member of the Society for Photographic Education bared a breast for the camera. *(plate 95)* Members of the Lloyd Rod and Gun Club look so oafish, lunatic, and potentially violent, that a casting director would probably have rejected them as too cliched.

Although his approach is purportedly nonjudgmental, it occasionally seems that Slavin has operated with tongue in cheek. Photographing the Xavier High School R.O.T.C., he underexposed the deep blue uniforms, melting them all together in murky blackness. Yet the white stripes on their pant legs appear so graphically bright that the members

Plate 97 Jerry Dantzic

Plate 98 Jerry Dantzic

152

look like heads and saluting hands mounted on white sticks.

Most notions of ridicule or comedy attributed to Slavin's pictures stem mainly from viewer inference. Members of certain groups, such as the Companions of the Forests of America, the International Society of Bible Collectors, and the World Body Building Club, do seem to take themselves a trifle too seriously. Yet there is no indication that Slavin made these or other images with an attitude of superiority, or intent to disparage. He takes pains to convince us that his role was incidental. "I just picked the location and set up the lights. The people all arranged themselves, they made the pictures,"[17] as if his technical tricks and aesthetic selections have no significance in the resultant presentation.

More effective than his disclaimer of active involvement, however, is his decision to face each photograph in his book with a recitation of the group's vital statistics. This differs radically from the tactic taken by Bill Owens in his project *Our Kind of People: American Groups and Rituals*. Owens captions his black-and-white photographs with statements purportedly spoken by the people in the images. But they all articulate in the same punchy fashion, and the quotations smack of heavy editing for sensationalist effect. Such spliced dullness can manufacture drama. The strange lack of continuity engendered is often good for a laugh, and that laugh is usually at Owens's subject's expense.

Slavin's photographs function most effectively as commemorations, in which people project what Erving Goffman called the unavoidable, socially conditioned dramatic presentation of self, rather than the true creation of self.[18] Yet Slavin apparently intended far more. In a memo to himself, included as the preface to his book, Slavin stated his basic premise:

When a group presents itself fully to the camera, revealing the totems and markings that make it unique and individual, then that group will simultaneously reveal the innate sense of belonging. I envision a work that communicates the desire to belong in America in the mid 70s and the conflicts caused by that wish. . . . In short, I want to photograph groups—they are the American icon.[19]

Carol Squiers correctly observes that such "magic riddled" words "coat the endeavor with a disarming mixture of sociology and voodoo," but in no way address the crucial question of content.[20] Certainly we would like to be able to determine which (if any) individuals have lost "self" by capitulating to club stereotypes, or which (if any) have created "self" by becoming more fully human through the intense play that Johann Huizinga hypothesizes as the very source of civilization. But no single photograph can be expected to answer such questions, and Slavin's photographs don't even provoke them.

Yet as commemoration, Slavin's book constitutes, as Kozloff wrote, "social picture-making of novel distinction." There may be something "perplexing, uplifting, strained, or finally touching about these thousands in mufti losing themselves in their role, at least for this one formal moment, to a stranger."[21]

William Christenberry has been photographing the shacks, churches, diners, gas stations, junkyards, and cemeteries of Hale County, Alabama, since the early 1960s. Because he was inspired by *Let Us Now Praise Famous Men*—and had a close personal association with Walker Evans from

Plate 99 William Christenberry

Plate 100 William Christenberry

1961 until Evans's death in 1975—Christenberry's work is widely assumed to be equally unpretentious and uninflected. Evans was entranced with Christenberry's images:

The fact that William Christenberry is not fully a professional photographer is of some importance in any comment on his current phenomenal exhibition. The look and the feel of the work would not be the same were he more professional. Christenberry is a sculptor and an art teacher. What he has done with breathtaking candor, ease, charm and perfect instinct is to take a cheap "instamatic" box camera, something of this sort, from the drug store, and to trust his eye and his intuition, and to push the button at some hidden inner command. Will you claim that anyone can do this with similar results? Not if you know anything about art, vision, talent; about color; about seeing and the eye.

I need not proclaim the distinction in these unpretentious pictures. They will be spotted by the many experts who now follow photography in all its turns— and they will probably be mishandled in one way or another, as usual. I want, though, to indulge myself in the truly sensual pleasure of savoring these things in their quiet honesty, subtlety, and restrained strength and their refreshing purity. There is something enlightening about them, as ranged here; they seem to write a new little social and architectural history about one regional America (the Deep South). In addition to that, each one is a poem.[22]

As Evans's statement implies, directness does not dilute poignance or poetry. And if some of Christenberry's documentary tacks seem objective, his methods often have quite the opposite effect.

As if making typologies, he excludes the human element as well as other indications of size or context. Photography thus permits the equalization of Christenberry's subjects so that their visual characteristics can be compared without distraction. Yet removal of certain referential clues makes the images less informative on many levels and more susceptible to imaginative musings. In conjuction with the softening effect of the Brownie camera's lens and the diminutive $3 \times 5''$ scale of Christenberry's prints, the tactic transforms his apparent documents into fiction.

Christenberry miniaturizes the Southern rural world. The immaculate white churches might have been dropped from heaven. *(plate 99)* Shacks seem less rustic and more like rusticated doll houses. A sheet metal sign, shaped like an ear of corn, gestures like some droll confection on a stick. *(plate 101)* Plastic toys, Clorox bottle vases, wired wreaths, and miniature fences seem to virtually dance around the graves of children they adorn. Colors detach themselves at will from their objects, frolicking freely as if infected by some antic muse—in orgies of lavender, green, pink, and yellow.

The absence of living figures fails to deplete the richness of these images. Artifacts and shrines remain in timeless, quiescent suspension, as if awaiting the kiss of the proper prince. Each photograph's intimate size is crucial—it forces us to enter the fictional space of the pictures. Photographs Christenberry has taken since 1977 with an $8 \times 10''$ view camera and blown up to sizes as large as $20 \times 24''$ fail to cast such spells.

As a grown man and a trained artist, Christenberry can hardly be assumed to have "the innocent eye of childhood." Yet his pseudo-documents suggest it; the naiveté they exude

eludes any impression of artifice. No other documentary work better demonstrates this extraordinarily paradoxical, profound aspect of the medium—the way fiction impinges on utilitarian fact.

Photographers captivated by the camera's informative capacities have long gravitated to the panorama format. Daguerre with his diorama, and Felix Beato, Samuel Bourne, and Eadweard Muybridge with their pieced-together theatrical documentaries, are only the best known of those taking the long, long view.

The panorama camera has been primarily a commercial tool. Touting its "profitmaking" Cirkut at the turn of the century, Kodak promised would-be buyers that they would find "customers willing to buy more, and—more important—pay more, for pictures that are a radical departure from the old style view." Manufacturers would be "more than willing" to pay extra for "real" views of their factories, which contained visible descriptions of all the important details too numerous to be included in conventional photographs. Kodak promised that group portraits would be especially lucrative. If all the Knights of Pythias could be gathered in one image, the photographer could sell each member a print, in effect selling hundreds, even thousands of photographs made from a single negative.[23]

Today, custom-cut film has made the Cirkut camera a nonprofit, expensive obsession. Consequently, its use is largely confined to those devoted practitioners who persist with it for personal reasons, despite the apparent obsolescence of its profit-making potential.

Photographers such as **Jerry Dantzic**, who is developing an aesthetic of extended vision, must somehow ensure that the technical feat and novel format do not overpower the individual distinctiveness of each image.

Dantzic's photographs are contact prints, eight inches high and anywhere from six to twelve feet wide. He uses the Cirkut—one of the most arcane and mechanically recalcitrant panorama cameras ever made—for the simple reason that no other equipment combines such immense size with intricate information-gathering capabilities.

The wealth of information, however, comprises an unusual reconstruction of reality. As the word Cirkut suggests, the camera revolves around a fixed point and describes a visual span of up to 360° (more if the subject is repeated). The images pose no problems if exhibited on the interior walls of a circular room of appropriate circumference. In such an environment, the comparative positions of a viewer and any part of the photograph parallel the photographer's relationship to the actual scene.

But when the panoramic images are exhibited on a flat wall, the natural continuity snaps. Objects at opposite ends of the print would have been adjacent on the actual site. Shadows appear cast in opposite directions. Curved lines may appear straight in the panorama view, while actual straight lines become curved. Unlike conventional photographs or paintings, the expanded images exceed the normal periphery of human vision, forcing viewers to track narratively from one end to the other, or to scan at random. If one retreats until both ends of a panorama image fall within comfortable visual peripheries, the details so diminish in size that they cannot be examined, and the image congeals into a series of generalized passages of marginal coherence.

Plate 101 William Christenberry

Early Cirkut operators measured their skills by the straightness of their horizontals. Dantzic seems entranced with the way facts can be formed into impossible fictions. He plots out his photographs, calculating distortions so they will produce the most aesthetically and narratively significant effects. His ongoing photographic essay *America at Length* is therefore as much a personal recreation of legend as it is quantified research.

Dantzic's view of Manhattan Bridge undulates gracefully, exaggerating the distance between the connected land masses of Brooklyn and Manhattan. *(plate 97)* Such dramatic extension of factual scale elevates the bridge's reach and function into the realm of myth. The sun gilds its mid-section, as well as the distant skyscrapers of Manhattan, as if to suggest that the bridge leads from the shadows of Brooklyn to the Promised Land across the river.

With illumination emanating from opposite directions in the single image, Monument Valley *(plate 98)* becomes an otherworldly scape, as free of human society's litter and twitter as it is unaffected by natural laws. Even the jewel-like clarity of Dantzic's photographic description encroaches upon our concept of normalcy. His extraordinarily vivid definitions of nature's texture and hue seem somehow as unnatural and poignant as a dream.

158

Plate 102 William Christenberry

Dantzic's search for higher aesthetic and metaphorical significance will be complicated by more than panorama technology's domination of personal vision. Colin Westerbeck Jr., writing about a wide range of works in the panorama format, spoke of the difficulties: "It's not that panoramic photographs aren't pregnant with meanings; on the contrary, they seem almost *too* pregnant. They run off in 10 different directions at once, with philosophical and metaphysical implications we cannot control."[24]

The works of Christenberry and Dantzic contain sufficient glimmerings of extra-factual content to suggest that, in certain instances, their aesthetic super egos have yielded to the registering of unconscious impulse and of feelings that exceed the grasp of intellectual cognition.

Gary Metz has pointed out that the etymologies of "document" and "record" refer to essential human experience. "To document originally meant to show again to the mind. To record meant to hold again to the heart."[25] Christenberry and Dantzic are not fully engaged in this approach to defining their age and contributing to self-knowledge. Such larger meanings and broader judgments accrue in the images of documenters whose work decisively encompasses the realm of myth as well as that of perceivable fact.

159

CHAPTER 6: **MORAL VISIONS**

John Gardner contends that most art today is either trivial or false and that few artists break through the limited reality around them to build a new one.[1] Some artists fear that all they might say would be mocked as well-intentioned propaganda, and so continue to preoccupy themselves with surfaces. Postmodernist artistic direction has certainly allowed a return of content, yet its moral center is most often a joke; sardonic allusions, double entendres about medium and process or throw-away visual references seem to "legitimize" concerns that seem trivial, self-serving, and irrelevant in the context of life's broader, deeper scope.

The problem is much the same as in the time of William Butler Yeats, who said that "the best lack all conviction while the worst are full of passionate intensity." It should be pointed out that the sublime perfection of a worthy Stephen Shore photograph and the multileveled theoretical and visual complexity of the best of Michael Bishop's images are worth more than all of the bromides promulgated in most of the popular photographic publications.

Yet a few artists, ravenous for the fully human and opposed to what Ortega y Gasset called "the dehumanization of art," passionately commit themselves to pursuing larger, more meaningful syntheses. The world, the self, and art collide in their photographs as they attempt to clarify life by illuminating reality.

On the whole, they pursue character, not caricature; form, rather than adventitious novelty. Though parody often functions in their work, it facilitates rather than preempts engagement with larger issues. What Gardner calls "the higher artist" or the "real artist" adopts the stances of his time and toys with them, suggesting indirectly the existence of something better, something truer.

Photographers who attempt to locate their feelings by way of elaborate inventions of the mind do so at their peril. The photographic medium is a clumsy instrument when employed in blatant manipulation. But the practitioner who perceives the mystery in the visible can transmute empirical data in such a way that the unconscious seems to reveal itself through the real.

Popular opinion to the contrary, explicit description does not preclude richness, mystery, metaphor, or pathos. Those qualities may well reside within explicit factuality and seem the more cogent for their tie with truth. Expressionism is a demanding and venerable goal in any art medium. But what is being expressed should somehow speak to the depth and complexity of life itself.

Concentrating on the world without violating it, photographers can induce significant emotional sensations or suggest transcendent spirituality without resorting to contrivance. Those who succeed at this understand the subjective possibilities of objective things.

The relationship between form and content is complex almost beyond explanation. John Szarkowski has rightly called translation of artworks into words "a fool's errand."[2] Nonetheless, the risk of repetitive, soporific, and ultimately gratuitous verbal explanations must be taken because content is so frequently overlooked except when it is most overtly promulgated, such as in an image of a knife, drenched in red to suggest anger, hostility, or terror. The photographs addressed in this chapter have rich polysemic possibilities. The myths they contain often exist in a state of uneasy tension and can only be apprehended through an act of the

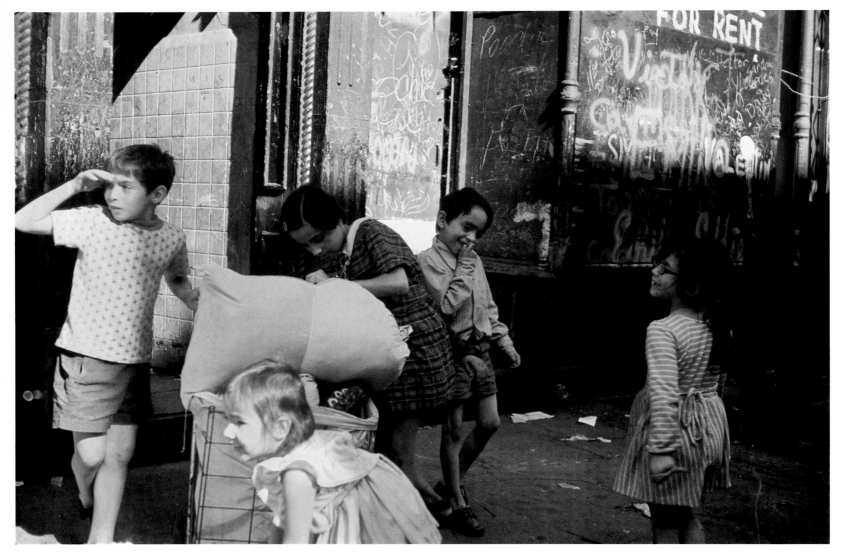

Plate 103 Helen Levitt

162

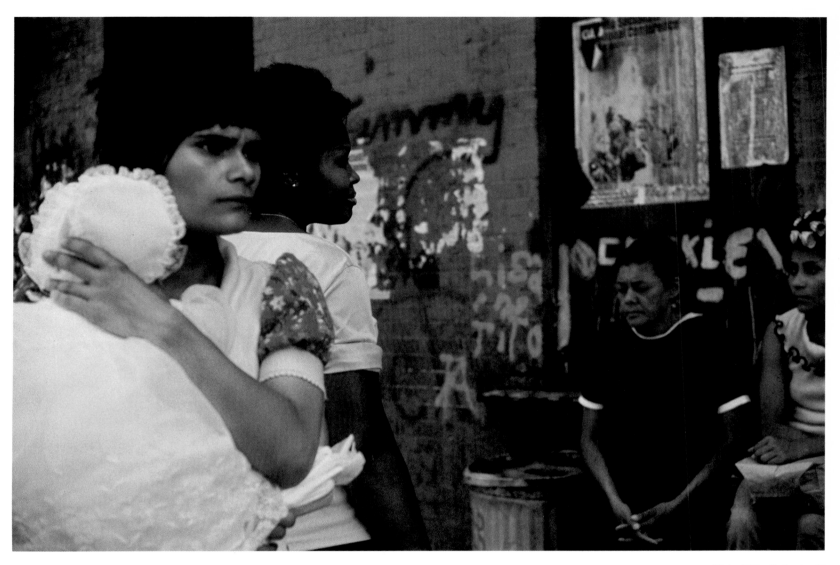

Plate 104 Helen Levitt

163

imagination; at other times they defy conscious resolution altogether. Complex and unresolvable as life itself, they transcend the moment and time of their making.

The four photographers to be discussed—Helen Levitt, Joel Sternfeld, Kenneth McGowan, and William Eggleston —assume stances that range from ironic distance to intense emotional involvement. But all seek a truth that exceeds ideology and self-reference. Their photographs contain varied proportions of visceral and intellectual input. Through presentation of organized, coherent facts—whether by sophisticated and obviously formal strategies or through the apparently casual "styleless" style or a somewhat mannered Romantic Expressionism—a certain profound significance is released. Style does not inundate vision. Their sense of responsibility to what is seen and felt transcends the preconceptions of style. Investigation precludes implementation of any rehearsed system. Vision becomes a moral act as photography modulates reality from the dimension of the actual to the synthesis of art.

Just such a moral sense is the "weaker morality" of which Nietzsche wrote:

> With regard to recognition of truths, the artist has a weaker morality than the thinker; he will on no account let himself be deprived of brilliant and profound interpretation of life, and defends himself against temperate and simple methods and results. He is apparently fighting for the higher worthiness and meaning of mankind; in reality he will not renounce the *most effective* suppositions for his art, the fantastical, mythical, uncertain, extreme, the sense of the symbolical, the overvalidation of personality, the belief that genius is something miraculous.[3]

164

Helen Levitt uninsistently but irrefutably transforms the commonplace into the mythic. Though her photographs contain explicitly described gestures, facial expressions, and localized environment detail, her subjects—primarily the urban poor and their neighborhoods—assume a larger significance. Because Levitt perceives and represents them as transcendently human entities, not as materialized socio-economic statistics, their obvious poverty neither threatens nor relieves us. Grateful acknowledgement that "there, but for the grace of God, go we" yields to recognition, at least on the subconscious level, that Levitt's people *are* us—they, we, and she are the same. Their gestures may be more open, awake, honest, and vulnerable because children and the urban poor hide little of themselves behind public personas. But they enact rituals of birth, love, the hunt, and death. They progress from birth to decay and from innocence to knowledge as we all do.

By photographing children's playful competition, Levitt describes what Johann Huizinga called "a social impulse older than culture itself that pervades all life like a veritable ferment." To him ritual grew up in sacred play; poetry was born in play, music and dancing were pure play. The rules of warfare, the conventions of noble living were built on play patterns. Even our legal system functions much as a contest between opposing teams."

In plate 103 the action unfolding beneath vividly checkered contrasts of sunlight and shadow is somehow like a harvest dance or a school play or some ritualized participation in a festival. The individual figures seem choreographed into poses that act out heroic daring, vigilance, curiosity, work, productivity, dance, and courtship—all the more remarkably entrancing for the way the eye moves among

these children—and for the fact that their formation is spontaneous, coalesced through Levitt's pictorial anticipation.

When Levitt's subjects grow up, their psychological tenor intensifies. On a debris-strewn, paint-streaked patch of patinated sidewalk, a Latin youth crouches warily while he rinses his gleaming hands in a battered pot. The orange and tan of his shirt and skin combine with the red spray paint splatters all around him to aggravate the photograph's ambience to a threatening pitch. We might be viewing preparation for or the aftermath of a blood sacrifice, or the bloodied portion of a battlefield, or a warrior engaged in ritual prior to or following mortal combat.

James Agee's comments on the mythical implications of Levitt's black-and-white photographs from the 1940s pertain to her 1970s color photographs as well:

These are pastoral people, persisting like wild vines upon the intricacies of a great city, a phantasmagoria of all that is most contemporary in hardness of material and of appetite. In my opinion they embody with great beauty and fullness not only their own personal and historic selves but another self also which I presume to be warm-blooded, and pastoral, and, as a rule, from its first conscious instant onward, as fantastically misplanted in the urgent metropolis of the body as the body in its world.

The over-all preoccupation in these photographs is, it seems to me, with innocence—not as the word has come to be misunderstood and debased, but in its full original wildness, fierceness, and instinct for grace and form; much may be suggested to some readers by Yeats's phrase, the "ceremony of innocence." This is the record of an ancient, primitive, transient and immortal civilization, incomparably superior to our own, as it flourishes, at the proud and eternal crest of its waves, among those satanic incongruities of a twentieth-century metropolis which are, for us, definite expressions and productions of the loss of innocence.[5]

Levitt never tweaks our conscience or exhorts us to action. Nor does she arrest a fact and elucidate it in order to show it superior to other truths. Her truth is intuited and felt, rather than intellectually defined and validated.

Levitt engages the world on its own terms, for to stylize it would reflect ambivalence or contempt. She seizes and distills the moments when aesthetic and mythical significance materialize before her lens.

Though she uses a 35mm camera, her presence never seems to intrude upon her subjects. People perform as if she had the power to will them into choreographed configurations and symbolic stances without seeming to manipulate or interfere with them. Their bodies and limbs may be arranged with the aplomb of a master draftsman, but the pictorial placements never seem contrived or conspicuously structured.

The credibility and expressive power of Levitt's imagery greatly depend on her ability to structure apparently factual, found visual confluences of gesture and environment into cohesive pictorial units without making her involvement conspicuous. She subordinates her formal role as image-maker, as well as any blatant reference to the artifice of imagery, in order that the integrity and unmitigated impact of her vision be protected from the compromising distractions of process and authorship.

Like her better-known black-and-white works, Levitt's color photographs incorporate masterful combinations of

Plate 105 Joel Sternfeld

Plate 106 Joel Sternfeld

human gesture and graphic structure drawn from the data of visual reality. Her color work relies heavily on chromatic correspondences and weavings derived from the visual character of subjects throughout her compositions. Her images mesh patinated walks, peeling walls, and patterned clothing into fields of texture, shape, and color.

In works like plate 103 Levitt deliberately builds with segments of light and shadow that sprawl in alternating configurations of controlled visual chaos across the scene, producing pictorially and narratively dramatic effects. The boy at the frame's left glows vividly in direct sunlight, while the two children at right conduct their bashful, prepubescent courtship in the subdued contrasts and rich, enveloping tonalities of shadow. The face and left arm of the girl in this pair emerge from the murky dark in a magical first walk into the realm of flirtation.

Levitt has no peer in her understanding of color's power to reinforce, transform, or even create emotional content. The sultry intensity of the youth washing his hands is amplified by the juxtapositions of red paint and orange cloth against blue wall and gray cement. The simmering energy of his stealthy crouch and intense gaze seems to emanate from the image's precarious chromatic stalemate as well. The overall mood is hot and foreboding with an undercurrent of terror—as much the result of Levitt's color tensions as of the rendering of the young man's gesture. As Ben Lifson observed, Levitt is one of "America's half dozen or so great photographers—great like Turgenev, that is, an artist whose scope isn't broad, but who penetrates to unusual emotional depth and whose handling of her materials amounts to a profound understanding of the plain style."[6]

Joel Sternfeld's photographs of the intrusion of "America the Banal" upon "America the Beautiful" are so visually sublime that considerable tension ensues. Factual representation spars with visual presentation, signaling the ironic mode.

His sensual pictorial schemes appear impervious to the significance of the narrative unfolding within his frame. Indeed, the compositions often camouflage poignant events, rather than punctuate them. A fireman, who apparently steals pumpkins from a farm market while the farmhouse burns, functions as one of many yellow-orange coordinates in the image's formal arrangement. (plate 109) Carcasses of whales, beached along the Oregon coast, are tiny, barely identifiable shapes in a photograph that emphasizes expanses of sand, sea, and sky. (plate 110)

In a Sternfeld photograph, all facts are presented with equal meticulousness and apparent emotional distance. Though the body of his work reveals cognizance of multilayered narrative, literary, and historical contradictions, Sternfeld himself might be morally ambivalent, disapproving, hesitantly hopeful, or merely uncertain. Because he presents us with the very evidence that he continues to sort out for himself, his images seem to document the 1970s—a decade in which strident, unequivocal positions gave way to accommodation of differing viewpoints.

Visual strategies, though never directing attention to crucial ironic narrative thrusts, reflect and even paraphrase this country's mellowing attitude. Strident primary colors, more appropriate to the emotionally and intellectually cacophonous decade of the 1960s, have evolved into harmonious pastels. Woven textural passages unify the most

discrete facts. Monochromatic roofs, skies, and roads moderate more intense hues that would otherwise predominate.

Sternfeld's method would seem to be more gracious than the obtrusive procedures of 35mm street photographers. His cumbersome 8 × 10″ view camera and tripod impede fluid mobility, making it difficult either to lurk in hiding or insert himself into the thick of things. Rather, he must remain at a polite distance or inspire his subject's trust and cooperation. The decorum shows in the prints; the results rarely suggest exploitation or deliberate misrepresentation for salient effect. Thus he achieves a mystique of factuality. Yet these photographs, like all photographs, must be carefully considered for all possible meanings.

Sternfeld neither ducks nor deprecates the contradictions found in the social landscape. For the most part he includes them as details—often such tiny details that they are found only after extended examination of the print. To note the ''luna-cy'' of a moon on a portable outhouse or a bird painted on the side of a building while kites fly in the sky is to laugh at a witty aside; it enlivens the discourse, but does not determine the photograph's full meaning.

Signs often seem oddly oxymoronic or utterly inappropriate, yet Sternfeld declines to enforce our preconceptions. A gas station offering a ''mini-serve'' island seems indicative of the decline of courtesy and care, yet Kwikness here does not necessarily connote cheerless carelessness. ''Meadowwood,'' a name typical of many a tract home development where the meadow was paved over and the woods reduced to newly planted saplings may have its woodland heritage intact or nearly grown anew and retain its meadow as a commons.

At his best, Sternfeld pushes ironic detail into the realm of complex discourse. Depicting a bicyclist cruising along a wooded road, he restrains the obvious impulse to ridicule the slick, sleek, supergraphic, mass-marketed, make-a-buck-on-the-back-to-basics-physical-fitness-fad jogging suit worn by the cyclist. Instead, the rider rests astride his bike like an alert pheasant, somehow emulating an authentic woodland denizen. A nudist in jogging shoes, bending in the woods, seems less of an eccentric acting out nature-loving fantasies than a genuinely harmonious inhabitant—as though the countryside might be full of the likes of Puck and Pan. If, as Gore Vidal proposed, we become what we seem, nature may yet regain purity.

Then again, sensibility and technology may have already merged. Leslie Fiedler, noting that psychedelic drugs are synthetically manufactured, has presented a vision of a future in which sensuous pleasure, art, and culture are no longer in alienated opposition to technology but in harmony with it.

For Fiedler, the polar antitheses which have marked the history of American culture—such as the primitive ''redskin'' West versus the rationalistic, mechanized ''paleface'' East and the Pastoral Garden versus the Machine—are reconciling. In his opinion, Americans will no longer need ''to pursue some uncorrupted West over the next horizon'' but will ''make a thousand little Wests in the interstices of machine civilization on its steel and concrete back'' living the ''trivial life among and with the support of machines.''[7]

If Sternfeld's works sometimes suggest Fiedler's reconciliation of antithetical forces, they more often contain some horror, which, though susceptible to various, multi-

Plate 107 Joel Sternfeld

170

Plate 108 Joel Sternfeld

171

leveled interpretations, seems not to offer much hope. Consider the photograph of the fire. *(plate 109)* What could better represent America's moral decline than a fireman (that nineteenth-century American symbol of rough-and-ready rectitude) pilfering pumpkins while a house burns? But such an assessment—so editorially fortuitous and morally horrible—bucks belief. Another echelon of explication, initially more tolerable yet ultimately as disquieting, emerges: Perhaps the house occupies land sold to a developer who plans to turn the farm into profitable parcels. Cognizant of the ways to proclaim his civic virtues and abet government approval of future land abuse schemes, the developer may have offered the farmhouse to the local volunteer fire company for a practice pyre. The pumpkins perused by the fireman might be a legitimate purchase for his 2.3 children, or part of the developer's afternoon attractions, or leftovers from a recent spree of vandalism. Nearby smashed and rotting pumpkins celebrate a hollow, lean world, bereft of moral and physical tradition.

Sternfeld counters the myth that humans can discover themselves and God in the "trackless wilderness" with a luminous desert scene marred by tracks inexplicably left by inanimate boulders. *(plate 106)* An unbeneficent nature may be rolling things, rather than "rolling through things" as was the Wordsworthian view. Or the tracks can be interpreted as the seemingly pointless result of human progress. The photograph speaks less of God's eternal presence than of the eternal presence of the moment recorded. Thus Sternfeld uses the very act of photographing to elevate the ironic discourse. By alignment of two boulders, the large Saguaro cactus, and a gnarled bush into an essentially rectangular constellation, Sternfeld creates a meaningful, self-sufficient universe where nature has been restituted through art.

Sternfeld's photographs often suggest mystical visions. Industrial complexes (parks, as they are ironically called) seem particularly apparitional, out of context, even when logic tells us that their mystery devolves directly from fog or mist. When emerging in triangular formations, they seem aloof, ageless, and uncompromisingly present—industrial pyramids, testaments to the spirituality of progress. *(plate 107)* Our knowledge of commercial architecture, whether impersonally plain or pretentiously gew-gawed, makes the impression ring ironically. But one might also recall the enthusiastic excesses of the American Futurists who similarly saw and foresaw the wonders of progress. Joseph Stella's meditations on the Brooklyn Bridge seem particularly pertinent: ". . . .a weird metallic apparition, under a metallic sky . . . a shrine containing all the efforts of the new civilization of America—the eloquent meeting point of all forces arising in a superb assertion of their powers."[8]

Photographing the space shuttle *(plate 108)*, a true technological wonder, Sternfeld fuses near and far planes so that the balding, paunchy man in the white undershirt becomes a Blue Collar God beholding the miracle of the shuttle and positing a great grand future for the attendant crowd of Lilliputians.

For realist writers, inclusion of extraordinary events are even said to be improper. As Susan Fromberg Schaeffer writes:

While everyone at one time or another will mouth the truism that truth is stranger than fiction, few people

are actually willing to allow reality the variety, sometimes the shocking variety of which it is so demonstrably capable. Reality as they conceive it, does not allow for these aberrant events.[9]

Most art photographers share this attitude, leaving disasters to photojournalists willing to serve up sweeping summaries for immediate, vicarious delectation and voyeuristic consumption. Though Sternfeld photographs floods, volcanos, and the beaching of the whales on the Oregon coast, he avoids sensationalizing, in order to encompass natural ironies and suggest metaphorical possibilities.

Mr. and Mrs. America wear gas masks, not because of foreign invasion but as protection from volcanic fallout. A blue car, seemingly cast away in a bulldozed hole, is not tragi-comic evidence of instant obsolescence, but of a recent major flood. (plate 105) Amid the debris of a tornado, wrecked house, a refrigerator stands intact, packed with food products, like a monument to the industrial state's inability to provide protection against natural disasters.

Photographing the beached whales (plate 110), Sternfeld tells us nothing about rotting carcasses, stench, barking dogs, or bursting flash cubes. We are unable to discern drunks walking up and down the whales' backs or men ready with saws who intend to cut out the teeth for scrimshaw. From the vantage point of Sternfeld's lens, the scientists gathering evidence or attempting euthanasia are indistinguishable from the volunteers seeking to save the whales, or the policemen staving off the curious crowds.

The minimal evidence he does provide seems alien to the documentary tradition, yet the tragedy was an incident where mountains of amassed data led to few firm conclusions. Public opinion persists in the belief that either the whales' navigating systems went haywire as a result of chemicals polluting the ocean, or that they committed mass suicide, either in protest of those same pollutants or of their own slaughter by commercial whalers. Yet no definitive evidence implicates the industrial state, and whales have inexplicably beached since the time of Aristotle's Historia Animalium.[10]

To attribute human purposes to the whales is to open up the incident metaphorically in a way reminiscent of the tale of the elephants told by James Agee in his last letter to Father Flye.[11] Agee there proposed a film plot beginning with a no-longer omnipotent god informing the elephants of Africa that they were entering a new age in which they would be "taken to be looked upon, to be regarded as strange and wonderful, and my dear ones, as funny." Having heard the word, the oldest of the elephants left the assembly to die. Others were captured for circuses to suffer the tragic fates of Old Bet, Jumbo and Tennessee Mary. Agee concludes with an episode in which thirty-six elephants danced in pink tutus for George Balanchine, despite their embarrassment and shame. That night the wisest of the elephants deliberately dropped a lit cigar butt into fresh straw. With the elephants death, came the "peace that passeth all understanding."

Sternfeld's placid lyrical photograph in which the dead whales appear as black glyphs on beige sands, similarly evokes bittersweet reaction and spiritual blessing. This photograph, as well as many other of Sternfeld's images, seems to elegiacally sum up our civilization.

Plate 109 Joel Sternfeld

Plate 110 Joel Sternfeld

175

Kenneth McGowan parodies and mythicizes California phenomena from movie stars to body builders. McGowan includes a bit of good natured bizarrerie, of witty exposé, yet his art transcends shallow justaxpositions and recalls Baudelaire's essay in which he extolled the humanness of the cosmetic. McGowan exploits the falseness that we know to be true. The advertising image, whether for steak or stars, is very real, however hyperbolically distorted. "Steak Billboard" *(plate 118)* is so graphic and vivid that it seems to have literally sucked the color out of the "real" world around it.

The current obsession with physical fitness certainly generates sufficient zeal to qualify as a secular religion, which McGowan parodies in his photograph 'Yoga." *(plate 119)* A Caucasian yogi stands on his head, but the photograph's spatial condensation and McGowan's crafty alignment converts him into a saint crucified upside down, a martyr who seems hung by his ankles from the chinning bar that is actually behind him. The cross at the image's top right reinforces the parody of Christian iconography.

In "Float" *(plate 120)* McGowan's allusions refer to the contrived majesty and exaggerated masculinity of the warrior heroes proliferated on the covers of sword and sorcery novels by illustrators like Frank Frazetta. McGowan's camera transforms this parade float into a garish dais, staging a peculiar ceremony. The incongruity of the muscular male arm that seems to protrude from the woman's chest is of less significance than the stridently still, monumental, and alien character of the whole scene, in which McGowan has deliberately excerpted color, shape, figure, and action from a larger context in order to reveal the primitive pageantry beneath the artifice of contemporary celebration.

In "Azaleas" *(plate 121)* a trio of tourists stand meekly, as if in awe—as a futuristic scape of ground, buildings, and sky extend around and before them. The clouds seem to contain elusive godheads, alternately recognizable as cherubim or sagacious male faces. Yet the scene's sheer visual beauty and drama far transcend any simple mockery of Los Angeles as the embodiment of man's apocalyptic destiny and confused values. Instead, a genuinely mythical quality predominates.

In Hollywood, the tradition of unreality persists. McGowan coopts its various manifestations to flesh out his own fantastic visions. The candyfloss Elysium of a miniature golf course seems to revert to its mythical origins because McGowan's photographic rendition of diminutive, Disneyland style castles and gingerbread houses lends a graphic tangibility to its make-believe reality. Mother and child mammoths placidly stand beside Los Angeles' La Brea Tar Pits, seemingly as real, or as unreal, as the urban skyline beyond them.

Cibachrome is essential for the realization of McGowan's vision. Its garish "grabby" colors make the subjects more vivid than real. Its high contrasts result in shadows that produce a lurid, gothic quality. Its sharpness lends itself to surreal clarity. Furthermore, the print's shiny plastic surface reminds us of how commerce typically substitutes a flawless but debased surface for authentically sensuous, pleasing surfaces.

McGowan's visions dramatically demonstrate what Susan Sontag called photography's perverse relationship to reality. As she wrote: "Surrealism lies at the heart of the photographic enterprise; in the very creation of a duplicate world,

or a reality in the second degree, narrower but more dramatic than the one perceived by natural vision."[12]

William Eggleston's persistent search for an ethically conscious vision is encapsulated in the title of one of his limited edition books of photographs, *Morals of Vision*.

The word "morality" so often connotes pretentiousness, hypocrisy, or self-righteous oppression that most artists would refrain from using it. But for Eggleston, art is not a morally indifferent activity. He maintains the romantic position that art can affirm life, unseat complacency, and indict mediocrity.

Eggleston's determined striving bears little relationship to the tinsel romantic's indulgent wallowing in picturesque and emotional cliches. Instead, Eggleston might pray as did Faust, "All mankind's portion I want to feel within myself, seize with my soul the highest and the lowest, its joys and woe." Furthermore, in his imagery the entire ego is exalted —not merely the emotions but also the mind—for a completeness of expression.

Unlike Romanticism, Classicism (which is to say most formal works) fastidiously discriminates and excludes. Jacques Barzun's definition of the distinction between the two attitudes pertains: "The geometrician works in a closed universe limited by his own axioms and definitions. The Romanticist works in an open universe limited by concrete imperfections—imperfections which have not all been charted, which may change and which need not be the same for all men—classicism is thereby stability within known limits; romanticism is expansion within limits, known and unknown."[13]

Eggleston's apparent openness to every possibility the world offers has led him to a style that is more illuminative than creative. His works are sufficiently factual to be evidence in court. Curiosity, the trait T. S. Eliot found "most permanent and good in Romanticism" supplies much of Eggleston's motivation. "A curiosity which recognizes that any life if accurately and profoundly penetrated is interesting and always strange."[14]

Eggleston's works contain the inexhaustible potential for speculation that the world itself invites. Likewise, they complicate elucidation with multilayered possibilities that can never be utterly resolved.

Place names identify Eggleston's photographs. He seems to believe that specification of place allows meanings to accrete—particularities enlarge into generalities while retaining their identities as specific entities. Like the Southern author William Faulkner, Eggleston may provide maps with his groups of photographs. One literary critic writes of a conviction "firmly held and hotly argued" by many of the best Southern writers:

> . . . the land is sacred, that the really moral life is one lived in close relationship to it, that the land should not be "violated" (i.e. that Nature should neither be ignored, exploited, nor viewed abstractly) and that violation of the land is a major sin, for which there were major punishments.[15]

But the particulars of Eggleston's realism hold history, romance, and allegory together in precarious synthesis, bridging the world of discrete facts and the patterned, economized world of imagination. His early works are the most balanced in this regard.

Plate 111 William Eggleston

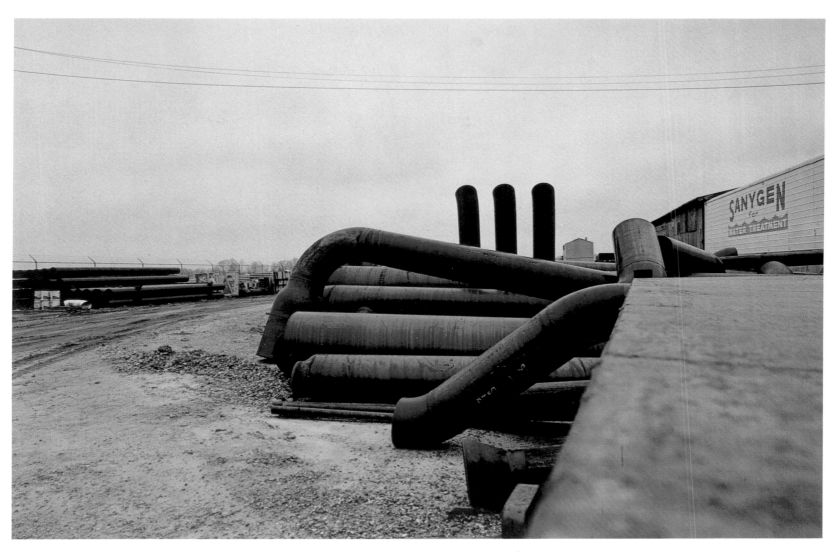

Plate 112 William Eggleston

179

John Szarkowski has demonstrated the rich interpretative possibilities of the photograph "Southern Environs of Memphis" (plate 2), which was analyzed in Chapter 2 for its formal properties. Szarkowski suggests that we:

Think of it as a picture that describes boundaries; the boundary between the city and the country, civilization and wilderness, the fail-safe point between community and freedom, the frontier of restrained protest or cautious adventure. And the boundary between the new and the old, the new neighborhood advancing into the old land, but the neighborhood itself not so new as last year, the house in the foreground no longer the last in the line, and the '56 Buick that stands by its doors already poised on the fulcrum of middle age, still well-shined and well-serviced, competent and presentable but nevertheless no longer young. And the boundary that separates day from evening, the time of hard shadows and yellow heat from the cool blue opalescent dusk, the time of demarcation between the separate and public lives of the day and the private communal lives of evening, the point at which families begin to gather again beneath their atavistic roofs and the neighborhood sounds with women's voices crying the names of children.[16]

Eggleston often reveals the malign clues and flaws that peek through the scrim of normalcy. Though he hardly shares the black comic vision of Thomas Berger, he might agree with him that Kafka "taught me that at any moment banality might turn sinister, for existence was not meant to be unfailingly genial."[17]

Powerful inquietude achieved through pictorial ambiguity is displayed in "Memphis" (plate 1), which was also examined previously for its formal properties. Eggleston seems to have arranged an allegory about the failure and renewal of life, or about good and evil, or the corruption of innocence. Sinister forces—the brooding symbols of the car, figure fragment, and the brazier—surround the child's small bicycle, which is the green of newly sprouted leaves. The large motifs are formidably dark, amplifying the hits of hot color they contain. They stand so threateningly near the camera that the frame partially eclipses them. In addition to the bicycle, their obverse is represented by the struggling patches of grass. So much soil shows through and around each clump that its hold on life seems precarious, just as the diminutive bicycle appears threatened by the masses looming around it.

Oil cans, cast about on dry land and in mud puddles, indicate "Troubled Waters," (plate 111) the title of a portfolio in which they provide the key image. Another from this series depicts frozen foods in an ice clogged freezer. This is not the gothic grotesque of the stacks of perfectly preserved cats in a Truman Capote story, yet in the context of the other pictures, a sinister undercurrent cannot be ignored. Other works in the portfolio include a neon Confederate flag (plate 113) that glows luridly in the dark—a shocking, frightening presence in the night, and a taunting reminder of the destructive influence of the past upon the present in the contemporary South. A pinball machine, glittering with an eerie alien life of its own, helps denizens of the troubled waters region forget their oppressive reality. (plate 114)

Eggleston's image of a row of boxcars demarcating planes of sky and grassy field *(plate 5)* has often been cited as a photographic approach to minimalism. But Eggleston's pictorially static portrayal reflects more on the railroad's abandoned state and probable termination. The nineteenth-century symbol of power and progress then appeared to sensitive souls "in the woods shattering the harmony of the green hollow like a presentiment of history bearing down on the American asylum."[18] The inoperative cars may squat in Eggleston's "garden," but the asylum is hardly restored, nor does the present state of ground or boxcars foretell their resurrection.

In place of flowery meads, verdant vales, and mossy banks, Eggleston often represents grass and foliage that seem to be swallowing up civilization. Shakespeare's Gonzalo would have found few occasions, on examining Eggleston's oeuvre, to exclaim "How lush and lusty the grass looks." When Eggleston photographs weeds taking over gentle stains of earth or tree leaves and branches lashed together in agitated interlace, the fields of energy are less indicative of beneficent nature than of a cancer metastasizing down South. Brown rot or dryness creeps up on leaves, concrete is pitted and cracked, fields lie fallow, fences have rusted—suggesting that Eggleston's vision is sometimes apocalyptic, involved with the Four Last Things—death, judgment, heaven, and hell. *(plate 115)*

Sometimes Eggleston seems to be pantheistically worshipping ground, sky, and atmosphere. In his book *Wedgwood Blue*, he points his camera at sky and clouds in an investigation of unmoored spaces, the topology of clouds and the color blue. The book's epigraph, a William Butler Yeats poem, suggests a desire for "the cloths of heaven, enrought with golden and silver light."

In the same spirit, the final image in *Morals of Vision* contains a little girl with flowers and a little boy whose innocent gestures suggest God's presence. Though each portfolio includes works suggesting a darker vision, these are haunting images, swelling with ineffable meaning.

These photographs remain attentive to the actual, particular subject. Eggleston mirrors his own era while creating metaphysical poetry in a time when most artists seek either to sequester their emotions in ideological discourse or squander feeling gratuitously without regard for insight or articulation.

Color is always an expressive force in Eggleston's work, but in many photographs he escalates its impact. Expressionist painters often use color aggressively but usually distort every other phase of representation as well. Eggleston consistently retains descriptive legibility and cohesion. His sense of his own purpose differs little from that elucidated for Southern fiction writers by Flannery O'Connor:

. . . to know how far he can distort without destroying, and in order not to destroy, he will have to descend far enough into himself to reach those underground springs that give life to his work. This descent into himself will, at the same time, be a descent into his region. It will be a descent through the darkness of the familiar into a world where, like the blind man cured in the gospels, he sees men as if they were trees, but walking. This is the beginning of vision, and I feel it is a vision which we

Plate 113 William Eggleston

Plate 114 William Eggleston

in the south must at least try to understand if we want to participate in the continuance of a vital Southern literature. I hate to think that in 20 years Southern writers too may have lost their ability to see that these gentlemen are even greater freaks than what we are writing about now. I hate to think of the day when the Southern writer will satisfy the tired reader.[19]

Many Eggleston photographs make palpably real the heat and tensions of the South. His color is often syrupy and saturated, quite unlike the reserved, restrained combinations of neutrals and rich hues so fundamental to the aura of ostensible detachment in Stephen Shore's work. Eggleston's subjects and surroundings sometimes seem virtually embalmed with an intense saturation that projects a darkly disquieting, even sinister character. Such images seem cloying and claustrophobic, as though revealing sites of immanent tragedy. Lacking light and air, they metaphorically lack faith and hope.

The old man in plate 116 may be dotty or dangerous or both, but the relaxed familiarity with which he handles his revolver suggests a horrifyingly offhanded intimacy with violence and its tools. Eggleston's presentation of pattern and shape seem metaphorically dark and sardonic, with predominant concentrations of black, charcoal gray, and blood red underscoring the old man's casually threatening expression.

Photographing in the night air *(plate 57)* Eggleston's film and flash costume the skies and land of Memphis in lurid lavender and eerie green just as the three children are themselves costumed for Halloween. The family snapshot effect of the children's arrangement draws on the myth of the "folk soul" in which common people hold mysterious, dormant powers.

Eggleston's luridly anthropomorphic view of a courthouse at Christmas time *(plate 58)* manifests a vision alien to the official concept of the impressive dignified repository of justice. Preconceptions collide with Eggleston's delivery in a manner that recalls Faulkner who, in *Requiem for a Nun*, considered the fusion and confusion of ethics with law. The courthouse—the symbol of human dreams of secular moral perfection also effects their destruction. When the *idea* became entombed in magnificent architecture and concrete, living human values were partially buried with it.

In declining the realist gambit in order to pursue a higher fidelity to consciousness and the unconscious, one risks becoming more contrived than inspired. But process rarely dominates Eggleston's imagery. Instead, bizarre effects suggest an ordinary life steeped in the supernatural, that there are facets of existence beyond the accounting and speculation of positivist philosophy.

Eggleston's work has supplanted the self-sufficient artwork with organically welded groups of photographs intended to be experienced in a book format. The effects can be almost incantatory, with individual photographs providing interdependent statements that contribute to an aura of feeling. Flashes, fragments, and snared moments ultimately cohere. By proceeding in such an indeterminate and dynamic manner, Eggleston appears to be tapping what William James called "invasive experiences"—upsurges of subliminal energies into the conscious mind. Formalism,

an act of will, would dam that flow. Eggleston might well agree with Willem de Kooning who said, "I think it is the most bourgeois idea to think one can make a style beforehand. To desire to make a style is an apology for one's anxiety. Style is a fraud. I always felt that the Greeks were hiding behind their columns."[20]

In his latest work—photographs of Africa—Eggleston has traveled far from the places and people he knows and immersed himself in a living nature of jungles and flowers. From a perverse, visual song of the South, he has ventured outward. With Faust he might declare, "Let us hurl ourselves into time's dynamic sweep."

Plate 115 William Eggleston

186

Plate 116 William Eggleston

Plate 117 Kenneth McGowan

Plate 118 Kenneth McGowan

Plate 119 Kenneth McGowan

Plate 120 Kenneth McGowan

Plate 121 Kenneth McGowan

CHAPTER 7: **ENCHANTMENTS**

Many color photographers seek enchantment in and through their art. Conjuring imaginary worlds and ideal states, they provide visual refuge from the trivia of routine conflict and disappointment, as well as larger questions. Their images range from the sheer sensual strokes of the world's visible beauty to suggestions of magical, alternative scapes where grime is unknown and physical laws seem not to apply.

Although often reworking and revitalizing the picturesque mode, they all seem to refuse acknowledgment of "the view" which Harold Jones calls "the intimidated landscape, a caged garden. . . ."[1]

Control of form is vital to achieve fantasy; gradation and nuance provide this control. Patterns of visible events, designed to move toward climax and resolution, must be counterbalanced by patterns of events designed to delay this climax and resolution.

Just as important in keeping fantasies from deteriorating into sentimental mush is solidity of specification. Shimmering chromatics that arise from precisely recorded detail seem far more inscrutably magical than the blurry sensationalism so frequently preferred in the name of emotion or imaginative provocation. When the wonderfully improbable derives directly from the world's clear facts, criticism is disarmed and credibility established, inducing us to share willingly the artist's vision.

The intensity of these photographs is, as T.S. Eliot observed about poetry, "something quite different from whatever intensity in the supposed experience it may give the impression of." The effect of the work is "different in kind from any experience not of art." The "significant emo-tion" rests in the artwork.[2] That these photographs ring with notions of the ideal is less significant than the charismatic charge deriving from ideal structural fusion.

Ben Lifson has applied W.H. Auden's method of understanding poems to photography.[3] To Auden, poems invoke either the stance of Prospero, the moralist-magician hero of Shakespeare's *The Tempest*, or the attitude of Prospero's attendant spirit, Ariel. Prospero wants a poem to be true, but then it must include the problematic, the painful, the disorderly, and the ugly. Only then can it provide the sort of revelation that will define life accurately, dispelling "self-enchantment and deception." Ariel, on the other hand, wants a poem to be beautiful, a timeless world of pure play, which gives delight precisely because of its contrast to historical and material existence. While in most poems the two stances mingle, poems are usually Ariel-dominated or Prospero-dominated.

The photographers in this chapter cultivate the realm of Ariel, typically avoiding the realism frequent in other approaches to serious photography. They might agree with Oscar Wilde's Lord Henry Wotton that "the man who could call a spade a spade should be compelled to use one."[4] In a time of excessive critical self-consciousness, they behold the world with wondering, expansive appreciation.

Joyce Culver is concerned with what Syl Labrot called the "iridescent nature of colors which seem to live in an object."[5] Taking advantage of the ability of chromatic intensity to upset the spatial order established by tones, she inflects fields of color with selected notes of vivid chroma.

193

Plate 122 Leo Rubinfien

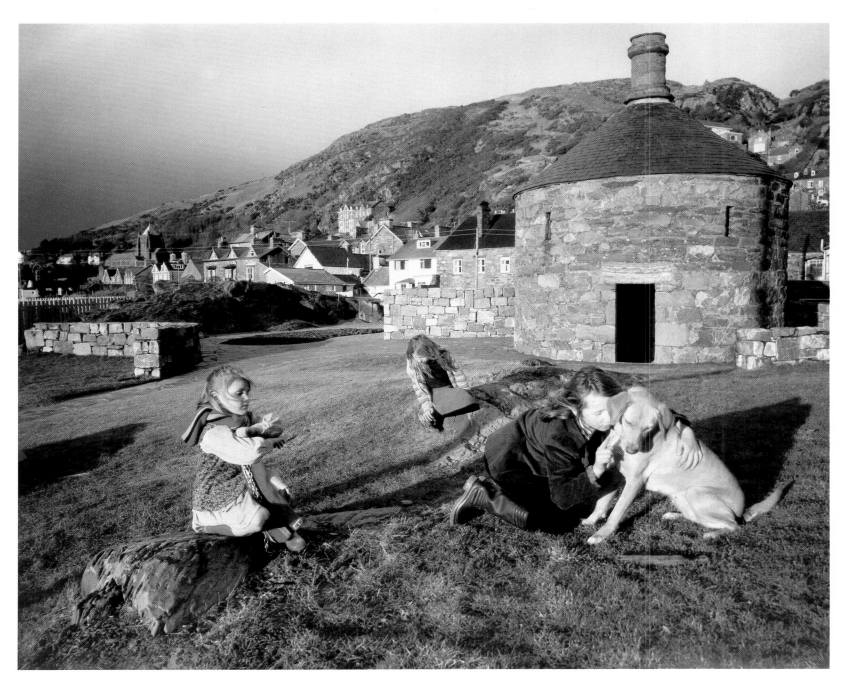

Plate 123 Leo Rubinfien

In plate 126 blue leaves and purple grapes painted on a cast-iron fence seem to detach and dance upon the picture surface.

Such color oscillations subvert the representation of natural space. Culver uses the resultant *non sequiturs* for abstract and occasionally narratively suggestive purposes. In plate 127 red and white Christmas tree ornaments on an evergreen tree, postal stickers on two mail boxes, and the crimson berries on a hedge provide color-keyed counterpoint to a fantasyland aura. The Christmas tree inclines toward a light post while one of its branches seems to grasp at the white rim of the post's rainguard, which, in turn, tilts as jauntily as the brim of a Southern gentleman's fedora. A white-boled palm tree, rising from behind the hedge, injects the spirit of Christmas in Florida or even suggests a studio set constructed to showcase Ronald MacDonald and his friends for a Floridian version of Christmas in Burgerland.

In a less pixyish image than Culver's, **Leo Rubinfien** records bright blotches of cast light that mottle furniture, floor, and wallpaper, dissolving surfaces and contours, sabotaging the sobriety of ordinary spatial illusion and inflecting the scene like apparitional presences *(plate 122)*. Rubinfien's room in Wales thus suggests a shrine, complete with elfish annunciations.

Rubinfien also uses consonances of figures and landscape that allude to the savory sensations of pure being or emphasize the ecstasy of simple actions harmonized by the accompaniment of enchanting surroundings.

In Barmouth, Wales *(plate 123)* sunrays seem to melt like honey on the triangular constellation of figures whose gestures enact a sublimely peaceful communion with the moment represented. The sweep of the distant hill and crisp, earthy greens of the low grass join with sunstruck stone to complete a picture of emotional bliss. Rubinfien's orchestration of vast fields of neutral chroma enriches the sparkling incidents of red and rich tan, providing purely visual sensations that are as emotionally rewarding as his narrative.

A more electric, simultaneously secretive mood invests Rubinfien's image of an artfully foliated slope in Tokyo. *(plate 124)* A solitary man sits just within the frame's lower right edge, beating a small drum held between his knees. Rubinfien's composition directs primary emphasis away from the diminutive drummer and toward the lush slope, reinforcing the sense of seclusion and secrecy that envelops the solitary figure's nocturnal performance.

Adam Bartos's virtually monochromatic image of a solitary column in an Egyptian garden *(plate 125)* seems suspended in a brittle, remote, eternal moment. The picture's frozen quietude conjures a realm of appealing, serene detachment—a refuge that we may long to enter but which remains too distant to permit our approach. The oddity of the powdery-surfaced, pinkish-gray column's protrusion from the center of the circular planter—and the bright door visible through the vined archway—contribute to the cryptic and exotic intrigue of the scene.

Like Joel Meyerowitz, **Len Jenshel** and **Mitch Epstein** seem to function like "Aeolian harps" responding when strummed by the exceptional confluences of the world's appearance. Using hand-held, 6 × 9 cm. cameras, they are able to cruise fluidly in search of their subjects, reacting with greater

rapidity than a large format camera would allow. Meyerowitz, once moved to photograph, must carefully construct his pictures from the sobering, stationary vantage point of his 8 × 10″ view camera. But Jenshel and Epstein shoot intuitively and omnivorously, navigating through realms of subject matter with the mobility of fighter planes in search of an appropriate target. Despite such emancipated procedures, they frequently incorporate visually unifying strategies that include color-field wefting or fuguelike repetitions, inversions and transformations of particular motifs.

Jenshel prefers curvaceous, man-made elements that flow or sweep into ocean or sky. His framing may complete a tumultuous event or create one. His cropping reflects considerable regard for formal design, but his vantage point rarely addresses a clear horizon frontally or measurably. Although his compositions are often asymmetrical, he tends to balance dominant shapes on one side of the rectangle with concentrations of visual intricacies on the other.

Jenshel's appetite for sumptuous visual material often comes close to excess, but he warily incorporates devices that mitigate unbridled surpluses of color or sentiment. When he shoots a road, it may appear more blue than neutral gray, but this is so it can flow uninterruptedly into the sky. (plate 129) Rather than assume a calendar photographer's tack of filling the frame with the melting amber hues of a sunlit hilltop, Jenshel enlists a more distant outlook that includes shadowed roads, telephone poles, suburban houses, and road signs. Such man-made clutter congeals into textural clusters of cool hues offsetting the richness of the distant hill and tying the scene to a less ecstatic context.

He embraces blue/orange color schemes because they supply a chromatic charge equal to the dramatic sweep of his organized, interlaced motifs. But his passion never seems to produce abrupt, disjunctive, or spatially incoherent contrasts. He maintains sufficient detachment to ensure that every flickering nuance of light, selected for its emotive power, retains its factual aspect as well.

As Ben Lifson wrote, "the huge patches of delicate, diffuse and subtle color spread out in his skies as slowly and sweetly as the tunes in Schubert andantes."[5]

Jenshel's works demonstrate photography's potential in the romantic, picturesque mode. The formal play is relaxed. The forms unfold gradually but ineluctably, while colors shift into delicately nuanced and often improbable variations. Such melifluous features prolong the pleasureable act of seeing, caressing imagination while reviving subconscious yearnings for paradisiacal worlds of milk and honey.

Jenshel presents children as unself-conscious innocents. (plate 132) He offers us the opportunity to live vicariously and opulently (and, in our fantasies, trouble-free) amidst the manicured shrubbery and magnificent mansions of the very, very rich. (plates 128, 133)

Although he refrains from providing wholly articulated dream worlds, he loves to proffer the solitary metaphor. The distant electric towers in plate 130 perch like steeples of some sun-blessed cathedral.

Jenshel's interest in symbols of decay and death in some of his earlier work sometimes seemed reminiscent of Caspar David Friedrich, but his image of a half-drained swimming pool, guarded by a broken fence and a solitary tree, seems less of a memento mori to sun-loving Californians than the storm-ravaged oak was to German pagans. Jenshel's re-

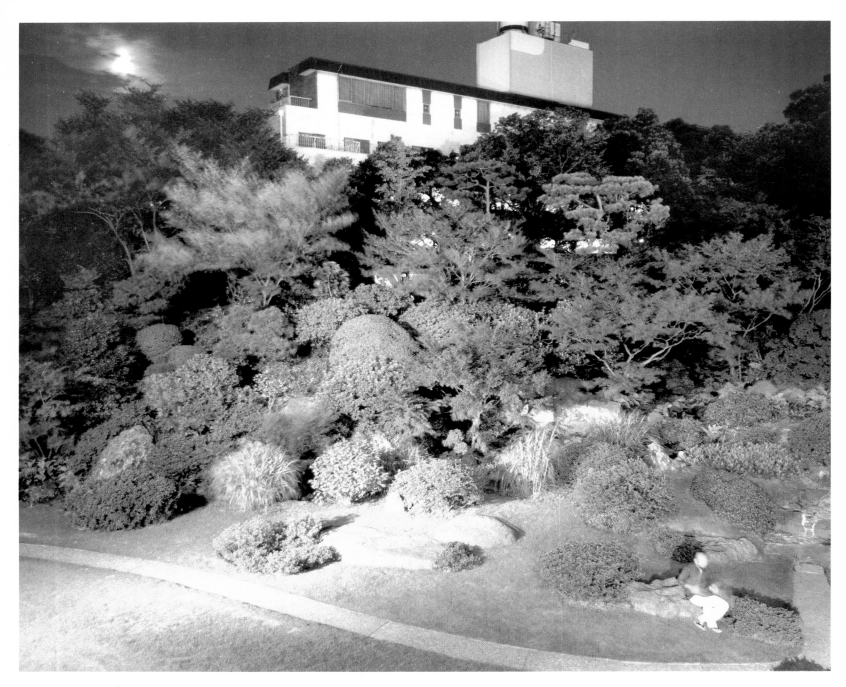

Plate 124 Leo Rubinfien

198

Plate 125 Adam Bartos

minder, with the setting sun's last rays tinting clouds that hover over gently rolling mountains beyond the pool, seems somehow poignantly sweet and unthreatening.

Mitch Epstein's photographs reflect the playful fantasies and meditative wonderment of an American abroad.

Epstein's record of his travels to foreign lands invite inevitable comparisons with *National Geographic* and travelogue photographs. Although similar subjects seduce him and he generally excludes evidence of the polyester and plastic society, Epstein avoids the quantitative values of supersaturated color and extreme contrasts typically tied to travelogue-genre "expressivity." A full range of neutral hues buffers exotic colors, preventing the bazaarlike cacophony so typical of color photographic journalism. Objects in Epstein's photographs may be sun blessed, but they are never gilded.

Aesthetic preoccupation coexists with emotive involvement. Viewed from a distance, many of Epstein's photographs do not break up into disjunctive patterns; textures blur and bleed into each other as in plate 137. Or Epstein's expert formal harmonizing may culminate in a sublime pictorial moment. In a photograph taken at Pohkara, Nepal *(plate 135)*, a diagonal row of clay pots leads to a crackling center of orange blossoms that sweeps, in turn, to orange-tinged clouds. Green grass on each side modulates to a yellow-green—the necessary chromatic force to make the blossoms glow. Grays in the sky echo neutrals of the ledge; the white hat of a worker repeats the snowy peak of a distant mountain. Having learned to regulate the chromatic torrents that Ernst Haas and others mistook for "expressivity,"

Epstein has made his passion more potent.

Each image is its own world, often a realm of fantasy. A statue of Pegasus, rearing from a pedestal in the Boboli Gardens, seems about to take flight. A windblown figure in white seems to float on a plaza in New Delhi like an apparition just emerged from a pervasive green mist. A monkey family and a human family coexist in harmony on a temple porch in Galta, Rajastan. *(plate 137)* A statue of Neptune with a trident is imbued with power only when seen as a reflection in his natural habitat of water, even though the sea has become a pool in the Boboli Gardens.

Epstein's sensitivity to ethnic gesture—the manner in which Indian men wrap their arms around their knees or the way a woman's bent arm curves as she balances a jug—accords with western notions of grace and beauty. The nearly mythical quality of Epstein's rendition of a camel caravan *(plate 136)* derives less from smoke-caused diffusion.than from an arrangement of figures that seems to realize the ideal structural possibilities of the photograph.

Imaginative takes can often be fashioned. In plate 137, saris drying on a hillside and sari-clad women first appear as spots of color spilling down a rocky face to culminate in turbans worn by men crouched on a temple porch. But some saris, laid over protruding rocks, seem to stir with burgeoning life as if they, too, may soon sit and stand in the manner of the Indian women. The blankets draped across supports in the caravan picture seem like some strange, two-humped beast, perhaps invoked by a genie in the smoke.

Epstein's view of an Upper West Side Manhattan park at night maintains some of the spirit of such fantasies but seems conspicuously more "high tech" in its use of flare

and glare (plate 139), as if Epstein exchanged an Eastern wooden flute for an electric guitar. Although his descriptions of tree limbs, cement steps, ledges, and a stone statue are informative and restrained, the harsh glare of a lamp provides the illumination that reveals the forms. Alternately lurking in the blue-green and magenta nocturnal gloom and looming eerily into the path of light, the branches sway like spirits brought to life for some secret ceremony, which only the photographer and the viewer may witness. The fantasy is crowned by a translucent, pentagonal shape that hovers like some spiritual manifestation at the edge of the lamp's white-hot center. This oddity is the result of flare, a technical fault produced when light shines directly into the lens, recording the shape of the aperture on the film.

Not all of Epstein's work is pure play. It is not unusual to find an undercurrent of psychic tension, which suggests that Prospero has intruded upon Ariel's realm. The figures huddled against pink ceramics in Egypt brood in shadow. (plate 142) A tower in Egypt suggests the shape of a gallows. An approaching storm in Jamaica implies the apocalypse: tree leaves have fallen, lounge chairs sit abandoned, and an eerie peach cement spreads like lava over steps, paths, and rocky terrain. (plate 141) While visually sublime, such photographs seem portentous, as if about to erupt with a cruel reality that will encroach upon enchantment.

David Hockney calls his photographs "holiday snaps," but when they go on exhibit, they become "photographic pictures." Although Hockney protests that they were taken in a desultory fashion, at their best they reflect his genius, at worst they are worthy notations for further exploration.

Hockney's paintings, drawings, lithographs, and etchings command most of his artistic attention. If he regards the camera less reverently than he values his pencil or brush, it is probably because the camera precludes his eccentric markmaking, forcing a partial shutdown of his prodigiously creative filtration system. Unable to include and exclude, accentuate and minimize according to his own eccentric bent, Hockney suffers from a clear functional handicap imposed by the camera's mechanical character.

He copes by modifying and containing his ambition. His photographs are virtually depopulated; no attempt has been made to match the trenchant characterizations and psychological duels of his most ambitious paintings. He includes fewer self-conscious plays with perceptual theory and the history of art, although curtains and mirrors bring up questions about "levels of reality."

But his penchant for extracting the world's lively, quirky decorative characteristics—and strategically reinvesting them as stripes and other patterns that inject reality's routine narratives with an infectious, eccentric chromatic vitality—is evident in his photographs, if less prominent than in his paintings. The wry wit that negotiates geometry and gesture, the odd surrealism produced by extreme visual quietude, and the graceful choreography of shape are Hockney's signatorial touches.

"Herrenhausen-Hanover" (plate 143) typifies his peculiar coupling of the picturesque and the bizarre. The cast stripes of shadows and the militaristic line of trees are so regular that a regimented clicking of heels is almost audible. This rigor is defused with the gumdrop colors and lush

Plate 126 Joyce Culver

Plate 127 Joyce Culver

textures. Both the mystery of the shadow's source and the extreme stillness provide surrealist overtones. But this is a surrealism disrupted by the wry twist of branches as though the trees defy the unnatural regularity imposed on their alignment and their lawn. Theatrical devices appear, though they are less obtrusive than in his paintings. The dense concentration of tree leaves cuts across the upper third of the picture's surface like a stage curtain. If lifted, there might well be a scenic attraction at the far end of the lane between the "marching" rows of trees.

The teasing curtain device appears again in "The Pines, Fire Island." *(plate 148)* Here matchstick blinds partially obscure an alfresco couple, setting up a Hockneyesque joke. While we, the viewers of the photograph, will not fail to take in the peep show, the bent-necked lamp in the room seems to peer away in embarrassment. Had Hockney raised the blinds to reveal the couple in brassy sunlight, explictness would have supplanted voyeurism. Instead, he employs the diffusing blinds to induce an air of eroticism, producing a more delicate, elusive, and subtle image.

Hockney's photograph of a line-up of orange chairs at poolside *(plate 145)* embraces repeating motifs, strong geometric structuring, Crayola colors, and quirky gestural details. The four chairs comprise a central tier in a spatial flow from top to bottom that cascades like a terraced water-fall. Each color, in turn, seems to bleed into the cumulative, free-form reflection in the pool. Always the sensualist, Hockney provides sumptuous visual sensations with movements into and out of different spatial zones as well as up, down, and around the photographic surface itself.

More dreamy yet wittily decorous is a view of wicker chairs lined up before a table as if awaiting afternoon tea. *(plate 144)* An ochre fedora with a blue band sits upon the blue and white striped cushions of each chair. The repeating shapes provide a progression from out-of-focus to in-focus while the tea service reflects and refracts other features of the scene. The scheme is comprised of cool, shimmering blues, ochres, and whites invested with fluid animation by Hockney's varied degrees of focus, thus infusing objects with a living quality independent of human mastery.

The wealthy trappings of laid-back California culture, with its swimming pools, deluxe bathrooms, parks, and tennis courts are known in the art world as Hockney territory; his dominion is as secure as Andy Warhol's patent on the soup can. Although his imagery describes a life of sensual pleasure, his photographs are most sensuous when least overt. Hockney's genius is that of reflex, triggered by the stroke of the world.

Plate 128 Len Jenshel

205

Plate 129 Len Jenshel

Plate 130 Len Jenshel

Plate 131 Len Jenshel

Plate 132 Len Jenshel

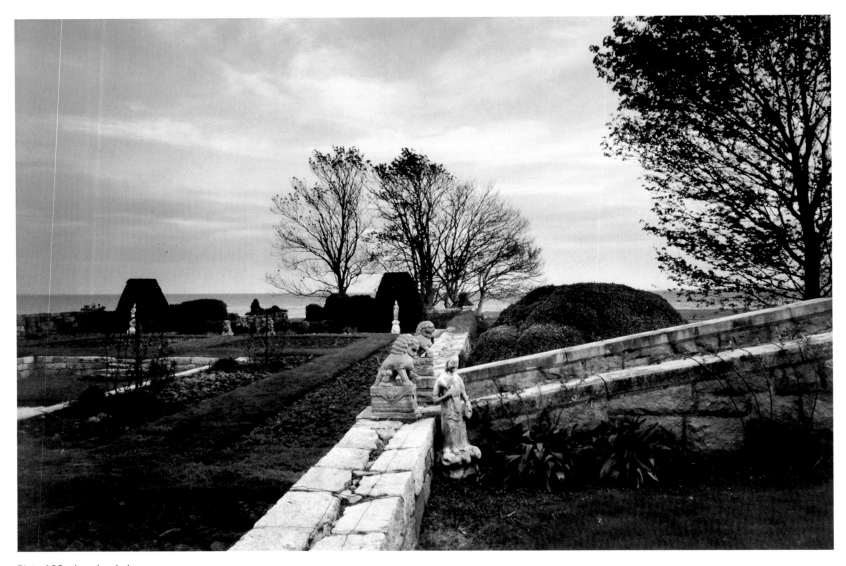

Plate 133 Len Jenshel

210

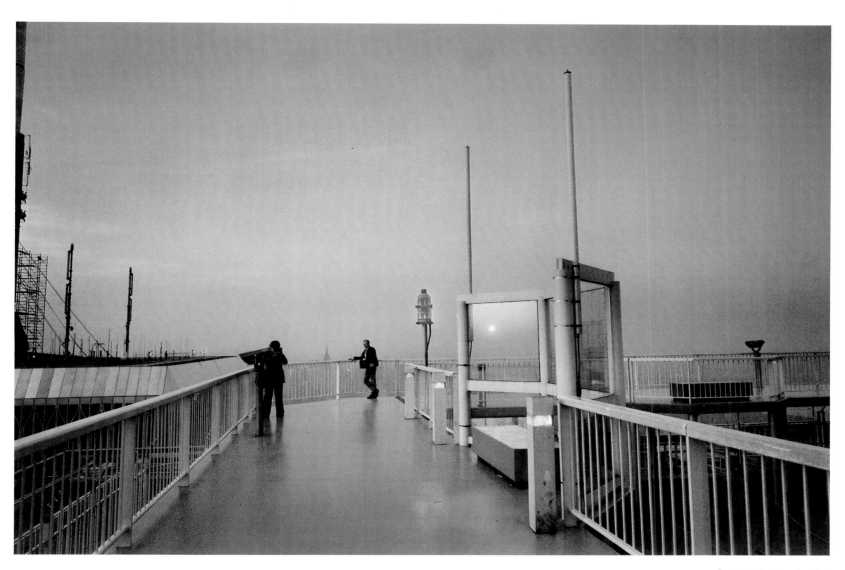

Plate 134 Len Jenshel

211

Plate 135 Mitch Epstein

212

Plate 136 Mitch Epstein

213

Plate 137 Mitch Epstein

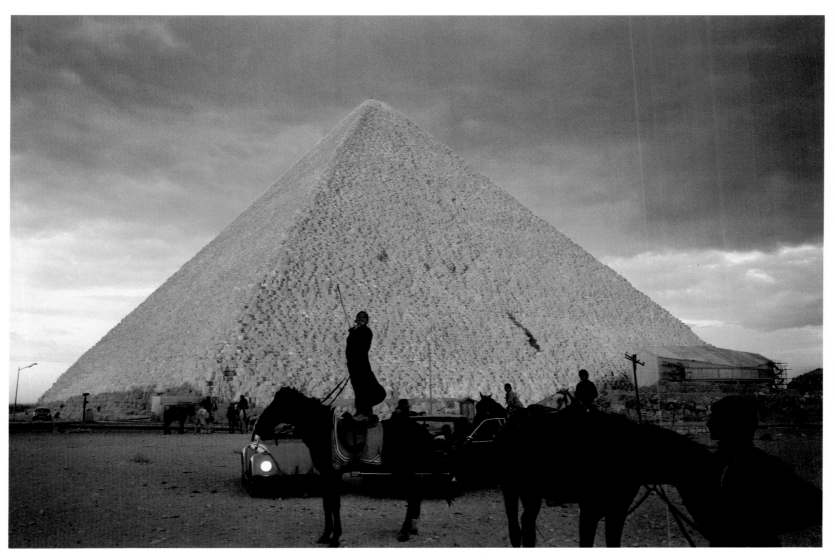

Plate 138 Mitch Epstein

215

Plate 139 Mitch Epstein

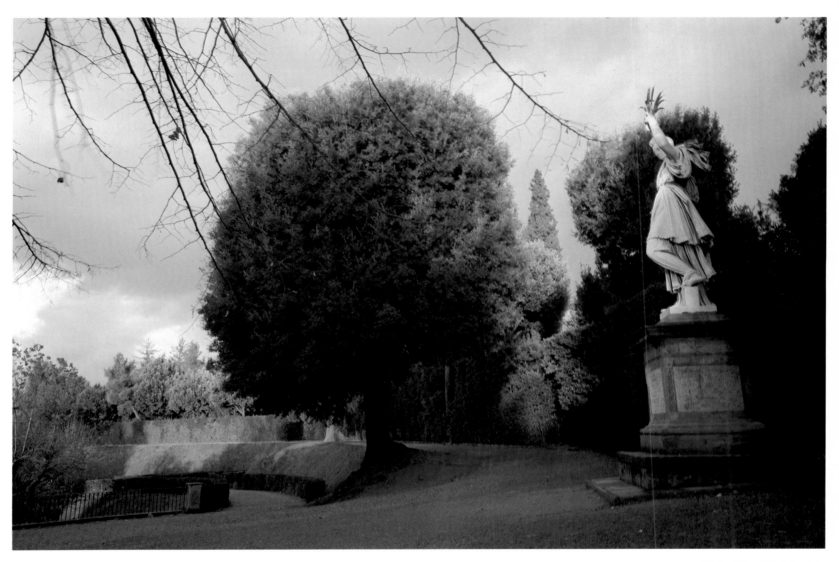

Plate 140 Mitch Epstein

217

Plate 141 Mitch Epstein

218

Plate 142 Mitch Epstein

219

Plate 143 David Hockney

220

Plate 144 David Hockney

Plate 145 David Hockney

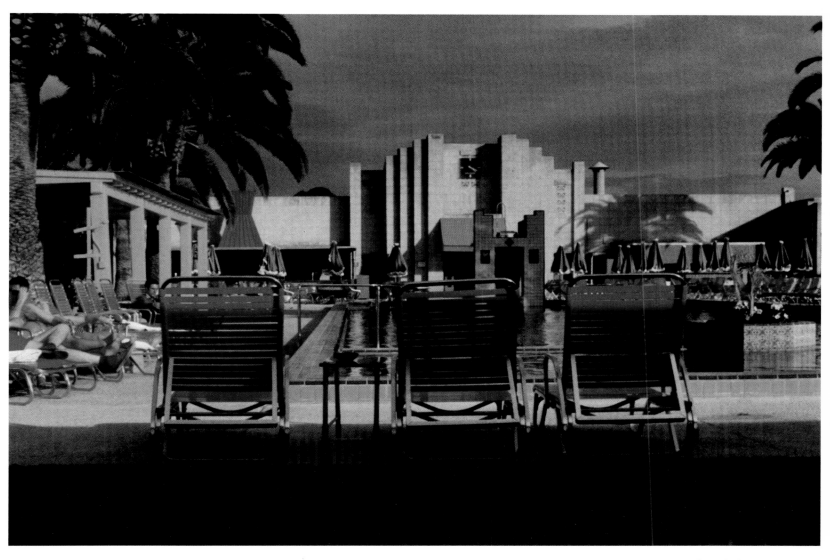

Plate 146 David Hockney

223

Plate 147 David Hockney

224

Plate 148 David Hockney

225

Plate 149 David Hockney

226

CHAPTER 8: FABRICATED FICTIONS

Photographers impatient or dissatisfied with the world's visual offerings often fabricate and then photograph objects and/or entire environments. Some observers seem to infer intellectual depth, toughness, and daring in the resultant images, more because such pictures defy the traditional, purist prejudice against directorial procedures in still photography than from intrinsic values detected in the individual works.

In fact, though studio conditions offer optimum opportunity to control every aspect of an image, few fabricators exercise this option to any significant extent. Most seem content with rather deadpan recordings of their frequently provocative subject matter, even though more ardent technical manipulations of every variable could well produce a photographic transformation of transcendent visual quality as well as emotive effectiveness. Although concern for purely plastic components is usually considered an exclusive preoccupation of formalist imagemakers, masterful command of visual events can precipitate the expression of fantastic or mythic content as eloquently as purely pictorial values.

Most fabricated fictions inadvertently testify to the expansion of narcissistic trivialization in the "Me Decade" rather than provide poignant perceptions of it. This nearly pervasive indulgence in uninhibited expression has manifested itself in innumerable recreations of dreams, cultivations of personal nostalgia, the coddling of identity crises, and puerile parodies of sacred shibboleths. Arranged more like informal visual diaries, scrapbook pages, or cliched collages than in effective, narrative form, these images seem to confuse the inconsequential for the universal, the cryptic for the profound. The intellectual exhibitionists among these fabricators offer fidgety little conundrums that seem intended as fables or morality plays about aesthetic activity, or they photograph profusely piled and overlapped reproductions of paintings, graphics, and photographs, as if "layered meanings" might automatically accrue.

Inventively exuberant at best, the childish gratuitousness of many of these images predominates. Nonetheless, fabrication shows signs of becoming a popular mode of expression in the 1980s. Some such photographs do offer considerable promise, but even these are tentative and comparatively embryonic. Only Lucas Samaras has succeeded in generating images of a brilliant, bizarre fictional realm that seems genuinely provocative and profound.

The current interest in fabrication has blossomed for a variety of reasons. Robert Rauschenberg's protean belittling of art world categories paved the way for the mixed-media explosion of the 1960s and the concomitant attitude that "anything goes." Although Philippe Halsman and other studio photographers spoke of the "directorial mode" long before A. D. Coleman began proselytizing in its behalf, Coleman has effectively drawn attention to an area usually ignored or played for laughs. Interest in Paul Outerbridge's cubist still lifes and fetishistic nudes has already had significant effect.

The growing interest in and use of Polaroid products—a phenomenon with aesthetic implications of such magnitude that it must be addressed in some depth—has also figured prominently in the increase of fabrication and fantasy.

Polaroid products have radically altered the course of color photography. Besides the convenience of positive

Plate 150 Carla Steiger-Meister

228

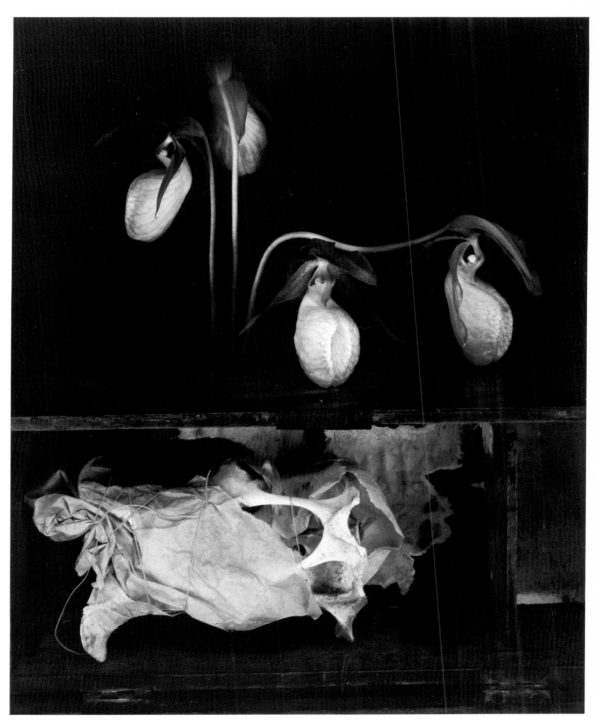

Plate 151 Olivia Parker

prints that self-develop within seconds of exposure, there is the print itself with its distinctive, liquid, luxurious color and notable absence of grain. Subjects as disparate as still lifes and street scenes often seem virtually embalmed in the opulent, syrupy-colored Polaroid print. Users of the process proclaim such features to be desirable distinctions, which elevate Polaroid films above all other color processes. Their chromatic obtrusiveness does offer sumptuousness, but it presents insurmountable visual impositions to artists trying to produce restrained saturations and moderated tonalities.

The jostling hue combinations that result from Polaroid film's propensity to overreact to certain colors may "extend vocabularies" as Eugenia Parry Janis has suggested,[1] but most often seem to lead to a language without grammar. Certainly it is difficult to render color-separated facts coherently and cohesively in a Polaroid photograph. Without control of nuance, formalists turn to other films for assistance in their search for the ideal structural arrangement of line, tone, shape, and color.

Documentarians, too, are at a disadvantage. Max Kozloff writes that each "artifact betrays a looser tie with outer reality than we normally expect from a photograph. It does bear witness to our world but not continuously nor forthrightly."[2] Going beyond the transformative codifications typical of other processes, Polaroid color invades every subject it describes. In making a traditional negative-to-positive color coupler print, the photographer can render a still life of tomatoes, celery, and eggs. Polaroid films serve up an aspic.

Polaroid can well serve fabricators of fictions if a level of studio control is maintained and the photographer uses Polacolor sheets in the back of a 4 × 5″, 8 × 10″, or 20 × 24″ view camera. The film's difficulties become compounded and may prove insurmountable when "one-step" cameras are used. Of these, the SX-70 is the most praised and used by artists.

Claims for the SX-70 make it sound like Yankee ingenuity's answer to the daguerreotype. Each image is said to be "one of a kind," a precious, palm-sized print that can be both afforded and created by Everyman. Designed to produce "accident proof" souvenirs of baby's face, Aunt Tilly before the Christmas tree, or the whole family under the spires of Disneyland, it tends to relegate the results obtained by amateurs and artists alike to a similarly low common denominator of visual quality.

Equipment with such rudimentary descriptive capability produces superficially acceptable, yet visually crude results every time. SX-70 images are simultaneously raucous and bland—raucous in their brassy colors and extreme ratios of light and shade, yet bland because the SX-70 lens describes with such marginal clarity. Although the 3 × 3″ square invites intimate examination, the longing to linger is stymied by the absence of the intimate detail that makes manuscript illuminations and daguerreotypes so seductive.

Thus this fail-proof toy for amateurs, designed to delight the consumer appetite for facility of means and quantitative production, is most suited to conceptualists for whom idea, not visual quality, is paramount, or for parodists and provocateurs who deliberately subvert the system for their own witty or bizarre ends. Unfortunately, most SX-70 users do not fall into these categories.

Only the most obdurate ideologists would insist that the

SX-70 print be esteemed simply because its visual characteristics are saliently and unseverably "photographic." Even Polaroid film's desirably rapid consummation of the photographic act, which provides the opportunity of on-site appraisal and adjustment, has not convinced some directorial photographers to attempt to tame Polaroid color.

Polaroid Corporation's subsidy of exhibitions and books showcasing talented applications of its products surely spurred many photographers to sample the SX-70. Although Polaroid has actively encouraged such renowned color photographers as Jan Groover, Stephen Shore, William Eggleston, Michael Bishop, and John Pfahl to test their products, the results of their experimentation failed to produce converts to "instant photography." Black-and-white photographer Roger Mertin began working in Polacolor at Polaroid's encouragement, yet despite considerable accomplishment in that medium, he subsequently switched to color-coupler printing because it offered the opportunity for greater aesthetic control. Although Polaroid products have inadvertently fostered the trend in fabricated fictions, only about half of the photographers who have produced substantive bodies of work of this kind—or whose fabrications reflect the promise of future accomplishment—use Polaroid products.

Carla Steiger-Meister's photographs are paeans to memory, dream, and intuition. Unlike most photographers who heap nostalgic objects into three-dimensional scrapbooks, Steiger-Meister photographically transforms her subjects into suggestive realms of suspended and/or alternative reality, infusing her images with the subtle ambience of daydream. *(plate 150)*

Avoiding the "truth to material" Modernist dictate, she craftily excludes certain spatial clues and explicit references to her objects' physical structure, combining fragmented views of various items that coalesce into a suggestive, evocative image. The gray and sepia of old photographs and postcards contrast with the saturated hues of philodendron leaves, feathers, and sea shells. But they all seem submerged in an atmosphere heavy with the pang of memory or subtly aglow with affectionate musing.

Steiger-Meister's images embrace a sort of homespun surrealism that owes a debt to Joseph Cornell's tiny, elusive, symbol-laden assemblages and shares certain of the concerns expressed in the Kwik Print, color Xerox, 3M Color-in-Color, and other "colored" photographic images of Bea Nettles, Evergon, and other artists whose work is compounded of myth and sentiment. But Steiger-Meister's color-coupler photographs impose less of a process-derived transformation upon her results.

Olivia Parker transforms her assemblages of faded photographs, illustrations, letters, plants, boxes, birds, rodents, and skeletons through the "embalming" quality of Polacolor film, which has a visually transformative function—old, decaying, man-made objects are changed into lush, luminous, and living things.

When Parker wraps an animal skull in pink tissue paper and yarn, she alters it to look like the luminous flowers positioned above it. *(plate 151)* Passages of mint green and blue-tinged pink loom from an infinitely rich black-and-brown darkness, glowing with a quiet, opalescent radiance. Parker's fabrication, transformed by luxuriant Polacolor,

231

Plate 152 Mark Schwartz

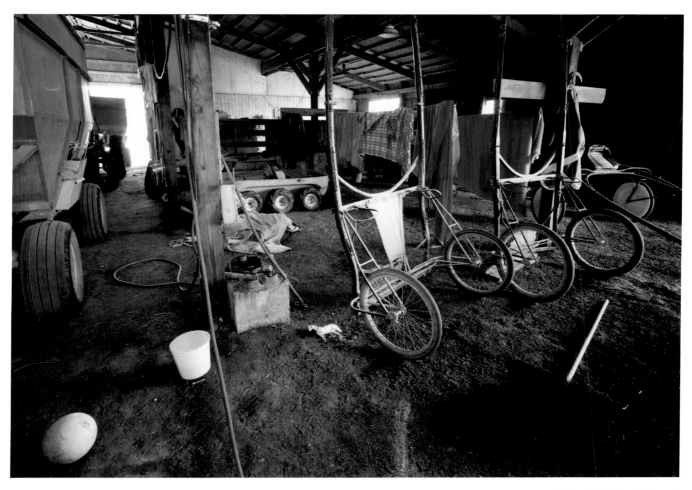

Plate 153 Mark Schwartz

233

converts the normal disparity between skull and living flower into a close family resemblance. This may represent a somewhat simplistic declaration about the relationship between life and death, but Parker's use of color and form is extremely sensitive. Her "memento mori" warnings seduce rather than frighten.

With whimsical assemblies of kites, sports equipment, buckets, tools, and the assorted detritus typically contained in handymen's storage sheds, **Mark Schwartz** fashions eccentric and beautiful worlds that recall the spirits of Alexander Calder, Joan Miró, and Arshile Gorky. Schwartz's objects convene in mischievous constellations that generate chain reactions of color, shape, and texture. In such schemes suggestions of surrealist symbolism occur too infrequently to confirm any pervasive underlying message.

Clearly intrigued with extracting the visually sublime and provocative from the most mundane subjects, Schwartz uses field strategies to integrate hues and shapes selected from diverse locations of the actual scenes. Like Jan Groover, he delivers the sensations of three-dimensional illusion without providing all the clues needed to solve his spatial riddles. But Schwartz's arrangements are less rational and architectonic than Groover's, seeming more akin to exploding pinball machines than to Cézanne's late still lifes. He reinforces this theater-of-the-absurd ambience with radical diagonalization of vertical motifs (a by-product of his use of a wide angle lens) and through cropping techniques that cause the lateral edges of his pictures to act like stage curtains opening onto a scene in progress. *(plate 152)*

Jo Ann Callis draws on two of the most emotionally sensitive areas of the human psyche: sex and death. Through harsh spotlighting of her models, Callis suggests the coercion, oppression, and terror that lurk beneath beauty and sexuality. Her forced clinical scrutiny withholds clarification of verifiable conclusions, offering, instead, perplexing suggestions that elicit discordant responses. Naked people often appear to be wearing masks, as if acting out some pornographic harlequinade.

Callis has created a parallel world designed to comment cogently on our own. In her scenarios, everyone is an actor, no one is innocent, personal identity is cause for shame, sex is power, true eros is corseted and true feeling cosmetically disguised.

A garish, crimson light reveals a nude girl's hairless pubis, *(plate 154)* as if to express our society's vanishing pudicity while lucidly evoking the tenor of pornographic movies and magazines. This image seems simultaneously to illustrate, mock, and protest the adult male preoccupation with young Lolitas and the confused values that promote such obsession. Callis's selection of grimly dingy and disconcertingly hot color oppositions create sensations of alarm, augmenting the suggestion of violence and violation in the image.

Such grim themes recur in Callis's work. A woman sits with her arms crossed behind her chair back as if bound, while a disconcertingly nearby lamp casts a harsh, nasty light that suggests an interrogation or immanent torture. In a photograph of a woman's torso and head, the figure's stiffened gesture and rigidly upward-pointed chin—coupled with the thin blue ribbon tied in a bow around her neck—seems an almost intact, framed fragment from a porno-

graphic snuff film. The pose of the figure, borrowed from Man Ray's formally beautiful "Neck" and Emmet Gowin's mildly disconcerting closeup of his wife's neck and chin, implies a forced, bound horror.

Callis seems to indict the fetishistic languor of Paul Outerbridge's nudes of the 1940s as well as recent fashion photographs such as the "White Women" of Helmut Newton and the sado-masochistic dramas of Guy Bourdin. By mimicking their fashionable fantasies yet debasing their formal solution, she seems to condemn the content they embrace.

John Divola selected an abandoned beach house that had been vandalized and then used for practice drills by the local fire department. With aggressively spray-painted dots and graffitilike scrawls, Divola imposes a pervasive patterning that, when transposed into a photographic image, induces the savaged, scorched, and otherwise violated interior details of the house to cohere into surprisingly orderly visual schemes. *(plate 155)* Despite the "primal crudeness" of his sprayed markings, they strategically mimic the visible characteristics of the site. Fiery reds continue the color of sunsets viewed through a gaping window. Mottled paint imitates the foamy caps of the ocean's distant waves.

Divola's works document the results of his performance with the spray can, but they also seem to transform it, to convey an image of some bizarre and frantic holy place, or a realm where the identities and shapes of interior and exterior, illusion and pure visual event flex and weave like the inside of an amusement park fun house, wherein the apparent facts evade confirmation.

Using the windows and mutilated interior walls to frame the seascape beyond, Divola seems to parody picturesque notions of "le beau et le bien" by brutishly distorting them. Repeatedly scorched during the period when Divola produced his series of images of it, the house provided a dramatically deteriorating foil against the ever-renewing ocean and sky. While contributing to the destruction of the humanist past represented by the house, he returns to the origins of form, to half-articulate, instinctive, uncensored artistic response.

Bernard Faucon acts as decorator, costumer, accessorizer, stage manager, and director of dramas acted out by a cast of mannequins and an occasional living figure. *(plate 156)*

Little boys, wearing the shorts popular thirty or forty years ago, play blindman's buff, go on butterfly hunts or cherry-picking. Boy mannequins, costumed as hussars, engage in battle, while a real child with stained face and ripped clothes runs through flames. Mannequins attend a Last Supper while a Dionysiac boy lies across the table amidst grapes. The same characters react in a variety of ways to a fire that breaks out behind a lavish picnic. One dummy carries another in an image that mimics St. Christopher carrying the infant Jesus.

Childhood, the mythical age of spontaneity and innocence, seems parodied by the waxen, wooden bodies. The gestures may seem spry, but the eyes are clearly sightless. The dummies' eager smiles seem manic compared to the inquisitive looks on real children. The material perfection of adult mannequins and their incongruous reactions to bizarre incidents comment wryly on the façades and decorum demanded by polite society.

But Faucon does not intend his parodies to be gaily

235

Plate 154 Jo Ann Collis

236

Plate 155 John Divola

237

amusing. His pieces are markedly moody, with overtones of Renoir movies, the ominous macabre of Chabrol, and the insatiable, surreal orgies of Fellini. Reviewing Faucon's work, Roland Barthes asked: "What can be more disturbing than an expression which denies the laws of expression, whose immutability denies the correspondence between the internal and the external, between cause and effect?"[3]

Faucon's use of the Fresson carbro process results in sham color and lack of sharp rendition, amplifying the overall unreality of his work.

Boyd Webb's advertising photographic techniques have decidedly broken away from their marketplace-oriented origins. His fanciful, parodoxical, sometimes parodical tableaux are neither instantly nor even eventually comprehensible. Instead, they comprise an insidious, private attack on logic. Actors (including the singing sculptors Gilbert and George, as well as Webb himself) combine with props to create living hieroglyphs with no Rosetta Stone.

Webb's works look a bit like Victorian genre paintings, yet defy the Victorian's rational concept of a world in which everything could be explained. Following the lead of Marcel Duchamp, Webb revels in uncertainties and contradictions. Yet, his beautifully photographed, impeccably and elaborately framed presentations suggest that he does not believe cerebration necessarily precludes sensuous "retinal art."

Webb's photographs induce the examination of concepts typically taken for granted. What, for instance, is "cipher" without "decipher"? Where and what is an equator? Two grown men play tug of war in front of a picture of worms. Heads or tails, who wins? But who can tell which is the head and which is the tail of the worm? A male and a female dualist wait at opposite ends of a banquet table while the man's pistol is examined, each seemingly unaware of the vivid tear in the center of the tablecloth that spreads out between them. *(plate 159)*

Since Webb has been influenced by Alfred Jarry, it might be assumed that, if these ciphers are to be deciphered, it must be through "pataphysics"—Jarry's term for a metaphysics where the laws that govern exceptions and imaginary solutions might be found.

Although the tableaux include mysterious maps and diagrams that suggest alchemy, Webb's frames are often shaped like medieval Christian altarpieces. Rather than a triptych format, with its serene stability, Webb often employs a diptych, as if to emphasize further his dualism. The scenes depicted are veritable bulwarks against interpretation. Any attempt to grasp these issues rationally seems destined to bog down in a seizure well described by the title of one of Webb's images "Prehensile Torpor."

Don Rodan has had the hubris to redefine such revered themes of art history as the nude, the still life, Hokusai's *36 Views of Mt. Fuji* and the Greek myths. Rodan's Mt. Fuji views stop at 35, not in deference to the master, but as an irreverent jape at the 35mm camera. He prefers to use that toy of amateurs—the SX-70. What better way to mock popular culture, psychological jargon, and the connoisseurship of art historians than by using a mass-marketed method that rapidly spews out pseudo-precious, rich-looking, and easily obtainable prints.

In Rodan's pantheon of gods, a Saran-wrapped Tantalus mocks Madison Avenue's dream definition of "tantaliz-

ing"—a plastic person imprisoned in plastic see-through clothes. *(plate 157)* His Hermes *(plate 158)* lunges downward into a mass of bright, colored feathers; the flatcapped, winged-sandaled messenger has been surrealistically reversed into a barefoot boy running through millinery feathers. His Perseus wears a Playtex Living Glove as though the touch and not the gaze of the fearful Medusa results in petrification. Ambidextra grips a pencil fervidly with two left hands. Narcissus is a beautiful black boy peering into a drink.

Although King Midas' touch turned all except himself into gold, Rodan shows a "gold-fingered" crime scenario in which a glittery, lamé glove touches the dismembered hand of a mannequin. What better way to spoof the kinky display of the chic, sleek Fiorucci boutique, where those in the money find jeans and boots afflicted with the Midas touch?

Rodan's works furnish high-camp, chic amusements for the "smart-set," whose adeptness at unraveling *New York* magazine's puns and riddles is matched only by their aesthetic ecstasies over stylish coordinations of color and shape. Teasing and tempting us with revue, impersonations, and sight gags, Rodan decadently abets our avoidance of the still-relevant, age-old issues that true myths confront.

Les Krims's pseudo-pornographic shockers contain cryptic fictions apparently designed to address and assail the tolerance of morally uptight Americans and provoke the indignation of all feminists. In his "Fictcryptokrimsographs," nude young women and his own less-than-nubile mother appear simultaneously decorated and desecrated with hooks, chewing gum, bananas, kosher pickles, broomsticks, and other objects stuck onto their bodies or penetrating their orifices. Drawing on Polaroid's reputation as an ideal medium for home pornography, Krims regales us with a surfeit of irreverent, improbable perversion.

Etching the still-wet SX-70 print emulsions, Krims sends deadly rays from his subjects' eyeballs or transforms their bodies into mutations of peeling, bubbling, and moulting flesh. This hand-rendered tampering brazenly violates the material sanctity of his prints, imposing unexpected transformations upon the Polaroid processes' patented predictability just as his preoccupations metamorphosize his subjects. Krims's prickly humor seems utterly dependent upon his inventive visual language. This "Coneylingus," with its psychedelic chromatics and kaleidoscopic distortions induced by skillfully precise manipulative marks, licks and twirls his submissive subjects into the most improbable, comic, and debasing situations—as if cross breeding the porno-horrific genre with an amusement park fun house.

Like the pornoparodical strain in avant-garde fiction (the granny in one of Robert Coover's neo-fairy tales speaks of "death-cunt-and-prick songs," for instance), Krims's results frequently seem more playfully imaginative than meaningful, geared more to shock than to illuminate. Consequently, many of his images seem to embrace somewhat adolescent flights of fancy about sexuality, lacking the *saeva indignatio* of more mature satire.*

Sandy Skoglund is a modern P.T. Barnum whose superbly modeled packs of creatures and objects invade her claustrophobically monochromatic, painted environments—

*Regrettably, Les Krims refused to permit the reproduction of any of his photographs in this book.

Plate 156 Bernard Faucon

Plate 157 Don Rodan

Plate 158 Don Rodan

transforming the ordinary into materialized fantasies and scenes of the absurd. Schooling red-orange ceramic goldfish undulate and levitate around two real humans in a bedroom of continuous blue *(plate 166)* Chartreuse papier maché cats overrun an elderly couple's habitat. Lavender coat hangers or green plastic ferns risibly and irresistably congregate in ways that belie and often belittle their everyday utilitarian or decorative functions.

Skoglund's "Revenge of the Goldfish" and other such scenarios seem less illustrations of nightmares or outtakes from horror movies than wondrous peculiarities or elaborately constructed tall stories. The familiar laws of nature have clearly blown a fuse in these eccentric, often spatially anomalous tableaux. Curiously, they seem both exuberantly funky and painlessly frozen. In fact, the only sure thing about them is their indifference to the latest ideologically self-conscious prescriptions for requisite pictorial purity.

Whether painting, sculpting, fabricating, or photographing, **Lucas Samaras** appropriates media for his own narcissistic, exhibitionist, and fetishistic ends. His preoccupations remain constant; the results are simultaneously terrifying, titillating, and transformative.

Just as he had earlier used felt pens, cardboard, paper doilies, and knitting yarn for purposes alien to those of the hobbyist, Samaras annexed the Polaroid 360 in 1969 and the SX-70 in 1973 and subverted every intention of the manufacturer. His "family pictures" include the activities and obsessions that snapshot albums routinely exclude.

Samaras's loved one is himself. In his "Autopolaroids" he stars in dramas in which he eats, excretes, masturbates, and auto-copulates in single, double, and triple exposures under bizarrely intense illumination. He is seen as an embryo, a transvestite, and a hermaphrodite. His nipples and navel appear as targets. He positions silverware in his mouth to look like fangs.

Decorating these not-so-decorous "homemade" dramas, Samaras doodles in dots and patterns on the Polaroid 360 print, subverting the space in which the unmentionable, or, at the very least, hush-hush acts were committed.

Using the SX-70 for his "Photo-Transformations," *(plates 162, 163)* Samaras discovered that the still-wet emulsions could be massaged until the image was a visually oozing, amusing, caricatured grotesquery. This accommodated both Samaras's unrestrained violative urges and his obsession with transformation.

The altered pieces are altarpieces, within which Samaras acts out his own turbulent incarnations in the forms of malevolent deities, a winged Christ, a black-cloaked Dracula, as well as various protean freaks, magicians, and shamans. The SX-70 prints also serve as tombs. Akin in appearance to sweet preserves, their emulsions seem as if they could both attract flies and decay like dead flesh, yet serve to preserve this "god's" photographic record of his acts and objects of value.

Currently working with 8 × 10″ Polacolor, Samaras audaciously exploits the film's epicurean predisposition. Gaudily lit, spatially ambiguous, crazily congested pile-ups of fabrics, utensils, glass, decals, and self-reflections demonstrate every preoccupation of his protean career. *(plate 165)*

Solid objects seem to dematerialize in the lollypop glaze of Samaras's colored lights. Representations of already two-dimensional images seem to come to life, while actual

Plate 159 Boyd Webb

Plate 160 Boyd Webb

Plate 161 Lucas Samaras

Plate 163 Lucas Samaras

Plate 162 Lucas Samaras

Plate 164 Lucas Samaras

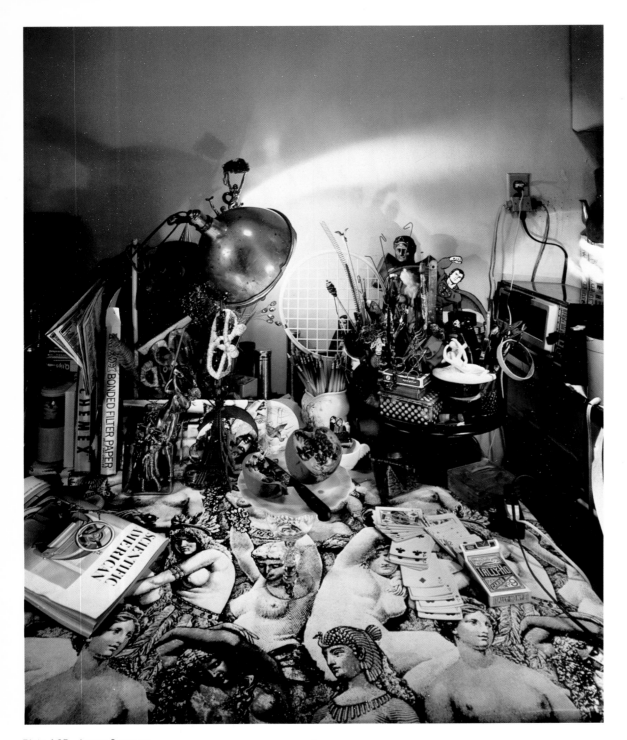

Plate 165 Lucas Samaras

solid forms flatten out. Samaras's content is as charged as the green and red color oppositions he favors.

A knife threatens a pomegranate. Bared breasts spar with pencils and flashlights, while rational thought is pitted against the random chance of playing cards. Measuring tools parody unmeasurable, ambiguous space. Samaras himself appears intact in photographs or reflected and refracted in drinking glasses and on the giddy surface of Mylar. Samaras toys with, iconicizes, and cannibalizes his props, his family heirlooms, his own image, and his art.

Samaras has called himself "The Last Byzantine,"[4] but without Polacolor's inherent excesses of color and contrast—its lush surface and instant feedback allowing him to adjust and readjust until his bizarre conceptions are fully realized—these Epicurean masterworks might never have been photographically created.

Plate 166 Sandy Skoglund

ARTISTS' BIOGRAPHIES

LARRY BABIS

Larry Babis was born in New York City in 1949 and received his B.F.A. from Cooper Union in 1975. He began photographing while at Cooper, where he also studied drawing, silk-screen printing, Spanish guitar, and animated filmmaking. For Babis, "Photography was—and continues to be—one of several tools I use to exercise a potential for some kind of self-awareness."

Inspired by lyric documentary photographers, such as Walker Evans and Atget, and encouraged by Joel Meyerowitz and Tod Papageorge, Babis began photographing the double houses and postage-stamp-size gardens of New York City's residential sections. After two years exploring Brooklyn and Queens, he increased his range by riding busses to the New Jersey coast, then trains to Philadelphia and Chicago. By 1976 he was traveling all over America by small plane, land rover, or hitchhiking. Recently Babis has traveled to Nova Scotia, Newfoundland, Mexico, Egypt, Italy, and Australia.

Travel offers Babis the "challenge of unexpected subject matter and contact with the fundamentals of human experience. The change from night to day, the changing of the seasons, the stars and alternation of the tides, wind, vast spaces and quiet recognition of scale and geologic time in landscapes are all qualities I would like to permeate my existence—and somehow my photographs."

The photograph in *The New Color* was made while hitchhiking in Colorado at work on a 1977 National Endowment for the Arts fellowship. Babis used a 2¼ x 3¼" Calumet camera with a 75mm Schneider super-angulon lens and Vericolor II type L negative film.

Selected Exhibitions
1975 "Color Photographs," Cooper Union, New York
1976 "Spectrum," Rochester Institute of Technology, New York
1977 "Contemporary Color Photography," Bard College, Annandale-on-Hudson, New York

ADAM BARTOS

Adam Bartos was born in New York City in 1953. While a student at New York University's film school, he saw a Joel Meyerowitz street photograph and took up photography seriously. Later he was markedly influenced by nineteenth-century photographs of Baldus, Muybridge, and Watkins shown to him by Richard Pare.

Bartos has traveled to Greece, Italy, Yugoslavia, Kenya, and Egypt, making photographs with a 5 x 7" view camera. He works as a freelance commercial photographer when at home in New York City.

A limited edition book of original prints, *Phainomene*, was published by Caldecot Chubb, New York, in 1980. A portfolio of eight photographs was published in *Zoom* in the August/September 1976 issue. He has shown at group summer exhibitions at the Light Gallery, New York, in 1977 and 1978; and at the Stephen White Gallery in Los Angeles in 1979.

Selected Bibliography
Black, Roger, Annie Leibovitz and Karen Mullarkey, eds. "Twelve Hot Photographers: Taking Pictures for a Living Living to Take Pictures," *Rolling Stone*, May 19, 1977.
Laroche, Joel, ed. *Zoom*, Paris, August/September 1976.
Lifson, Ben. "A Little Summer Music," *Village Voice*, July 24, 1978.

MICHAEL BISHOP

Michael Bishop was born in Palo Alto, California in 1946 and received his B.A. and M.A. from San Francisco State College in 1970 and 1971. He has taught at the Visual Studies Workshop, Rochester, New York since 1975. Prior teaching experience was at the University of California, Los Angeles, the San Francisco Art Institute, as well as other schools and workshops.

In 1971 Bishop made double prints "in camera" by masking half of the lens, then the other half, and changing the vantage point so that the viewer would be disoriented by the resultant photograph. To make the pseudo-documents in his "Space/Technology" series of 1971–72, Bishop selected deserted areas suggestive of moonscapes, added multiple cross hairs similar to those found in scientific photographs, and incorporated photograms of plastic astronauts. Bishop's first widely recognized photographs were the "Tones" of 1972–75; they address many of the same conceptual and spatial concerns present in his color photographs.

Bishop's work has evolved logically from black-and-white to color. After toning black-and-white prints, he printed black-and-white negatives on color printing paper, and, in 1974 began using color film.

Bishop uses a Nikon camera, a 35mm f/2.8 PC Nikkor lens and color negative film. The movable optics of the PC lens allow him to achieve many of the effects possible by shifting the lens on the large format cameras favored by architectural photographers. Bishop states, "I'm using a 35mm camera as if it were an 8 x 10". Instead of mounting the camera on a tripod, though, I'm using a bipod—me."

Bishop won fellowships from the National Endowment for the Arts in 1975 and 1978, and from the New York State Council on the Arts in 1977.

Selected Solo Exhibitions (Color)
1975 Light Gallery, New York
1976 Light Gallery, New York
1977 Light Gallery, New York
1979 Chicago Center for Contemporary Photography; traveling exhibition
 Bard College, Annandale-on-Hudson, New York

249

Selected Group Exhibitions (Color)
1976 "Upstate Color: Michael Bishop, John Pfahl, Phil Block," Everson Museum of Art, Syracuse, New York
1978 "Spaces," Museum of the Rhode Island School of Design, Providence
1979 "Attitudes," Santa Barbara Museum of Art, California
1980 "Invented Images," University of California at Santa Barbara Art Museum "Photography: Recent Directions," De Cordova Museum of Art, Lincoln, Massachusetts

Selected Bibliography
Bishop, Michael. *Michael Bishop*. Chicago, Illinois, Chicago Center for Contemporary Photography, 1979.
Davis, Douglas. "The Ten 'Toughest' Photographs of 1975," *Esquire*, February 1976.
Eauclaire, Sally. "Camera Walks Fine Line," *Democrat and Chronicle* (Rochester, N.Y.), October 30, 1977.
Fischer, Hal. "An Interview with Michael Bishop," *La Mamelle*, #5, vol. 2, no. 1, 1976.
Foster, Hal. "Reviews," *Artforum*, January 1979.
Grundberg, Andy. "Reviews," *Art in America*, July/August 1977.
Hagen, Charles. "Michael Bishop: A New Perspective," *Modern Photography*, June 1978.
Lyons, Nathan. *Vision and Expression*. New York, Horizon, 1969.
Rubinfien, Leo. "Reviews," *Artforum*, May 1977.
Scully, Julia and Andy Grundberg. "Messages about the Medium," *Modern Photography*, July 1976.
Scully, Julia, Andy Grundberg and Mary O'Grady. "100 Years of Color," *Modern Photography*, Christmas 1976.
Thornton, Gene. "Turning the Camera into a Paint Brush," *New York Times*, March 27, 1977.
West, Ed. "Photography," *New Art Examiner*, January 1977.

HARRY CALLAHAN

Harry Callahan was born in Detroit, Michigan in 1912 and now lives in Providence, Rhode Island. He made his first amateur photographs in 1938 and became committed to photography in 1941 after attending a lecture by Ansel Adams.

In 1946 Callahan joined the faculty of the Institute of Design (formerly the New Bauhaus; after 1950 part of the Illinois Institute of Technology). In 1961 he became head of the photography department of the Rhode Island School of Design. He retired from teaching in 1967.

Callahan has won grants from the Guggenheim (1972) and Graham foundations (1956) and from the National Endowment for the Arts (1975).

Though Callahan made his first color photographs in 1942, most critics have ignored the color work in favor of the black-and-white. Edward Steichen, however, showed sustained interest, for he included Callahan's color photographs in several group exhibitions at the Museum of Modern Art, including "All Color Photography" of 1950; "Abstraction in Photography" of 1951; and "Photographs from the Museum Collection" in 1958. In addition, Steichen projected Callahan's slides in two lectures at MOMA; "Experimental Color Photography" of 1957 and "Toward Abstraction" of 1962.

Since 1977 Callahan has worked almost exclusively in color. The first exhibition devoted exclusively to Callahan's color photography was given by Light Gallery, New York, in 1978. The first retrospective of Callahan's color photographs was curated by Sally Stein and Terence R. Pitts for the Center for Creative Photography of the University of Arizona at Tucson. The show, culled from thousands of transparencies donated by Callahan to the center for his archive, opened in 1979 and traveled in 1980 to the Museum of New Mexico, Santa Fe; the Akron Art Institute, Akron, Ohio; and the Hudson River Museum, Yonkers, N.Y.

Selected Color Bibliography
Brody, Jacqueline. "Harry Callahan: Questions," *Print Collector's Newsletter*, January/February 1977.
Color Photography Annual. New York, Ziff-Davis, 1956.
Danese, Renato, ed. *American Images*. New York, McGraw-Hill, 1979.
Ebin, David. "Harry Callahan: Conventional Subjects Become Extraordinary Photographs," *Modern Photography*, February 1957.
Grundberg, Andy. "Color Under Cover," *SoHo News*, October 22, 1980.
Kramer, Hilton. "Photography," *New York Times Book Review*, November 30, 1980.
Liebman, Stuart. "Callahan's Puritan Color," *SoHo Weekly News*, April 13, 1978.
Lifson, Ben. "The Heart of the Matter," *Village Voice*, September 24–30, 1980.
Malcolm, Janet. "Photography: Two Roads," in *Diana and Nikon*. Boston, Godine, 1980.
Rotzler, Willy. "Farbaufnahmen von Harry Callahan," *Du*, Zurich, January 1962.
Rubinfien, Leo. "Harry Callahan's Detente with Experience," *Village Voice*, April 10, 1978.
Shook, Melissa. "Callahan." *Photograph*, Summer 1977.
Staniszewski, Mary. "Harry Callahan," *ARTnews*, December 1980.
Stein, Sally and Terence R. Pitts. *Harry Callahan: Photographs in Color/The Years 1946–1978*. Tucson, Center for Creative Photography, University of Arizona, 1980.
Stevens, Nancy. "Harry Callahan," *American Photographer*, October 1980.
Thornton, Gene. "Harry Callahan's Discerning Use of Color," *New York Times*, September 7, 1980.
Tow, Robert and Ricker Winsor, eds. *Harry Callahan: Color*. Providence, R.I., Matrix, 1980.

JO ANN CALLIS

Jo Ann Callis was born in Cincinnati, Ohio in 1940 and lives in Culver City, California. She has worked in various media including sculpture, collage, and painting and took up photography with Robert Heinecken at the University of California, Los Angeles, in 1973. She received her B.A. there in 1974 and her M.F.A. in 1977. Callis taught photography at California State University at Fullerton in 1977–78 and has been on the faculty of the California Institute of the Arts from 1976 to the present.

In 1975 Callis completed a series of photographs entitled "Morphe" after the Greek word

for form or shape. In the series, figures seem to float in states of ecstasy or pain, sometimes in sleep or death. For the "Black Sun Pictures" of 1976, Callis used her enlarger to burn out details of depicted sunbathers so that they would appear as flat cut outs on the cement. As a result, they seem conspicuously alienated from their surroundings. In 1977 Callis began using color so that its hues might provide additional emotive force. During the past year Callis's work has become more playful. People have been eliminated and animals and objects appear in somewhat incongruous still lifes. Callis hopes her photographs "communicate sensations and feelings to others on a level just below their consciousness."

Over the years Callis has changed from a 35mm Nikormat to a 4 x 5" Sinar view camera. "Girl on the Bed" was made with a 6 x 7 cm Pentax with a 55mm Takumar lens. The film was Vericolor II Type L negative film used with photo floods.

Callis received a Ferguson Grant from the Friends of Photography in 1978 and a photographer's fellowship from the National Endowment for the Arts in 1980.

Selected Solo and Two-Person Exhibitions
1978 Gallery of Fine Photography, New Orleans. Louisiana
1979 "Callis/Cummings," T.E.S.C. Gallery, Olympia, Washington; Blue Sky Gallery, Portland, Oregon
 "Color Transformations" (Callis and John Divola), University Art Museum, Berkeley, California

Selected Group Exhibitions
1976 "Exposing: Photographic Definitions," Los Angeles Institute of Contemporary Art
 "Emerging Los Angeles Photographers," Friends of Photography, Carmel, California; traveling exhibition
1978 "The Photograph as Artifice," California State University, Long Beach, California; traveling exhibition
1979 "Attitudes," Santa Barbara Museum of Art, California
 "Spectrum—New Directions in Color Photography," University of Hawaii, Manoa
 "The New Season," Witkin Gallery, New York
 "Color: A Spectrum of Recent Photography," Milwaukee Art Center, Wisconsin

Selected Bibliography
Colman, Cathy. "Jo Ann Callis," *Artweek*, February 11, 1978.
Fahey, David. "Interrogations into Color," *Photo Bulletin*, June/July 1978.
Fahey, David. "Jo Ann Callis: Between Eroticism and Morbidity," *Journal*, Los Angeles Institute of Contemporary Art, September 1979.
Field, Carol. "Jo Ann Callis," *New West*, November 6, 1978.
Goldsmith, Arthur. "New Images," *Popular Photography*, September 1979.
Grundberg, Andy and Julia Scully. "Currents: American Photography Today," *Modern Photography*, October 1980.
Hedgpeth, Ted. "Symbols and Significance," *Artweek*, June 21, 1980.
Hugunin, James. "Reviews," *Dumb Ox*, Winter 1977.
Mautner, Robert. "Jo Ann Callis: A Sense of the Theatrical," *Artweek*, December 21, 1974.
Murray, Joan. "Memorable Visions," *Artweek*, September 8, 1979.
Photography Annual/1978. New York, Ziff-Davis.
Photography Annual/1980. New York, Ziff-Davis.
Picture, vol. 1, no. 6, 1978. Los Angeles, Owens.
Reed, Rochele. "Best Bets," *New West Magazine*, July 17, 1978.
Witkin, Lee. *Ten Year Salute*. Danbury, N.H., Addison House, 1979.

WILLIAM CHRISTENBERRY

William Christenberry was born in 1936 in Tuscaloosa, Alabama. He grew up with many of the people in Walker Evans's and James Agee's book *Let Us Now Praise Famous Men*, yet remained unaware of the book until he accidentally discovered it during his college years.

While a student at the University of Alabama, Tuscaloosa, Christenberry was inculcated with Abstract Expressionist values. Yet by 1959, the year he received his M.A., he was finding gesture for its own sake insufficient. In search for more meaningful subject matter, Christenberry loaded a Brownie camera with color film and made photographs that provided rough guidelines for his paintings and drawings. It was not until 1962 that Walker Evans encouraged him to regard the photogaphs as artworks.

Christenberry works in a variety of media, including drawing, sculpture, painting, and photography, and frequently exhibits the works together. He has based pastel drawings on his photographs and built models of many of the buildings, including Sprott Church (pl. 99). He is also an avid collector of old signs and other artifacts from Hale County.

Christenberry taught at Memphis State University, Tennessee, from 1962 to 1968. Since 1968 he has been at the Corcoran School of Art, Washington, D.C. He received a photographer's fellowship from the National Endowment for the Arts in 1976. In 1978 the U.S. General Services Administration Art-in-Architecture program commissioned him to create a wall work for the Jackson Mississippi Federal Building.

Selected Solo Photographic Exhibitions
1973 Jefferson Place Gallery, Washington, D.C.
 Corcoran Gallery of Art, Washington, D.C. (The exhibition traveled to the Baltimore Museum of Art, Maryland)
1976 Zabriskie Gallery, New York (photographs and sculpture)
1977 Sander Gallery, Washington, D.C.
1978 Corcoran Gallery of Art, Washington, D.C.
1979 Montgomery Museum of Fine Arts, Montgomery, Alabama
1980 Sander Gallery, Washington, D.C.
 Cronin Gallery, Houston

Selected Photographic Group Exhibitions
1975 "14 American Photographers," Baltimore Museum of Art, Maryland; traveling exhibition
1977 "The Contemporary South," organized

by the New Orleans Museum of Art for the International Communications Agency; traveling exhibition
"The Second Generation of Colour Photographers." Photokina, Kunsthalle, Cologne, and Arles Festival, France

1978 "By the Side of the Road," Currier Gallery of Art, Manchester, New Hampshire
"Amerikanische Landschaftsphotographie," Neue Sammlung, Munich
"The Presence of Walker Evans," Institute of Contemporary Art, Boston

1979 "Photography of the 70s," Art Institute of Chicago
"Color Photographs: Corcoran Collection," Corcoran Gallery of Art, Washington, D.C.
"Fotografie im Alltag Amerikas," Das Kunstgewerbemuseum, Zurich

1980 "Zeitgenossiche Amerikanische Farbphotographie," Galerie Rudolf Kicken, Cologne

Selected Photographic Bibliography

Cohen, Alan. "New Look at the Old South: The Heroic and the Commonplace—Two Exhibits," *Washington Star*, June 21, 1977.

Danese, Renato, ed. *14 American Photographers*. Baltimore Museum of Art, 1975.

Forgey, Benjamin. "Photographs of Childhood," *Evening Star and Daily News* (Washington, D.C.), April 30, 1973.

Forgey, Benjamin. "Roadside Glories," *Aperture*, Winter 1978.

Forgey, Benjamin. "Washington, D.C.: William Christenberry at the Corcoran Gallery and Jefferson Place," *Art in America*, May/June 1973.

Frank, Peter. "William Christenberry," *ARTnews*, March 1977.

Gold, Barbara. "Shooting Shotgun Shacks," *The Sun* (Baltimore), November 25, 1973.

Lopes Cardozo, Judith. "Reviews," *Artforum*, March 1977.

Phillips, Ellen. "Gallery: William Christenberry," *Washingtonian*, February 1976.

Porter, Allan, ed. "The Second Generation of Color Photographers," *Camera*, July 1977.

Richard, Paul. "American Esthetic in Plain and Spooky Photos," *Washington Post*, June 18, 1977.

Sembach, Klaus-Jürgen. *Amerikanische Landschaftsphotographie*. Munich, Neue Sammlung, 1978.

Steinbach, Alice C. "Photographs of Alabama by William Christenberry," *Record*, Baltimore Museum of Art, December 1973.

Tannous, David. "Reviews," *Art in America*, July/August 1977.

Zito, Tom. "Washington Photography: Art" *Washington Post/Potomac*, May 23, 1976.

LANGDON CLAY

Langdon Clay was born in New York City in 1949 and raised in Princeton, N.J. and Arlington, Vt. He graduated from St. Paul's School, Concord, N.H. and attended Harvard College. He has lived in New York City since 1972, where he works as a freelance commercial photographer.

Clay taught himself photography in high school and has worked in color since 1975. He cites Vermeer as his greatest source of inspiration.

Clay's portfolio, *Cars*, issued by Caldecot Chubb in 1977 resulted in the first exhibition of color photography at the Victoria and Albert Museum in London. *Flat Lands*, a bound book of original prints published in 1979 by Caldecot Chubb was exhibited with related prints in a solo exhibition entitled "Color Atlas" at the Corcoran Gallery of Art, Washington, D.C.

Though Clay used a Leica and slide film for the photographs in *Cars*, he has used an 8 x 10" view camera and negative film since. The switch to the large camera reflects his view that "the more bits of sharp undiffused information per square millimeter, the better the photograph." Clay has also made a panoramic photograph of 42nd Street at night by assembling 22 exposures taken between March and June of 1970 into a totality 16½" by 15 feet long.

Selected Solo Exhibitions

1978 Victoria and Albert Museum, London
1979 Corcoran Gallery of Art, Washington, D.C.

1980 Carpenter Center, Harvard University, Cambridge, Massachusetts
Art Institute of Chicago

Selected Group Exhibitions

1978 Foire Internationale d'Art Contemporain, Paris
1979 "American Photography since 1970," Art Institute of Chicago
"Auto Icons," Whitney Museum of American Art Downtown, New York
1980 "Glimpses of America," Peking, China

Selected Bibliography

Artner, Alan G. "Exciting Developments in Color Photography," *Chicago Tribune*, December 29, 1978.

Artner, Alan G. "Institute Develops Three Photography Shows," *Chicago Tribune*, February 4, 1979.

Black, Roger, Annie Leibovitz and Karen Mullarkey, eds. "Twelve Hot Photographers," *Rolling Stone*, May 19, 1977.

Crisman, Jeff. "Four Photographers," *New Art Examiner*, January 1979.

Davis, Douglas. "They Park by Night," *Newsweek*, March 20, 1978.

Elliot, David. "Forget Art History and Enjoy the Views," *Chicago Sun-Times*, December 31, 1978.

Faraldi, Caryll. "Cars," *Observer*, July 30, 1978.

Haworth-Booth, Mark. *Cars*, London, Victoria & Albert Museum, 1978.

Laroche, Joel, ed. *Zoom*. Paris, November 1976.

Nuridsany, Michel. "La Découverte de Jeunes Talents," *Le Figaro*, July 19, 1976.

Parsons, Ann. "Color '77," *Boston Phoenix*, June 7, 1977.

Taylor, John Russell. "Transcending Images," *The Times* (London), September 12, 1978.

MARK COHEN

Mark Cohen was born in Wilkes-Barre, Pennsylvania in 1943. He attended Penn State University and received his B.S. from Wilkes College, Wilkes-Barre, Pennsylvania. He has taught photography at Kings College, Wilkes-Barre; Wilkes College, and Princeton Univer-

sity. Since 1967 Cohen has run a small commercial studio in Wilkes-Barre.

Though long interested in color, Cohen's omniverous shooting methods made it financially prohibitive. In 1975 William Jenkins, curator of twentieth-century photography at the George Eastman House, made an arrangement with Kodak by which the company printed all of Cohen's negatives, then made final prints of Cohen's choices for both the photographer and the museum.

Cohen has won two Guggenheim Fellowships (1971 and 1976) and a National Endowment for the Arts photographer's grant (1975).

The photographs in *The New Color* were made with a Leica M-4 and a 28mm lens. In 1975 he used Vericolor II and in 1978, Kodacolor 400 film.

Selected Solo Exhibitions
1973 Museum of Modern Art, New York
1974 International Museum of Photography at George Eastman House, Rochester, New York
Light Gallery, New York
1975 Art Institute of Chicago
Light Gallery, New York
1976 Visual Studies Workshop, Rochester, New York
1977 Castelli Graphics, New York
1978 International Museum of Photography at George Eastman House, Rochester, New York
Castelli Graphics, New York
Robert Self Gallery, London

Selected Group Exhibitions
1968 "Vision and Expression," George Eastman House, Rochester, New York
1970 "New Photographers," Museum of Modern Art, New York
1973 "Continuum 60s," George Eastman House, Rochester, New York
"Documentary Photography," Tyler School of Art, Philadelphia
"Sharp Focus Realism," Pace Gallery, New York
1975 "Documenta," Milan
"Photography in America," Whitney Museum of American Art, New York
1976 "Peculiar to Photography," University of New Mexico Art Museum, Albuquerque
"Through Other Eyes," Arts Council of Great Britain, London
1977 "Unposed Portraits," Whitney Museum of American Art, New York
"Flash," Miami—Dade Community College, Florida
1978 "Mirrors and Windows," Museum of Modern Art, New York; traveling exhibition
1980 "20 American Artists," San Francisco Museum of Modern Art

Selected Bibliography

Coleman, A.D. "From Repetitious to Monotonous and Distorted," *New York Times*, January 27, 1974.
Collins, James. "Reviews," *Artforum*, March 1974.
Doty, Robert, ed. *Photography in America*. New York, Random House, 1974.
Eauclaire, Sally. "Reviews," *Art in America*, June 1979.
Frackman, Noel. "Reviews," *Arts*, April 1977.
Grundberg, Andy. "Reviews," *Art in America*, March 1976.
Grundberg, Andy and Julia Scully. "Currents: American Photography Today," *Modern Photography*, November 1979.
Hagen, Charles. "Mark Cohen: An Interview," *Afterimage*, January 1979.
Liebman, Stuart. "Making People into Pictures," *SoHo Weekly News*, December 14, 1978.
Lifson, Ben. "Wilkes-Barre Visitation," *Village Voice*, December 18, 1978.
Longwell, Dennis. "Mark Cohen's Works," *Camera Mainichi*, October 1974.
Lyons, Nathan. *Vision and Expression*. New York, Horizon, 1969.
Maddow, Ben. *Faces*. New York, Chanticleer, 1977.
Poli, Kenneth. "Persistence of a Vision," *Popular Photography*. April 1977.
Porter, Allan, ed. "Photographis Interruptus," *Camera*, November 1977.
Rubinfien, Leo. "Reviews," *Artforum*, April 1977.
Squiers, Carol. "Mark Cohen: Recognized Moments," *Artforum*, March 1978.
Szarkowski, John. *Mirrors and Windows*. New York, Museum of Modern Art, 1978.
Turner, Peter, ed. "Mark Cohen," *Creative Camera Yearbook*, London, Coo Press, 1976.
Thornton, Gene. "They Must Mean Something," *New York Times*, April 1, 1973.
Thornton, Gene. "How Display Selection May Distort Artistic Intent," *New York Times*, February 13, 1977.

JOYCE CULVER

Joyce Culver was born in New York City in 1947. In 1969 she received a B.S. in art education from the State University of New York College at Buffalo and for the next seven years taught art at Pittsford-Mendon High School, Pittsford, New York. In 1976 Culver entered the Rochester Institute of Technology to major in still photography and received her M.F.A. in 1978. She has taught photography at Northampton County Area Community College, Bethlehem, Pennsylvania; Southampton College of Long Island University, Southampton, New York; Wagner College, Staten Island, New York; and Nassau Community College, Garden City, New York. To supplement her teaching she works as a freelance photographer. Culver lives in New York City.

Culver has exhibited in numerous juried exhibitions, and in 1980 had a one-woman show of her color photographs at the Popular Photography Gallery in New York City. In 1978 she was a juror for the New York State Council on the Arts Creative Artists Public Service grants panel. A black-and-white self portrait is included in *In/Sights: Self-Portraits by Women*, edited by Joyce Tenneson Cohen (Godine, 1978).

Culver's photographs in *The New Color* are Ektacolor prints from 2¼ x 2¼" negatives. She used acetate masks to accentuate portions of the prints and contribute to the semisurrealistic magical effect she desires.

JERRY DANTZIC

Jerry Dantzic was born in 1925. After serving

in the U.S. Army from 1943 to 1946, he attended Kent State University, Kent, Ohio, where he received his B.A. in 1950. In 1953–54 he studied with Alexei Brodovitch at the New School in New York, and since 1954 has worked professionally as a photojournalist and illustrator. His photographs have appeared in numerous publications including *The New York Times*, *Life*, *Look*, *Holiday*, and *Time*. Since 1968, he has taught photography at Long Island University, the Brooklyn Center. He lives in Brooklyn.

Dantzic's obsession with the panorama camera began in 1971 when, picking among the odds and ends at a Maine flea market, he discovered a photograph depicting 2,000 ministers before a church in Denver. Dantzic marveled at the tack-sharp focus and lack of distortion and wondered what camera could make such a photograph. After a search of more than a year, he acquired a decrepit, turn-of-the-century Cirkut, then spent months repairing and learning how to use the imposing Victorian machine.

"We are begrudging collaborators, this machine and I," says Dantzic. Though he curses its "sudden inexplicable mechanical failures, infernally slow shutter speeds, its present inability to handle low light levels, and the back strain from its 60-pound bulk," he sees many roads ahead.

From the outset, Dantzic determined to trace old techniques, then move beyond. For him "playing with historical ideas is one of the great pleasures of the profession." Though his camera was born in an age of black-and-white, he uses modern color negative film. The film is specially cut and obtained from whatever sources he can find in the world. Processing and printing methods are constantly considered and revised.

"Since I have capability up to 360 degrees and beyond, I must always be aware of the totality of my visual space. Contending with multilevels of light, with sudden directional and color changes, is something completely foreign to the standard formats I have worked with most of my professional life."

Dantzic's panoramic work has been assisted by grants from the National Endowment for the Arts (1975) and the Guggenheim Foundation (1977).

Selected Solo Exhibitions
1978 "Jerry Dantzic and the Cirkut Camera—Panoramic Color Prints," Museum of Modern Art, New York; traveling exhibition
1979 "The West at Length," Denver Museum of Natural History, Denver, Colorado
1980 "Australia at Length," Adelaide Festival of the Arts, Adelaide, Australia

Selected Group Exhibitions
1977 "Panoramic Photography," Grey Gallery, New York University, New York
1978 "Mirrors and Windows," Museum of Modern Art, New York; traveling exhibition
1979 "Attitudes," Santa Barbara Museum of Art, California

Selected Bibliography
Edkins, Diana. "Panorama," *Modern Photography*, August 1978.
Lifson, Ben. "Cirkut Rider," *Village Voice*, June 5, 1978.
"Taking the Long View," *Time*, May 29, 1978.
Thornton, Gene. "Panoramas—How Modern?" *New York Times*, June 4, 1978.
Whitin, Charles P. "Taking a Long Shot," *American Photographer*, September 1978.

JOHN DIVOLA

John Divola was born in Santa Monica, California in 1949 and lives in Venice, California. He received his B.A. from California State University at Northridge in 1971; his M.A. from the University of California, Los Angeles in 1973; and M.F.A. from UCLA in 1974. Divola has taught photography at many colleges in the Los Angeles area and now directs the photography program at the California Institute of the Arts.

Of his photographs Divola writes: "I think of them as being involved with three elements: 1. myself, my personality and my disposition at that particular place and time. 2. The nature of the medium and the way it translates information; 3. The nature of the place and the nature of the situation. And so all three of these elements interact, and the interaction is manifest in the photograph."

Divola uses a 6 x 7cm Pentax and makes Ektacolor prints. He has received National Endowment for the Arts photographer's fellowships in 1973, 1976, and 1979.

Selected Solo and Two-Person Exhibitions
1976 Center for Creative Photography, University of Arizona, Tucson
1978 Los Angeles Center for Photographic Studies
1979 Vision Gallery, Boston
 "Color Transformations" (Divola and Jo Ann Callis), University Art Museum, Berkeley, California
1980 Grapestake Gallery, San Francisco
 Robert Freidus Gallery, New York

Selected Group Exhibitions
1976 "Exposing: Photographic Definitions," Los Angeles Institute of Contemporary Art
 "Emerging Los Angeles Photographers," Friends of Photography, Carmel, California; traveling exhibition
 "American Photography: Past into Present," Seattle Art Museum
1978 "Photograph as Artifice," California State University at Long Beach; traveling exhibition
 "Mirrors and Windows," Museum of Modern Art, New York; traveling exhibition
1979 "Space in Two Dimensions," Museum of Fine Arts, Houston
 "Attitudes," Santa Barbara Art Museum, California
 "Divola, Henkel, Parker, Pfahl," Visual Studies Workshop, Rochester, New York; traveling exhibition
 "Color: A Spectrum of Recent Photography." Milwaukee Art Center, Wisconsin
 "Invented Images," University of California at Santa Barbara Art Museum,
1980 "Farbwerke," Kunsthaus, Zurich

Selected Bibliography
Artner, Alan G. "Contemporary Photos that Touch a Conceptual Base," *Chicago Tribune*, July 18, 1980.

Axelrad, Stephen. "Contrasts of Light, Space and Time," *Artweek*, September 16, 1978.

Fischer, Hal. "Contemporary California Photography: The West is . . . Well, Different," *Afterimage*, November 1978.

Grundberg, Andy and Julia Scully. "Currents: American Photography Today," *Modern Photography*, October 1980.

Johnstone, Mark. "John Divola," *Camera*, November 1980.

Larsen, Susan C. "Los Angeles: A Fantasy Life," *ARTnews*, May 1979.

Murray, Joan. "John Divola: The Zuma Series," *Picture*, March 1980, #14.

Murray, Joan. "Memorable Visions," *Artweek*, September 8, 1979.

Olejarz, Harold. "John Divola," *Arts*, September 1980.

Portner, Dinah. *Journal*. Los Angeles Center for Photographic Studies, September 1978.

Time-Life Books, eds. *Photography Year/1980*. New York, Time-Life, 1980.

WILLIAM EGGLESTON

William Eggleston was born in 1939 in Memphis, Tennessee, where he now lives. He attended Vanderbilt University, Nashville, Tennessee; Delta State College, Cleveland, Mississippi; and the University of Mississippi, Oxford, Mississippi.

Eggleston began photographing in 1957 and became seriously interested in 1962 after discovering the work of Henri Cartier-Bresson. He has been working almost exclusively in color since 1966. He was a lecturer in Visual and Environmental Studies at Harvard College, Cambridge, Massachusetts, in 1974, and a researcher in color video at the Massachusetts Institute of Technology, Cambridge, Massachusetts in 1978–79.

Eggleston won a Guggenheim fellowship in 1974, a National Endowment for the Arts photographer's fellowship in 1975, and a National Endowment for the Arts survey grant for a photographic and color video survey of Mississippi cotton farms in 1978.

Limited Edition Books and Portfolios
1974 *14 Pictures*, a portfolio of dye-transfer prints, privately published and distributed by Graphics International, Ltd., Washington, D.C.

1977 *Election Eve*, a book of 100 Type C photographs, preface by Lloyd Fonvielle, published by Caldecot Chubb, New York.
Morals of Vision, a book of eight EK74 color photographs, published by Caldecot Chubb, New York.

1978 *Flowers*, a book of 12 EK74 color photographs, published by Caldecot Chubb, New York.

1979 *Wedgwood Blue*, a book of 15 EK74 color photographs, published by Caldecot Chubb, New York.
Seven, a suite of seven mounted EK74 color photographs published by Caldecot Chubb, New York

Selected Solo Exhibitions
1974 Jefferson Place Gallery, Washington, D.C.
1975 Carpenter Center, Harvard University, Cambridge, Massachusetts
1976 Museum of Modern Art, New York; traveling exhibition
1977 Brooks Memorial Art Gallery, Memphis, Tennessee
Castelli Graphics, New York
Frumkin Gallery, Chicago
Lunn Gallery, Washington, D.C.
Corcoran Gallery of Art, Washington, D.C.
1978 Laguna Gloria Museum, Austin, Texas
1979 Photographers' Gallery, South Yarra, Australia
1980 Cowles Gallery, New York

Selected Group Exhibitions
1972 "Photography Workshop Invitational," Corcoran Gallery of Art, Washington, D.C.
1974 "Art Now '74," Kennedy Center for the Performing Arts, Washington, D.C.
1975 "14 American Photographers," Baltimore Museum of Art, Maryland; traveling exhibition
"Color Photography: Inventors and Innovators 1850–1975," Yale University Art Gallery, New Haven, Connecticut
1976 "Aspects of American Photography, 1976," University of Missouri, St. Louis
1977 "The Contemporary South," A USIA traveling exhibition organized by the New Orleans Museum of Art, Louisiana
"Contemporary American Photographic Work," Museum of Fine Arts, Houston
1978 "Mirrors and Windows," Museum of Modern Art, New York; traveling exhibition
"Photographs from the Wagstaff Collection," Corcoran Gallery of Art, Washington, D.C.; traveling exhibition
"Amerikanische Landschaftsphotographie 1860–1978," Neue Sammlung, Munich
1979 "American Photography in the '70s," Art Institute of Chicago.
"Curator's Choice: Contemporary American Photography," Venezia '79, Venice
"American Images," Corcoran Gallery of Art, Washington, D.C.; traveling exhibition
"Photographie im Alltag Amerikas," Kunstgewerbemuseum, Zurich

Selected Bibliography
Callahan, Sean. "MOMA Lowers the Color Bar," *New York Magazine*, June 28, 1976.
Danese, Renato, ed. *American Images*. New York, McGraw-Hill, 1979.
Danese, Renato, ed. *14 American Photographers*. Baltimore Museum of Art, 1974.
Davis, Douglas. "Photography," *Newsweek*, October 21, 1974.
Davis, Douglas. "New Frontiers in Color," *Newsweek*, April 19, 1976.
Eauclaire, Sally. "Color Photography as Art—Eggleston Paves Way," *Democrat and Chronicle* (Rochester, N.Y.), January 22, 1978.
Edelson, Michael. "MOMA Shows Her Colors," *Camera 35*, October 1976.
Fondiller, Harvey. "Shows We've Seen," *Popular Photography*, October 1976.
Forgey, Benjamin. "A Paradox in Color Photos," *Washington Star*, September 21, 1977.
Hellman, Roberta, and Marvin Hoshino. "What

Television Has Brought," *Village Voice*, July 5, 1976.

Jorden, Bill. "Eggleston at MOMA," *Photograph*, Summer 1976.

Jorden, Bill. "Three Wizards at Odds: New York Color," *Afterimage*, February 1978.

Kozloff, Max. "How to Mystify Color Photography," *Artforum*, November 1976.

Kramer, Hilton. "Art: Focus on Photo Shows," *New York Times*, May 28, 1976.

Malcolm, Janet. "Color," in *Diana and Nikon*. Boston, Godine, 1980.

Meinwald, Dan. "Color Me MOMA," *Afterimage*, September 1976.

Murray, Joan. "The Colors of William Eggleston," *Artweek*, September 18, 1976.

Porter, Allan. "The Second Generation of Color Photographers," *Camera*, July 1977.

Preston, Malcolm. "Photographed Silence," *Newsday*, June 10, 1976.

Rathbone, Belinda, ed. *One of a Kind*. Boston, Godine, 1979.

Rice, Shelley. "Eggleston's Guide to the South," *SoHo Weekly News*, June 17, 1976.

Richard, Paul. "Galleries," *Washington Post*, September 17, 1977.

Scully, Julia. "Seeing Pictures," *Modern Photography*, August 1976.

Sembach, Klaus-Jürgen. *Amerikanische Landschaftsphotographie*. Munich, Neue Sammlung, 1978.

Szarkowski, John. "Choice: A Gallery without Walls," *Camera*, November 1976.

Szarkowski, John. *Mirrors and Windows*. New York, Museum of Modern Art, 1978.

Szarkowski, John. "Photography—A Different Kind of Art," *New York Times Magazine*, April 13, 1975.

Szarkowski, John. *William Eggleston's Guide*. New York, Museum of Modern Art, 1976.

Thornton, Gene. *Masters of the Camera*. New York, Ridge, 1976.

Thornton, Gene. "New Photography: Turning Traditional Standards Upside Down," *ARTnews*, April 1978.

Tighe, Mary Ann, and Elizabeth Lang. *Art America*. New York, McGraw-Hill, 1976.

Time-Life Books, eds. *Photography Year/1976*. New York, Time-Life Books, 1976.

Trachtenberg, Alan, Peter Neill and Peter Bunuel, eds. *The City*. New York, Oxford, 1971.

Uno, Yoshihiko, ed. *Camera Mainichi*. Tokyo, December 1974.

Upton, Barbara and John, eds. *Photography*. Boston, Little-Brown, 1976.

Zimmer, William. "William Eggleston," *Arts*, March 1978.

MITCH EPSTEIN

Mitch Epstein was born in Holyoke, Massachusetts in 1952 and has lived in New York City since 1972. He attended Union College, Schenectady, New York; Rhode Island School of Design, Providence, Rhode Island; and received his B.F.A. from Cooper Union, New York City in 1974. In 1977 Epstein taught at the Carpenter Center for the Visual Arts, Harvard University, Cambridge, Massachusetts.

Epstein has photographed in Jamaica, Europe, Egypt, and India, in addition to the United States. Though initially afraid of falling prey to picturesque cliches, Epstein realized in 1977 that he "could respond instinctively and make photographs that transcend the whole travelogue genre."

Epstein has won grants from the National Endowment for the Arts (1978) and the New York State Council on the Arts (1980). He uses a 6 x 9 cm "Siciliano" camera, which allows him to respond almost as fluidly as with a 35mm camera but provides a larger negative.

Selected Solo and Two-Person Exhibitions

1977 "Mitch Epstein/Len Jenshel," Wilcox Gallery, Swarthmore College, Swarthmore, Pennsylvania

1978 Metro Arts Gallery, Springfield, Massachusetts

1979 Rizzoli International Bookstore, New York
Light Gallery, New York

1980 Vision Gallery, Boston
"Mitch Epstein and Frank Gohlke," Harris Photograph Gallery, Flint, Michigan

Selected Group Exhibitions

1976 "Color Photographs," Cooper Union, New York

1977 "After the Fact," Carpenter Center, Harvard University, Cambridge, Massachusetts
"Some Color Photographs," Castelli Graphics, New York; traveling exhibition
"New Artists," Light Gallery, New York

1978 "Color Photography," Creative Photography Gallery, Massachusetts Institute of Technology, Cambridge
"Contemporary American Color Photography," Atlanta Gallery of Photography, Georgia
"Summer Light," Light Gallery, New York

1979 "Attitudes," Santa Barbara Museum of Art, California
"Contemporary Frontiers in Color," Arles Festival, France

1980 "Contemporary Color," University of Notre Dame, South Bend, Indiana.
"Recent Acquisitions," Museum of Fine Arts, Boston
"Urban/Suburban," Addison Gallery of American Art, Andover, Massachusetts
"Colours," LeMoyne Art Foundation, Tallahassee, Florida

Selected Bibliography

Eauclaire, Sally. "Trips of the Shutter," *Afterimage*, Summer 1979.

Grundberg, Andy and Julia Scully. "Currents: American Photography Today," *Modern Photography*, June 1980.

Lifson, Ben. "Americans Abroad," *Village Voice*, April 23, 1979.

BERNARD FAUCON

Bernard Faucon was born in Provence, France in 1949, and now resides in Paris. He received a master of philosophy degree from the Sorbonne in 1974 and has been painting and photographing since 1965. He began fabricating environments to be photographed in 1976.

Faucon stores his collection of 200 mannequins at his parents' home near the town of Apt where he works for three months every summer and for several periods of two weeks each during the winter. Shots can take as many as eight days.

Faucon says, "In general the photographs I see bore me, I do not understand what goes on there. For me, to make a photograph is to fabricate an image. It is perhaps because of that that I try to construct everything, to leave the smallest place to chance." The photographs are printed by Michel Fresson using the Fresson carbro process.

Selected Solo Exhibitions
1977 Galérie Lop Lop, Paris
1979 Galérie Agathe Gaillard, Paris
Castelli Graphics, New York
Cannon Photo Gallerie, Geneva
Rotterdam Museum, Holland
1980 Visual Studies Workshop, Rochester, New York

Selected Group Exhibitions
1980 Biennale de Paris, Musée d'Art Moderne
"Photographic Contrivances," University of California, Santa Barbara

Selected Bibliography
Barthes, Roland. "Bernard Faucon," *Zoom*, June/July 1979.
Burnside, Madeleine. "Reviews," *Arts*, February 1980.
Caujolle, Christian. "Les Chromos d'Enfance de Bernard Faucon," *Libération*, 5 Avril 1979.
Faucon, Bernard. *Les Grandes Vacances*. Paris, Herscher, 1980.
Guibert, Hervé. "Les Plaisirs de l'Enfance," *Le Monde*, 5 Avril 1979.
Laude, Audré. "Photo: Bernard Faucon chez Agathe Gaillard," *Les Nouvelles Littéraires*, 26 Avril-3 Mai 1979.
Nuridsany, Michel. "Photographie: Faucon: L'Enfance Rêvée," *Le Figaro*, 10 Avril 1975.

EMMET GOWIN

Emmet Gowin was born in Danville, Virginia in 1941. He received his B.F.A. from Virginia Professional Institute in Richmond in 1965; his M.F.A. from the Rhode Island School of Design in 1967. He now lives in Pennsylvania and commutes to Princeton University where he teaches.

Gowin's reputation rests on black-and-white photographs of his wife and family, taken in a mannered "backyard gothic" style. Mystery, morbidity, and melancholy arise from Gowin's use of the extreme contrasts and deep shadows of chiaroscuro; in some cases extreme distortions about the edges of circular images result from Gowin's imposition of a lens intended for a 4 x 5" camera on his 8 x 10" view camera.

Gowin's recent photographs of the terrains of Italy, France, and the British Isles, also taken with a large-format camera, show the austerely formal pole of his sensibility. Both bodies of his work include a few color photographs, though attention, as yet, has focused almost entirely on his achievement in black-and-white.

Gowin's black-and-white work has been included in numerous group exhibitions. He has shown regularly at the Light Gallery in New York City since 1974. In 1973 he had a solo exhibition at the Corcoran Gallery of Art, Washington, D.C. and a show with Robert Adams at the Museum of Modern Art in New York City. He has received fellowships from the John Simon Guggenheim Foundation and from the Virginia Museum of Fine Arts.

Selected Bibliography

Coleman, A.D. *The Grotesque in Photography*. New York, Summit, 1977.
Coleman, A.D. *Light Readings*. New York, Oxford, 1979.
Davis, Douglas. "Photography," *Newsweek*, October 21, 1974.
Doty, Robert. *Photography in America*. New York, Random House, 1974.
Gilson, Robert. "Family Circle," *Afterimage*, January 1977.
Gowin, Emmet. *Emmet Gowin Photographs*. New York, Knopf, 1976.
Lifson, Ben. "Americans Abroad," *Village Voice*, April 23, 1979.
Rubinfien, Leo. "Reviews," *Artforum*, January 1977.
Szarkowski, John. *Mirrors and Windows*. New York, Museum of Modern Art, 1978.
Thornton, Gene. "The New Photography: Turning Traditional Standards Upside Down," *ARTnews*, April 1978.

JAN GROOVER

Jan Groover was born in Plainfield, New Jersey in 1943. After receiving her B.F.A. in 1965 from Pratt Institute, she taught high school art for three years. She then attended Ohio State University, received her M.F.A. in 1970, and taught for three years at the University of Hartford, Connecticut, before moving to New York City.

Groover's first mature photographs were black-and-white diptychs. In 1973 she switched to color and began making her own prints in 1975. In 1977 Groover changed from modular works made up of photographs taken outdoors with a small-format camera to single-image still lifes taken in the studio with a 4 x 5" view camera. Groover is an avid collector of historical and contemporary photographs and has been experimenting with palladium printing since 1979.

Groover has won fellowships from the Guggenheim Foundation (1979), the National Endowment for the Arts (1978), and the New York State Council on the Arts (1975 and 1978).

Selected Solo and Two-Person Exhibitions
1974 Light Gallery, New York
1976 Max Protetch Gallery, New York
Corcoran Gallery of Art, Washington, D.C.
International Museum of Photography at George Eastman House, Rochester, New York
1977 Sonnabend Gallery, New York and Paris
Baltimore Museum of Art, Maryland
Bruna Soletti, Milan
1978 "Jan Groover/David Haxton," Whitney Museum of American Art, New York
Sonnabend Gallery, New York
1979 Thomas Segal Gallery, Boston
Galérie Sonnabend, Paris
Wright State University, Dayton, Ohio
Galerie Wilde, Cologne
1980 Sonnabend Gallery, New York
University Art Gallery, Rutgers University, Rutgers, New Jersey
Milwaukee Art Center, Wisconsin

Selected Group Exhibitions
1975 "Time and Transformation," Lowe Art

Gallery, University of Miami, Coral Gables, Florida

"(photo) (photo)2 . . . (photo)3," University of Maryland, College Park; San Francisco Museum of Art

1976 "Photographers' Choice," Witkin Gallery, New York

"Sequences," Broxton Gallery, Los Angeles; Max Protetch Gallery, New York

"New Directions in Color Photography," Miami-Dade Community College, Florida; San Francisco Museum of Art.

1977 "Locations in Time," International Museum of Photography at George Eastman House, Rochester, N.Y.

"Contemporary American Photographic Works," Museum of Fine Arts, Houston; traveling exhibition

1978 "Mirrors and Windows," Museum of Modern Art, New York

1979 "Attitudes," Santa Barbara Art Museum, California

"Photography in the '70s," Art Institute of Chicago

"American Images," Corcoran Gallery of Art, Washington, D.C.

1980 "Photography: Recent Directions." De Cordova Museum, Lincoln, Massachusetts

"Twenty American Artists," San Francisco Museum of Modern Art

Selected Bibliography

Bourdon, David. "Not Good Ain't Necessarily Bad," *Village Voice*, December 8, 1975.

Burnside, Madeleine. "Reviews," *ARTnews*, March 1977.

Danese, Renato, ed. *American Images*. New York, McGraw-Hill, 1979.

Eauclaire, Sally. "Knives, Forms and Spoons," *Afterimage*, February 1979.

Forgey, Benjamin. "Opposites Attract at M Street Gallery," *Washington Star*, April 25, 1976.

Foster, Hal. "Jan Groover," *Artforum*, April 1980.

Grundberg, Andy and Julia Scully. "Currents: American Photography Today," *Modern Photography*, September 1979.

Karmel, Pepe. "Reviews," *Art in America*, May 1980.

Kozloff, Max. "Photos within Photographs" and "Warm Truths and Cool Deceits," in *Photography and Fascination*. Danbury, N.H., Addison House, 1979.

Lifson, Ben. "Jan Groover's Abstractions Embrace the World," *Village Voice*, November 6, 1978.

Lifson, Ben. "Running Hot and Cold," *Village Voice*, March 20, 1978.

Lifson, Ben. "Still Lifes Run Deep," *Village Voice*, February 18, 1980.

Patton, Phil. "Reviews," *Artforum*, April 1976.

Perrone, Jeff. "Jan Groover: Degrees of Transparency," *Artforum*, January 1979.

Pincus-Whitten, Robert. "Entries," *Arts*, March 1976.

Russell, John. "(Drawing Now), One of the Modern's Best," *New York Times*, January 24, 1976.

Staniszewski, Mary Anne. "Reviews," *ARTnews*, May 1980.

Szarkowski, John. *Mirrors and Windows*. New York, Museum of Modern Art, 1978.

Thornton, Gene. "Post-modern Photography: It Doesn't Look 'Modern' at All," *ARTnews*, April 1979.

Wise, Kelly, ed. *Photographer's Choice*. Danbury, N.H., Addison House, 1975.

Woolard, Robert. "Uses and Misuses of Sequential Images," *ARTweek*, May 22, 1976.

DAVID HAXTON

Photographer and filmmaker David Haxton was born in Indianapolis, Indiana in 1943. He received his B.A. from the University of South Florida in 1965, and his M.F.A. from the University of Michigan in 1967. He teaches at William Paterson College, Wayne, N.J., and lives in New York City.

As a boy, Haxton learned the technical aspects of color photography from his father, a commercial photographer. He first majored in painting in college and did not realize the potential of photography as an art form until after he switched to filmmaking in 1969. Haxton's photographs then and now derive from the sets and materials left over from his films.

Haxton's films have been screened in the "Cineprobe" series at the Museum of Modern Art; at the Anthology Film Archives; and the Sonnabend Gallery, all in New York City. In 1978 Haxton received filmmaking grants from both the National Endowment for the Arts and the New York State Council on the Arts.

In his photography Haxton's technical choices are dictated by his desire to "obtain a high resolution image and reproduce the colors as close to the original scene as possible." On request he wrote further, "My photographs are made primarily in low light situations. Therefore it is necessary to use exposures of thirty seconds to one minute at f 22 or f 32. These long exposures positively affect color saturation. However the reciprocity factor must be compensated for in printing. I use a Sinar 4 x 5" camera with a 180mm Simmar lens. The normal lens provides adequate coverage with the least amount of distortion. I use Vericolor Type S film when photographing with fluorescent illumination and Vericolor type L film when photographing with tungsten illumination. In the darkroom I use Kodak RC74N surface paper. The prints are processed in my Kodak 30A processor with Ektaprint 300 chemistry."

Selected Solo and Two-Person Exhibitions

1978 "Jan Groover—David Haxton," Whitney Museum of American Art, New York. Galérie Sonnabend, Paris

1979 Sonnabend Gallery, New York

1980 Sonnabend Gallery, New York

Selected Group Exhibitions

1979 "Photography in the '70s," Art Institute of Chicago

"Concept Narrative Document," Museum of Contemporary Art, Chicago

"One of a Kind" traveling exhibition; circulated by Polaroid Corporation

"20 x 24," Light Gallery, New York

"Decade in Review: Selections from the '70s," Whitney Museum of American Art, New York

"Attitudes," Santa Barbara Art Museum, California

1980 "Invented Image," University of California, Santa Barbara

Selected Bibliography (photography)

Grundberg, Andy. "Photography," *SoHo Weekly News*, April 9, 1980.

Lifson, Ben. "Photography," *Village Voice*, January 29, 1979.

Rathbone, Belinda, ed. *One of a Kind*. Boston, Godine, 1979.

Smith, Philip Rand. "David Haxton," *Arts*, February 1979.

ALLEN HESS

Allen Hess was born in Dayton, Ohio in 1950. He received his B.F.A. from the School of the Dayton Art Institute in 1972; and his M.F.A. from the School of the Art Institute of Chicago in 1976. Hess currently teaches at Princeton University.

Hess first pursued photography as an undergraduate and took up color in graduate school. Among his influences, Hess cites his father, a mechanic who taught him "to be carefully observant of the way things fit together because something worked best, if at all, when put together in one unique way." Emmet Gowin, with whom Hess studied for three years in Dayton, had a profound effect on his development. Speaking of Gowin, Hess quotes Frederick Sommer, ". . . you learn not from what anyone tells you; you learn in the presence of other people's living." You are learning "the attitude that he has toward his task."

Hess has accomplished two distinct bodies of work, a series on rivers and boats begun in 1975; and a series of still lifes of birds begun in 1979. He won a National Endowment for the Arts fellowship in 1980, and was one of 24 photographers commissioned for the *Court House* project.

Of his technique Hess says, "I have a perpetual fascination for the mechanics and the medium of photography. Believing that the camera and format can impose much upon the picture, I try to choose the equipment most sympathetic to my needs." Hess works in a variety of formats ranging from 6 x 6cm to 8 x 20". The photograph reproduced in *The New Color* was made with a 6 x 9cm Horseman with a 90mm Super Angulon lens. The film was Vericolor II Type S and the negative was printed on Ektacolor 74 paper.

Selected Solo and Two-Person Exhibitions

1976 Campus Martius Museum, Marietta, Ohio

1977 Old Courthouse Museum, St. Louis, Missouri

Carnegie Art Center, Covington, Kentucky

1978 University of New Orleans Fine Arts Gallery, Louisiana

Selected Group Exhibitions

1979 Douglas Kenyon Gallery, Chicago

1980 "Photography in Louisiana: 1900–1980," New Orleans Museum of Art, Louisiana

Western Heritage Museum, Omaha, Nebraska

A Gallery for Fine Photography, New Orleans, Louisiana

Selected Bibliography

Pare, Richard, ed. *Court House*. New York, Horizon, 1978.

DOUGLAS HILL

Douglas Hill was born in London, England in 1950, moved to the New York City suburbs in 1955, and has lived in Los Angeles since 1968.

Since the age of 15, Hill has worked as a club musician, art director for a television station, commercial portrait photographer, and, since 1977, as a commercial photographer specializing in architecture and interiors. He has studied acting, made home movies, and worked in videotape. As the son of actors Peggy Hassard and Arthur Hill he had access to television and movie studios from an early age. Hill finds it fitting that many people mistake his photographs of buildings for movie sets.

Hill bought his first 35mm camera on impulse in 1969, and a year later entered the University of California at Los Angeles to study with Robert Heinecken, Darryl Curran, and others. After two years of manipulation, multiple printing, sequencing, and other forms of photographic experimentation, Hill transferred to the California Institute of the Arts where Ben Lifson encouraged straight, urban landscape photography.

In 1979 Hill was one of eight photographers chosen for the Los Angeles Documentary Proj-

ect funded by the National Endowment for the Arts. In 1978 a portfolio of his photographs was published in the May 1978 issue of *Camera* entitled "Document: The American Point of View."

Since 1977 Hill has worked in color using a 4 x 5" view camera. His film is Ektachrome 65 and he makes Cibachrome prints.

Selected Solo Exhibitions

1977 Soho/Cameraworks Gallery, Los Angeles

1978 Soho/Cameraworks Gallery, Los Angeles

1979 Arco Center, Los Angeles

1980 BC Space, Laguna Beach, California

Selected Group Exhibitions

1979 "Photo as Document." California Institute of the Arts, Valencia, California

"Photographic Directions," Security Pacific Bank, Los Angeles

"Photografie im Alltag Amerikas," Kunstgewerbemuseum, Zurich

1980 "Farbwerke," Kunsthaus, Zurich

Selected Bibliography

Johnstone, Mark. "Structures, Confidences, Nudes," *Artweek*, May 27, 1978.

Johnstone, Mark. "For Color's Sake," *Artweek*, September 22, 1979.

Porter, Allan, ed. "Document: the American Point of View," *Camera*, May 1978.

DAVID HOCKNEY

David Hockney was born in Bradford, Yorkshire, England in 1937 and lives in London, Paris, California, and New York. Besides painting, drawing, printmaking, and photography, Hockney illustrates books and designs stage sets. In 1976 he published an autobiography in the style of Benvenuto Cellini (*David Hockney by David Hockney*, New York, Abrams).

Hockney has taken "holiday snaps" since the early 60s and placed them in albums since 1967, the year he acquired his first good camera. He claims that he photographs in a desultory fashion, and that he ought not take credit for the form, color, or texture of his images. Hockney's gallery representatives select work to be exhibited from his more than 60 albums. In 1976 Sonnabend Gallery published a portfo-

lio, *Twenty Photographic Pictures*.

Hockney uses the camera as a sketching tool or as a jog for his memory. He never paints directly from photographs, and believes that the one painting whose composition was borrowed from a photograph is the worst painting he ever did. In his autobiography Hockney states: "I think photography has let us down in that it's not what we thought it was. It is something good, but it's not the answer; it's not a totally acceptable method of making pictures, and certainly it must never be allowed to be the only one; It's a view that's too mechanical, too devoid of life."

Hockney uses a Pentax K-2, a 50mm f/1.4 Takumar lens and Kodacolor II film. Both film and prints are commercially developed.

Selected Solo Exhibitions (photography)
1976 Sonnabend Gallery, New York
International Museum of Photography at George Eastman House, Rochester, New York
1978 Albright-Knox Art Gallery, Buffalo, New York
1980 Grey Art Gallery, New York University, New York

Selected Bibliography (photography)
Eauclaire, Sally. "Holiday Snaps Become Photographic Pictures," *Democrat and Chronicle* (Rochester, N.Y.), April 23, 1978.
Rathbone, Belinda, ed. *One of a Kind.* Boston, Godine, 1979.
Ratcliff, Carter. "Making an Art of Holiday Snaps," *Modern Photography*, April 1978.
Reed, David. "Viewed." *British Journal of Photography*, February 4, 1977.
Rubinfien, Leo. "Reviews," *Artforum*, February 1977.
Sullivan, Constance, ed. *Nude Photographs 1950-1980.* New York, Harper and Row, 1980.

LEN JENSHEL

Len Jenshel was born in Brooklyn, New York in 1949 and now lives in Manhattan. He received his B.F.A. from Cooper Union in 1975 where he studied with Joel Meyerowitz, Tod Papageorge, and Garry Winogrand. He has taught at Cooper Union, the International Center of Photography, and the School of Visual Arts, all in New York City.

After being trained as a black-and-white street photographer, Jenshel found it a special challenge to overcome the prejudices against color and picturesque subject matter. He learned from paintings and films, and after years of avoiding the subjects that so often led to photographic cliches, he photographed a sunset. For him it was "confrontation like in an old western gunfight."

Jenshel won a Guggenheim Fellowship in 1980, a National Endowment for the Arts photographer's fellowship in 1978, and a New York State Council on the Arts grant in 1978.

Of his technique, Jenshel writes, "All the photographs in this book were taken with the 'Siciliano' camera, which I began using in 1976. It is a hand made, hand held 6 x 9cm camera built in Brooklyn, New York by Tom Germano. It takes both 120 and 220 roll film and houses a 65mm (wide angle) Mamiya f6.3 lens. The camera is simple—a roll film back and a 4 x 5 inch press camera lens adapted for 2¼ x 3¼ inches. There are no mirrors, no meters, no timers, or even a rangefinder. It is sleek and fast for the format and enables me to stalk and maneuver as if I were using a Leica. And because of the larger negative, my prints give me sharp definition and little grain at 13 x 19 inches."

Selected Solo and Two-Person Exhibitions
1977 "Mitch Epstein/Len Jenshel," Wilcox Gallery, Swarthmore College, Swarthmore, Pennsylvania
1980 Castelli Graphics, New York
Thomas Segal Gallery, Boston

Selected Group Exhibitions
1977 "Color Photography," Cooper Union, New York
"After the Fact," Carpenter Center, Harvard University, Cambridge, Massachusetts
"Some Color Photographs," Castelli Graphics, New York; traveling exhibition
1978 "CAPS Fellows," Whitney Museum of American Art Downtown, New York
"Pictures: Photographs," Castelli Graphics, New York
1980 "U.S. Eye," XIII Olympic Games, Lake Placid, New York; traveling exhibition

Selected Bibliography
Davis, Douglas. "The Young Romantics," *Newsweek*, March 19, 1979.
Grundberg, Andy. "Artbreakers: New York's Emerging Artists," *SoHo News*, September 17, 1980.
Grundberg, Andy and Julia Scully. "Currents: American Photography Today," *Modern Photography*, June 1980.
Karmel, Pepe. "Reviews," *Art in America*, October 1980.
Lifson, Ben. "Ariel Rising," *Village Voice*, April 28, 1980.
Lifson, Ben. "Still Life with Subsidy," *Village Voice*, July 31, 1978.
Lifson, Ben. "Voice Vanguard '79—Innovators to Watch," *Village Voice*, December 18, 1978.

BARBARA KARANT

Barbara Karant was born in Chicago in 1952. She received her B.F.A. in photography from the Rhode Island School of Design and her M.F.A. from the School of the Art Institute of Chicago. Since 1977 she has been a partner in the Chicago based firm Sadin/Karant Photography, specializing in architectural photography. In addition, she has taught part time at various Chicago colleges including Loyola University and Columbia College.

Karant's career as an architectural photographer has strongly influenced her personal work. As a counterbalance to the objective documentation demanded by most clients, her own work has become more interpretative. "With no one to please but myself, I can isolate and disrupt a space to create a composition, corrupt the color and generally have a marvelous time with the activity of picturemaking."

Karant began her architectural explorations with the premise that the rooms reflected the people who inhabited them. She has revised that assumption, and now believes that interior spaces and inanimate objects have a life of

their own. In her photographs she seeks to control and manipulate the psychological, emotional, and architectural ambience of spaces through her own interpretation.

Karant made the photograph in *The New Color* with a Horseman 2¼ x 3¼" field camera with a Schneider 65mm super angulon lens. Karant has since moved to an 8 x 10" view camera. She uses Vericolor Type L film and often pushes the film to its limits in exposure and by the recording of multiple light sources.

Selected Solo and Two-Person Exhibitions
1979 "Color Photographs by Barbara Karant and Lorie Novak," CEPA Gallery, Buffalo, New York
1980 Allan Frumkin Gallery, Chicago
 Art Institute of Chicago

Selected Group Exhibitions
1974 "Photography Unlimited." Fogg Art Museum, Harvard University, Cambridge, Massachusetts
1978 "Chicago Color: Six Workers," Chicago Center for Contemporary Photography
 "Light Images, '78," Chrysler Museum at Norfolk, Virginia
1979 "Perception: Field of View," Los Angeles Center for Photographic Studies
1980 "Contemporary Photographs," Fogg Art Museum, Harvard University, Cambridge, Massachusetts

Selected Bibliography
Harmel, Carole. "Barbara Karant: Interiors," *New Art Examiner*, March 1980.
Harmel, Carole, "Chicago: Barbara Karant's Elegant Interiors," *Afterimage*, April 1980.
Hughes, Jim, ed. "Gallery 35," *35mm Photography*, Winter 1979.

HELEN LEVITT

Helen Levitt was born in Brooklyn and lives in Manhattan. She began photographing in the late 1930s and realized the potential of the medium after seeing the photographs of Henri Cartier-Bresson. In the 1940s she accompanied Walker Evans while he made his subway photographs and was greatly influenced by his talks about art and literature. At Evans's place

Levitt met James Agee who became one of her most astute and eloquent admirers. An Agee essay written in the late 1940s accompanies Levitt's photographs in her monograph *A Way of Seeing*, which was published in 1965 (Viking).

In 1947 Levitt began working with film and in the 1950s she worked professionally as a film editor. Levitt's award winning documentaries *The Quiet One* of 1949 (made with Janice Loeb, Sidney Meyers, and James Agee), and *In the Street* of 1952 (made with Loeb and Agee) are considered classics.

A Guggenheim fellowship, awarded in 1959 and renewed in 1960, encouraged Levitt's return to still photography and the switch from black-and-white to color. In 1963 her color slides were shown at the Museum of Modern Art, New York. Shortly after the museum returned the slides, they were stolen from Levitt's apartment during a burglary. Because the slides had never been duplicated, little record of her pioneering color photography remains.

Levitt began photographing again in 1971 and worked in color throughout the decade. Using a Leica and color slide film, she gravitates to densely populated areas of New York City. She has been assisted by grants from the New York State Council on the Arts' Creative Artists Public Service Program in 1974, and from the National Endowment for the Arts in 1976.

Selected Solo Exhibitions (color)
1974 "Projects: Helen Levitt in Color," Museum of Modern Art, New York
 Pratt Institute, Brooklyn, New York
1976 Nexus Gallery, Atlanta, Georgia
1977 Carlton Gallery, New York
1980 Corcoran Gallery of Art, Washington, D.C.; catalogue
 Sidney Janis Gallery, New York
 Grossmont College Gallery, El Cajon, California; catalogue

Selected Group Exhibitions (color)
1963 "Three Photographers in Color," Slide presentation with William Garnett and Roman Vishniac. Museum of Modern Art, New York

1977 "Some Color Photographs," Castelli Graphics, New York; traveling exhibition
1978 "Mirrors and Windows." Museum of Modern Art, New York; traveling exhibition
 "The Presence of Walker Evans," Institute of Contemporary Art, Boston
1979 "Curator's Choice: Contemporary American Photography," Venezia La Fotografia, Venice
1980 American Pavilion, Salford '80, Salford, England

Selected Bibliography (color)
Davis, Douglas. "Photography," *Newsweek*, October 21, 1974.
Davis, Douglas with Mary Rourke. "Photography: New Frontiers in Color," *Newsweek*, April 19, 1976.
Edwards, Owen. "Her Eye is on the City," *New York Times Magazine*, May 4, 1980.
Glander-Bandyck, Janice. "Helen Levitt," *Arts*, March 1977.
Grundberg, Andy. "Reviews," *Art in America*, July 1977.
Grundberg, Andy. "On the Street, in the Shadows, of a Piece," *SoHo News*, May 14, 1980.
Grundberg, Andy. "Some Fare Over the Rainbow," *SoHo News*, May 21, 1980.
Hellman, Roberta and Marvin Hoshino. *Helen Levitt: Color Photographs*. Grossmont College Gallery, El Cajon, California, 1980.
Hellman, Roberta and Marvin Hoshino. "Levitt Comes in Color, Too," *Village Voice*, January 24, 1977.
Hellman, Roberta and Marvin Hoshino. "The Photographs of Helen Levitt," *Massachusetts Review*, Photography Issue, Winter 1978.
Lifson, Ben. "Dichtung und Wahrheit," *Village Voice*, May 26, 1980.
Livingston, Jane. *Helen Levitt*. Corcoran Gallery of Art, Washington, D.C., 1980.
Maddow, Ben. "New York City: Helen Levitt," *Aperture*, vol. 19, no. 4.
Rubinfien, Leo. "Reviews," *Artforum*, March 1977.
Westerbeck, Colin L. Jr. "Reviews," *Artforum*, May 1980.
Zelevansky, Lynn. "Levitation," *Afterimage*, October 1980.

261

JOE MALONEY

Joe Maloney was born in Worcester, Massachusetts in 1949 and grew up in Paramus, New Jersey. He was educated at Lycoming College, Williamsport, Pennsylvania, and Ramapo College, New Jersey, where he received his B.A. in photography in 1976. In 1979 Maloney moved to New York City. Since 1977 he has worked at Pace Editions. In 1979 he was an instructor at the International Center of Photography, New York City.

Maloney learned black-and-white photography while in the army in 1970 and 1971. Subsequently he worked as a store detective and credits his experience as a voyeur behind the two-way mirror as practice for the acute observation required of a photographer. At Ramapo College, Maloney studied with David Freund and Ed Scully, who acquainted him with the artistic and technical poles of photography respectively.

Since 1976 Maloney has worked with a 4 x 5" view camera. The unusual colors in his prints derive from his preference for Vericolor type L negative film. The film is balanced for artificial light, so Maloney uses an 85B conversion filter in daylight. Exposures range from 1/10 of a second to several minutes. He usually uses a 90mm (wide angle) lens. Maloney makes all prints on Ektacolor 74RC paper. Speaking of his color balance he says, "It is a subjective choice, made anew each time the image is printed, with little regard for faithfulness to the original scene."

Selected Solo Exhibitions
1976 Hannibal Goodwin Gallery, Westwood, New Jersey
1978 Rawspace Gallery, New York
Light Gallery, New York
1979 Galerie Schurmann & Kicken, Aachen
Zur Stockeregg, Zurich

Selected Group Exhibitions
1978 "Amerikanische Landschaftsphotographie: 1860-1978," Neue Sammlung, Munich
"New York, New York," Museum of Modern Art, New York
1979 "Views of America," Museum of Modern Art, New York
"U.S. Eye," XIII Olympic Games, Lake Placid, New York; traveling exhibition
1980 "Urban/Suburban," Addison Gallery of American Art, Andover, Massachusetts
"Movin'," Museum of Modern Art, New York

Selected Bibliography
Grundberg, Andy, and Julia Scully. "Currents: American Photography Today," *Modern Photography*, June 1980.
Sembach, Klaus-Jurgen. *Amerikanische Landschaftsphotographie*. Munich, Neue Sammlung, 1978.

KENNETH MCGOWAN

Kenneth McGowan was born in 1940 in Ogden, Utah and holds an M.A. from the University of California at Los Angeles. He began photographing in black-and-white in 1959 and switched to color in 1967. McGowan's earliest visual memories are of Technicolor movies, though he was impressed by Abstract Expressionist painting while a high school student.

McGowan is self-taught. Technical facility has come from 15 years of commercial work, including portraits, slide shows, magazine assignments, record album covers, pinups, and special effects for movies.

For the past six years McGowan has used a 2¼ x 2¼" camera. He prefers the normal 80mm lens for its "bluntness." He works with transparencies because they can be seen "right away" and prints in Cibachrome for extreme clarity, color brilliance, and supersaturated color.

Selected Solo Exhibitions
1977 Castelli Graphics, New York
1979 Castelli Graphics, New York
1980 Los Angeles Institute of Contemporary Art

Selected Group Exhibitions
1977 "Some Color Photographs," Castelli Graphics, New York; traveling exhibition
1978 "Color Photographs," Thomas Segal Gallery, Boston
"The American West," Galerie Zabriskie, Paris
"The Male Nude," Marcuse Pfeifer Gallery, New York
1979 "One of a Kind;" traveling exhibition circulated by Polaroid Corporation
"Color: A Spectrum of Recent Photography," Milwaukee Art Center, Wisconsin
1980 "Urban/Suburban," Addison Gallery of American Art, Andover, Massachusetts
"Photography: Recent Directions," De Cordova Museum, Lincoln, Massachusetts
"Contemporary Photographs," Fogg Art Museum, Harvard University, Cambridge, Massachusetts

Selected Bibliography
Foto, (Sweden), October 1978.
Frackman, Noel. "Kenneth McGowan," *Arts*, February 1978.
Grundberg, Andy and Julia Scully. "Currents: American Photography Today," *Modern Photography*, October 1980.
Jorden, Bill. "Three Wizards at Odds: New York Color," *Afterimage*, February 1978.
New West Magazine, March 1978.
Popular Photography Annual/1977, New York, Ziff-Davis
Rathbone, Belinda, ed. *One of a Kind*. Boston, Godine, 1979.
Zoom, March 1976.

ROGER MERTIN

Roger Mertin was born in 1942 in Bridgeport, Connecticut, and now lives in Rochester, New York. While a student at the Rochester Institute of Technology, he became seriously interested in photography and studied with Nathan Lyons and Minor White at workshops. In 1965 he received his B.F.A. from R.I.T. and in 1972 received his M.F.A. from the State University of New York College at Buffalo through the Visual Studies Workshop's photographic studies program.

Mertin has taught at the San Francisco Art Institute; University of New Mexico, Albuquerque; and the Visual Studies Workshop. Since 1975 he has been assistant professor of fine arts at the University of Rochester.

Mertin's black-and-white photographs have been widely exhibited and published. His first major solo exhibition was at the George Eastman House in 1966. He has shown regularly at the Light Gallery since 1973; and in 1979 had a major exhibition of his black-and-white work at the Chicago Center for Contemporary Photography, Columbia College. In addition, his black-and-white work has been featured in major group exhibitions from "Vision and Expression" (George Eastman House, 1979) to "Mirrors and Windows" (Museum of Modern Art, 1978).

Mertin's "Plastic Love Dream" of 1968 featured nudes enshrouded in plastic. His "Trees" (1971–76) showed the startling transformations effected by flash. Since 1976 Mertin has worked with an 8 x10″ view camera making quiet, implosive, and overridingly formal records of such all American subjects as apple trees and basketball hoops.

A little-known color project dates from 1973. Mertin and photographer Michael Becotte traveled across America making color photographs that were exhibited in "Road Shots" at the George Eastman House in 1974. The show mixed formal photographs with works resembling the out-of-focus, off-balanced, red-eyed efforts of amateurs. Views often included car windows and subjects no tourists would take, such as the backs of billboards. The exhibition was designed by the photographers so that viewers would experience it like a journey, traveling quickly over groups of small pictures and stopping for closer inspections of larger ones.

In 1978 Mertin began pursuing color seriously. He first worked with Polacolor sheets in the back of his 8 x 10″ view camera and a year later switched to color negative film.

In 1974 Mertin received a Guggenheim Fellowship and a C.A.P.S. grant from the New York State Council on the Arts. In 1976 he received a fellowship from the National Endowment for the Arts.

Selected Color Exhibitions
1974 "Road Shots" (with Michael Becotte), International Museum of Photography at George Eastman House, Rochester, New York
1979 "One of a Kind;" traveling exhibition circulated by Polaroid Corporation "20 x 24" Light Gallery, New York "Polaroid Photography," Philadelphia College of Art

Selected Bibliography (Color)
Eauclaire, Sally. "Exhibit Shows Photos from 'On the Road,'" *Democrat and Chronicle* (Rochester, N.Y.), December 16, 1974.
Rathbone, Belinda, ed. *One of a Kind*. Boston, Godine, 1979.

JOEL MEYEROWITZ

Joel Meyerowitz was born in New York City in 1938. He studied painting and medical drawing at Ohio State University and received his B.F.A. in 1959. After graduation, he returned to New York City to work in advertising as an art director and designer. That career ended abruptly in 1962 when Meyerowitz saw Robert Frank photographing and realized the gestural potential of 35mm photography. Though Meyerowitz initially used color slide film, making color prints proved so difficult that the work remained "invisible." As a result he began shooting in black-and-white so that prints could be made and exhibited. Color became the more important side of his work in 1973, when Meyerowitz began color printing.

In 1976 Meyerowitz acquired an 8 x 10″ Deardorff view camera for its descriptive powers. He still uses the 35mm camera and argues that the two poles of his work make him no more schizophrenic than the painter who also draws.

Meyerowitz won Guggenheim Fellowships in 1970 and 1978; a National Endowment for the Arts Photographer's fellowship in 1978; and a New York State Council on the Arts grant in 1976. In 1978 he won a National Endowment for the Humanities grant with Colin L. Westerbeck, Jr. to write a book on the history of street photography. Since 1971 Meyerowitz has been an adjunct professor at Cooper Union, New York City.

Selected Solo Exhibitions (color)
1977 Witkin Gallery, New York
1978 "Cape Light," Museum of Fine Arts, Boston; traveling exhibition
1979 Akron Art Institute, Akron, Ohio "St Louis and the Arch," St Louis Art Museum, Missouri
1980 Stedelijk Museum, Amsterdam Grapestake Gallery, San Francisco San Francisco Museum of Modern Art

Selected Group Exhibitions (Color)
1976 "Warm Truths and Cool Deceits;" traveling exhibition curated by Max Kozloff
1977 "Inner Light," Museum of Fine Arts, Boston
1978 "Mirrors and Windows," Museum of Modern Art, New York; traveling exhibition
1979 "American Images," Corcoran Gallery of Art, Washington, D.C.; traveling exhibition

Selected Bibliography
Allara, Pamela. "Chartreuse Light in a Phone Booth," *ARTnews*, February 1979.
Callahan, Sean, ed. "Moody Images from Cape Cod," *American Photographer*, August 1978.
Danese, Renato, ed. *American Images*. New York, McGraw-Hill, 1979.
Davis, Douglas. "New Frontiers in Color," *Newsweek*, April 19, 1976.
Davis, Douglas. "The Young Romantics," *Newsweek*, March 19, 1979.
Eauclaire, Sally. "From City to Cape," *Afterimage*, Summer 1979.
Edwards, Owen. "An Arch Fantasy," *Saturday Review*, August, 1980.
Edwards, Owen. "The Eighties: Decade of Another Color," *Saturday Review*, May 12, 1979.
Fern, Alan. "Three Photographers," *New York Times Book Review*, September 21, 1980.
Grundberg, Andy. "Joel Meyerowitz Gets His View," *SoHo Weekly News*, July 26, 1979.
Grundberg, Andy. "Joel Meyerowitz, Cape Cod: Making Beauty an Issue," *Modern Photography*, June 1979.
Grundberg, Andy. "Not Just Pretty Pictures,"

SoHo Weekly News, April 26, 1979.

Grundberg, Andy. "Reviews," *Art in America*, July/August 1978.

Grundberg, Andy, and Julia Scully. "Currents: American Photography Today," *Modern Photography*, June 1980.

Goldberg, Vicki. "The Photographer and the Monument," *American Photographer*, September 1980.

Jorden, Bill. "Three Wizards at Odds: New York Color," *Afterimage*, February 1978.

Kozloff, Max. "The Coming of Age of Color," and "Warm Truths and Cool Deceits," in *Photography and Fascination*. Danbury, N.H., Addison House, 1979.

Kozloff, Max. "Joel Meyerowitz," *Aperture*, Number 78, 1977.

Lifson, Ben. "Photography," *Village Voice*, December 5, 1977.

Lifson, Ben. "Running Hot and Cold," *Village Voice*, March 20, 1978.

McDarrah, Fred W. "Five Photographers," *New York Times Book Review*, April 1, 1979.

Maddow, Ben. *Faces*. Greenwich, Conn., New York Graphic Society, 1977.

Meyerowitz, Joel. *Cape Light*. Boston, Museum of Fine Arts/New York Graphic Society, 1978.

Meyerowitz, Joel. *St. Louis and the Arch*. Boston, New York Graphic Society/St. Louis Art Museum, 1980.

Porter, Allan, ed. "The Second Generation of Color Photographers," *Camera*, July 1977.

Porter, Allan, ed. "Transfiguration/Configuration," *Camera*, September 1977.

Sullivan, Constance, ed. *Nude Photographs 1850–1980*. New York, Harper and Row, 1980.

Szarkowski, John. *Looking at Photographs*. New York, Museum of Modern Art, 1973.

Szarkowski, John. *Mirrors and Windows*. New York, Museum of Modern Art, 1978.

Thornton, Gene. "Post-Modern Photography: It Doesn't Look 'Modern' at All," *ARTnews*, April 1979.

JOANNE MULBERG

Joanne Mulberg was born in New York City in 1954 and has spent most of her life on Long Island. She received her B.F.A. from Cooper Union and has been color printer to Joel Meyerowitz since 1976. Mulberg has worked as a freelance photographer and taught photography summers at the Usdan Center for the Creative and Performing Arts. She received a 1981 Creative Artists Public Service grant from the New York State Council on the Arts.

During her final year as a painting student at Cooper Union, Mulberg sought to alleviate tensions by walking the streets of Long Island with a 35mm camera. She found the experience so liberating that within a year her new love of photography superseded her painting.

Mulberg's first mature photographs were of the windows of banks, storefronts, and beauty salons on Long Island, New York City, and Paris. The fusion of reflections and views through the glass created unexpected, and often amusing, juxtapositions. More recent work is preoccupied with light, weather, construction, and other facets of the visual world in a state of change.

Mulberg now uses a 2¼ x 2¼" twin reflex camera. Because the photographer must look down to see the image on the ground glass, Mulberg feels more like an observer than a participant while she is working: "It's less intrusive and seemingly a more discreet way to look at things." When she prints, Mulberg tries to "translate the right color and feeling of what it was which moved me in the first place. More and more, I feel like the photographic paper is my canvas and colored light is my palette."

Selected Exhibitions

1976 "Warm Truths and Cool Deceits," traveling exhibition curated by Max Kozloff
 "Contemporary Color Photographs," Bard College, Annandale-on-Hudson, New York

1980 "Zeitgenossiche Amerikanische Farbphotographie," Galerie Rudolf Kicken, Cologne

Selected Bibliography

Kozloff, Max. "Warm Truths and Cool Deceits," in *Photography and Fascination*. Danbury, N.H., Addison House, 1979.

Lifson, Ben. "Running Hot and Cold," *Village Voice*, March 20, 1978.

Mulberg, Joanne. "Discoveries in the Changing Visual World," *Lens*, November/December 1979.

Mulberg, Joanne. "Pieces of Reality: The Art of Reflected Visions," *Lens on Campus*, September 1979.

OLIVIA PARKER

Olivia Parker was born in Boston in 1941 and now lives in Manchester, Mass. She received a B.A. in art history from Wellesley College in 1963. Parker began as a painter and did not take up photography until the early 1970s. Still life was a natural direction because she has been a collector of objects such as tintypes, etchings, fabrics, shells, and feathers since childhood.

Parker is best known for the black-and-white selenium toned prints reproduced in her 1978 monograph *Signs of Life*. She took up color photography in 1978 when Polaroid Corporation invited her to experiment with its recently introduced 8 x 10" materials. Parker was immediately attracted by the medium's instant feedback and came to feel Polaroid's rich saturations and high contrasts could be advantages. She uses an 8 x 10" Deardorff view camera with a Fujinon 250 lens. She shoots in mixed light and often uses filtration for long exposures. Because Polaroid's color products do not result in a usable negative, Parker usually tries to make an edition of three to nine prints "depending upon whether or not the natural light holds out and whether or not my construction collapses."

In 1978 Parker won a fellowship from the Massachusetts Artists Foundation. A limited-edition portfolio of original prints, *Ephemera*, was published in 1977 with an introduction by Gyorgy Kepes.

Selected Solo Exhibitions

1977 Vision Gallery, Boston
1978 Art Institute of Chicago
1979 Focus Gallery, San Francisco
 Friends of Photography, Carmel, California
 The Photography Place, Philadelphia
 Vision Gallery, Boston

1980 Marcuse Pfeifer Gallery, New York
Work Gallery, Zurich

Selected Group Exhibitions
1979 "One of a Kind;" traveling exhibition circulated by Polaroid Corporation
1980 "Zeitgenossische Amerikanische Farbphotographie," Galerie Rudolf Kicken, Cologne
The Artists Foundation (group show of 1978-79 fellowship recipients); traveling in Massachusetts

Selected Bibliography
Edwards, Owen. "Olivia Parker," *American Photographer*, February 1980.
Edwards, Owen. "The Clear Yankee Eye of Olivia Parker," Rev. of *Signs of Life, Saturday Review*, March 3, 1979.
Featherstone, David. "Olivia Parker: Shaping Color to Sensibility," *Modern Photography*, March 1980.
Goldberg, Vicki. "Signs of (Still) Life," *American Photographer*, May 1979.
Kramer, Hilton. "Olivia Parker (Marcuse Pfeifer)," *New York Times*, February 29, 1980.
Parker, Olivia. *Signs of Life*. Boston, Godine, 1979.
Popular Photography Annual/1978
Popular Photography Annual/1980

JOHN PFAHL

John Pfahl was born in 1939 in New York City. Majoring in art at Syracuse University, he received his B.F.A. in 1961 and his M.A. in 1968. From 1961 to 1968, Pfahl served in the army and worked as a commercial and architectural photographer. In 1968 he joined the faculty of the Rochester Institute of Technology where he still teaches. Pfahl commutes the 70 miles from his home in Buffalo.

Pfahl first attained recognition for screening photographs onto three-dimensional plastic bubbles. By 1974 he was concerned about the effect of plastic solvents on his health and felt that the work was all too literally part of the 60s fad for stretching the medium. Having already subjected a two-dimensional image to a three-dimensional surface, Pfahl began conspicuously translating a three-dimensional subject to the two-dimensions of the photograph. This was accomplished by placing tape, rope, and other materials so that they would appear to be markings on the print itself.

Pfahl's inspiration came as a result of a short-lived experiment with avant-garde musical notation. Working in Buffalo with composer David Gibson, Pfahl taped trees in such a way that musicians could follow the notation. Gibson moved to Albany, and Pfahl soon discovered that he couldn't present his photographs both to the audience and to musicians without staging "a glorified slide show." Nevertheless, the experience was an epiphany, and Pfahl decided to drop the musical aspects in favor of the visual.

In 1978 Pfahl began making images that only implied his participation; in 1979 he began photographing from the interiors of buildings, focusing on the ready-made views through picture windows.

Pfahl received a photographer's fellowship from the National Endowment for the Arts in 1977, and grants from the New York State Council on the Arts in 1975 and 1979.

Pfahl uses Vericolor II type S sheet film exposed in an Arca Swiss 4 x 5″ view camera. He uses a variety of lenses but generally favors the wider angles. He uses Polaroid 55 material as a monitoring device and exposure guide. Final prints are made on Ektacolor RC paper and occasionally by dye transfer. He chooses color because it permits the introduction of an "unabashedly sensuous quality which serves to flesh out the bare conceptual basis for the work." Pfahl's constant concern is to keep within the framework of photography. "If it were conceptual art, black-and-white Polaroid—any cheap, fast, dumb way possible would do."

Selected Solo Exhibitions
1976 Visual Studies Workshop, Rochester, New York
1978 Princeton University Art Museum, Princeton, New Jersey
Robert Freidus Gallery, New York
1979 Thomas Segal Gallery, Boston
Robert Freidus Gallery, New York
1980 Kathleen Ewing Gallery, Washington, D.C.
Visual Studies Workshop Gallery, Rochester, New York
Robert Freidus Gallery, New York

Selected Group Exhibitions
1972 "60s Continuum," International Museum of Photography at George Eastman House, Rochester, New York
1976 "Photography: Rochester, N.Y.," American Cultural Center, Paris
"Upstate Color: Michael Bishop, Phil Block, John Pfahl," Everson Museum of Art, Syracuse, New York
1977 "The Great West: Real/Ideal," University of Colorado, Boulder
1979 "Color: A Spectrum of Recent Photography," Milwaukee Art Center, Wisconsin
"Attitudes," Santa Barbara Museum of Art, California
"Photography in the '70s," Art Institute of Chicago
"Fabricated to be Photographed," San Francisco Museum of Modern Art; traveling exhibition
"Divola, Henkel, Parker, Pfahl," Visual Studies Workshop, Rochester, New York; traveling exhibition
1980 "Photography: Recent Directions," De Cordova Museum, Lincoln, Massachusetts
"Zeitgenossische Amerikanische Farbphotographie," Galerie Rudolf Kicken, Cologne
"Reasoned Space," Center for Creative Photography, Tucson, Arizona

Selected Bibliography
Artner, Alan G. "Contemporary Photographs that Touch a Conceptual Base," *Chicago Tribune*, July 18, 1980.
Bannon, Anthony. "John Pfahl's Picturesque Paradoxes," *Afterimage*, February 1979.
Bell, Jane. "Reviews," *ARTnews*, October 1979.
Coke, Van Deren. *Fabricated to be Photographed*. San Francisco Museum of Modern Art, 1979.

Eauclaire, Sally. "His Forte: Fooling the Eye," *Democrat and Chronicle* (Rochester, N.Y.), February 5, 1978.

Fischer, Hal. "Curatorial Constructions," *Afterimage*, March 1980.

Grundberg, Andy. "Gone with the Wind," *SoHo News*, October 8, 1980.

Grundberg, Andy. "Photography," *SoHo Weekly News*, May 17, 1979.

Grundberg, Andy. "Photos that Lie," *Modern Photography*, May 1978.

Hume, Sandy, Ellen Manchester and Gary Metz, eds. *The Great West: Real/Ideal*. Boulder University of Colorado; distributed by Light Impressions, 1977.

Lifson, Ben. "You Can Fool Some of the Eyes Some of the Time," *Village Voice*, March 6, 1978.

Picture, March 1980, #14.

Rice, Shelley. "Reviews," *Artforum*, November 1980.

Tatransky, Valentin. "Reviews," *Arts*, April 1978.

Time-Life Books, eds. "Discoveries," *Photography Year/1979*. New York, Time-Life Books, 1979.

BILL RAVANESI

Bill Ravanesi was born in Boston in 1947. He received his B.S. in biology at the University of Massachusetts, Amherst in 1969; and his M.A. in photography from Goddard College, Plainfield, Vermont in 1978. He now lives in Boston.

In 1974 Ravanesi's political commitments led him to photograph activists Angela Davis, the Berrigan brothers, and Alfredo Lopez. With Flora Haas, a political writer for the Boston *Phoenix*, an alternative publication, he spent several days with Cesar Chavez in New England as Chavez led marches, stood in picket lines, and held press conferences. According to Ravanesi, "Chavez planted a seed within me. I decided to expand my commitment to the United Farm Workers, from documenting anti-Gallo winery marches and picket lines in New England to planning a large-format documentary project about farm labor in California." After photographing the Salinas, Coachella, Imperial, and San Joaquin valleys of California, Ravanesi moved on to the Pioneer Valley area of western Massachusetts and Connecticut, and the lower Rio Grande Valley in Texas and Mexico.

In 1980 Ravanesi was awarded a National Endowment for the Arts photographic survey grant, and fellowships from the Ford Foundation and Massachusetts Artist Foundation.

Ravanesi gained technical facility through a variety of part-time jobs as a photographic laboratory assistant, consultant, and researcher. He has assessed films, printed photographic murals, refined three-dimensional photography, and worked as a freelance industrial photographer.

In 1975 Ravanesi purchased a 4 x 5" Deardorff view camera. He calls the 210mm Symmar Schneider lens his "workhorse." Most of his photographs are platform shots taken from the roof of his International truck. He uses Vericolor II type L film, generally with an 85B filter, and prints his negatives on Ektacolor 74N resin-coated paper. Ravanesi heat dries the processed prints to "add a mellow sheen and a slight increase in brightness."

Selected Solo Exhibitions
1979 "Farm Labor Portraits, Agricultural Landscapes," Boris Gallery, Boston
1980 Hampshire College, Amherst, Massachusetts
 Yuen Lui Gallery, Seattle, Washington

Selected Group Exhibitions
1978 "4 x 5 Plus" Community Arts Gallery, University of Massachusetts, Boston
1979 "Filipino and Mexican Portraits," First Annual Third World Conference, Third World Communities and Human Rights, Harvard Law School, Harvard University, Cambridge, Massachusetts
 "La Fotografia," Venezia '78, Venice

Selected Bibliography
Burns, James D. "Bill Ravanesi: Stilled Lives," *Northwest Photography* (Seattle, Yuen-Lui Gallery), April 1980.

Cooley, Martha. "Photographer Documents Agricultural Workers," *Bay State Banner* (Roxbury, Mass.), February 8, 1979.

Greene, Patrica. "His Subject: Forgotten Filipino Farmworkers," *Northampton Gazette* (Northampton, Mass), October 21, 1978.

Ravanesi, Bill. "A Farm Labor Project," *Picture*, issue #7, 1978.

Zellman, Ande. "Get the Picture," *Boston Phoenix*, October 10, 1978.

DON RODAN

Don Rodan was born in Cincinnati, Ohio in 1950 and now lives in New York City. He received his B.F.A. from Cooper Union in 1974 and has done editorial work for the *New York Times*, *Harpers*, *New York* magazine, and other publications. Rodan is best known for using the SX-70 system to wittily redefine such themes as the Greek myths, Biblical figures, nudes, still lifes, and Hokusai's views of Mt. Fuji. Rodan's "Cliches" were for several years a weekly feature of the *Village Voice*.

Most of Rodan's efforts are prior to the making of an exposure. He starts by drawing, then looks for the right models and props. Rodan then usually shoots between 10 and 30 images, which he edits down to the final image. He often uses the Polaroid SX-70 system, combined with various lighting techniques, including color-balanced parabolic lighting, stroboscopic flash, and flash bars made for use with the SX-70. In the case of "The Greek Myths," Rodan used the final Polaroid original as a matrix for the edition of prints. An internegative was made and then printed on Ektacolor resin-coated paper to make possible an edition of 50.

Speaking of his technique, Rodan says, "The nature of the Polaroid materials suits my objective approach to photographing the tableaux I construct. It's like a theatre within a theatre. There is a degree of improvisation and adjustment that takes place during the process to refine the various elements of the image, but it is basically a well-rehearsed act. Though the technical aspects of my work are quite simple, I give them the compulsory attention. I try to follow Man Ray's maxim: 'Le moindre effort possible pour le plus grand résultat possible. C'est ma règle.'"

Solo Exhibitions
1977 International Museum of Photography at George Eastman House, Rochester, New York
1979 Castelli Graphics, New York

Selected Group Exhibitions
1977 "Some Color Photographs," Castelli Graphics, New York; traveling exhibition
1978 "One of a Kind," traveling exhibition circulated by Polaroid Corporation
 "130 Years of Ohio Photographs," Columbus Museum of Art, Columbus, Ohio
1979 "Fabricated to be Photographed," San Francisco Museum of Modern Art; traveling exhibition
1980 "Photography: Recent Directions," De Cordova Museum, Lincoln, Massachusetts
 "Around Picasso," Museum of Modern Art, New York, Art Lending Service

Selected Bibliography
Black, Roger, Annie Leibovitz and Karen Mullarkey, eds. "Twelve Hot Photographers," *Rolling Stone*, May 19, 1977.
Coke, Van Deren. *Fabricated to be Photographed*. San Francisco Museum of Modern Art, 1979.
Eauclaire, Sally. "He Stages His Own Events and Catches Them on Film," *Democrat and Chronicle* (Rochester, N.Y.), July 2, 1977.
Fischer, Hal. "Curatorial Constructions," *Afterimage*, March 1980.
Grundberg, Andy. "One + One = One," *Modern Photography*, March 1978.
Hughes, Jim. "The Instant and Beyond," *Popular Photography*, January 1979.
Lifson, Ben. "Photography," *Village Voice*, January 22, 1979.
Murray, Joan. "Fabricated for the Camera," *Artweek*, December 8, 1979.
Rathbone, Belinda, ed. *One of a Kind*. Boston, Godine, 1979.
SX-70 Art. New York, Lustrum, 1979.
Whelan, Richard. "Reviews," *ARTnews*, May 1979.

LEO RUBINFIEN

Leo Rubinfien was born in Chicago in 1953. He lived in Chicago and then Cambridge, Massachusetts until he was 10 years old, when his family moved to Japan.

Though Rubinfien made photographs while in Japan and discovered the work of Cartier-Bresson while in high school, he first studied philosophy and literature at Reed College, Portland, Oregon. Then desiring "a more physical hold on the world than reading and thinking provided," he transferred to the California Institute of Arts to study photography. He received his B.F.A. there in 1974. In 1976 he earned an M.F.A. from the Yale School of Art, New Haven, Connecticut. While a Yale student he won a Ford Foundation grant.

From 1976 to 1978 Rubinfien wrote art criticism for a variety of publications including *Artforum* and *Art in America*. When he returned to photography, it was with a new attitude: "I came to think less about other pictures as sources of my pictures than of the world as my source." Because color describes the world more literally and more seductively, he switched from black-and-white to color at that time. Rubinfien uses a 6 x 9cm "Siciliano" camera, Kodacolor II or Kodacolor 400 film, and makes 16 x 20" prints.

Since 1978 he has taught photography at the School of Visual Arts, New York City. In 1976–77 he taught at Swarthmore College, Swarthmore, Pennsylvania.

When not traveling to Japan, Europe, or the British Isles, Rubinfien lives in Manhattan.

Selected Exhibitions
1975 "California Landscapes," Oakland Museum, California
 "Leo Rubinfien/Mitchell Paine," University of Rochester, New York
1976 "Recent American Still Photographs," Edinburgh Arts Festival, Edinburgh
1977 "After the Fact," Carpenter Center, Harvard University, Cambridge, Massachusetts
1980 "Likely Stories," Castelli Graphics, New York

Selected Bibliography
Lifson, Ben. "Photography," *Village Voice*, December 19, 1977.
Lifson, Ben. "Summer Stock," *Village Voice*, July 16, 1980.

LUCAS SAMARAS

Lucas Samaras was born in Kastoria, Macedonia, Greece in 1936 and arrived in the United States in 1948. He photographed occasionally in high school and as a student at Rutgers University, yet Samaras did not pursue photography aggressively until he began the "Auto-Polaroids" in 1969. He frequently used photographs in his other artworks, however. Most of the "Boxes" after 1963 contain photographic self-portraits. Some of these were developed as line, by dropping out the half-tones, and further transformed by pins, yarn, and string. Samaras also incorporated photographs in his "X-Ray Drawings" and used pornographic photographs as starting point for his pastels.

In 1969 Samaras began using Polaroid 360 materials in the "Auto-Polaroids." Double to multiple images were created by fooling the electric eye of the camera, thus leaving him about 20 seconds to manipulate the number of exposures. Samaras also painted patterns on many of these images. At the time of the publication of the *Samaras Album* in 1971, there were 405 altogether.

In 1973 Samaras began using the SX-70 system for the "Photo-Transformations." Transformations here were achieved prior to exposure through illumination and homemade filters, and after exposure by manipulating the chemical emulsions while they were still malleable.

In the summer of 1978 Samaras began working with 8 x 10" Polacolor sheets and a view camera, photographing bizarre conglomerations of objects in ambiguous spaces. For the series "Sittings," a clothed Samaras posed nearby friends clothed only in colored light. Samaras has also worked with the 20 x 24" "Big Polaroid."

Selected Solo Exhibitions (Photography)
1971 Pace Gallery, New York

1972 Samaras Retrospective, Whitney Museum of American Art, New York
Harkus-Krakow Gallery, Boston
Moore College of Art, Philadelphia
"Documenta V," Kassel, Germany
1974 Pace Gallery, New York
1975 Pace Gallery, New York
Art Galleries, California State University, Long Beach; traveling exhibition
1976 Pace Gallery, New York
1980 Pace Gallery, New York

Selected Group Exhibitions (Photography)
1973 "By SX-70," Light Gallery, New York
1974 "71st American Exhibition," Art Institute of Chicago
"Photography in America," Whitney Museum of American Art, New York
1975 "Body Works," Museum of Contemporary Art, Chicago
1978 "Mirrors and Windows," Museum of Modern Art, New York; traveling exhibition
"Manipulative Photography," Anderson Gallery, Virginia Commonwealth University, Richmond, Virginia
1979 "Photographic Surrealism," The New Gallery, Cleveland, Ohio
"Self as Subject/A Direction in Contemporary Photography," University of New Hampshire
"One of a Kind;" traveling exhibition circulated by Polaroid Corporation
"SX-70 Art;" traveling exhibition circulated by Polaroid Corporation
"Invented Images," University of California at Santa Barbara

Selected Bibliography (Photography)
Baker, Kenneth. "Reviews," *Artforum*, May 1972.
Baker, Kenneth. "Reviews," *Art in America*, July/August 1974.
Bernstein, Richard. "Interview," *Andy Warhol's Interview*, December 1972.
Bunnell, Peter. "Going the Way of All Flash," *Village Voice*, November 30, 1972.
Bunnell, Peter. *Photographic Portraits*. Moore College of Art, Philadephia, 1972.

Campbell, Lawrence, "Reviews and Previews," *ARTnews*, December 1971.
Coleman, A.D. *The Grotesque in Photography.* New York, Summit, 1977.
Coleman, A.D. *Lee, Model/Parks/Samaras/ Turner: Five Interviews Before the Fact.* Boston, Photographic Resource Center, 1979.
Coleman, A.D. *Light Readings.* New York, Oxford, 1979.
Doty, Robert. *Photography in America.* New York, Random House, 1974.
Ffrench-Frazier, Nina. "Reviews," *ARTnews*, February 1977.
Glenn, Constance W., ed. *Lucas Samaras: Photo-Transformations.* Long Beach, California State University; New York, E.P. Dutton, 1975.
Glimcher, Arnold. *Lucas Samaras: Photo-Transformations.* Pace Gallery, New York, 1974.
Glueck, Grace. "A Little Fetish Footage," *New York Times*, August 3, 1969.
Glynn, Eugene. "Reviews," *ARTnews*, June 1974.
Hughes, Robert. "Menaced Skin," *Time*, November 27, 1972.
Hunter, Sam and John Jacobus. *American Art of the Twentieth Century.* New York, Abrams, 1973.
Kozloff, Max. "Reviews," *Artforum*, June 1974.
Kozloff, Max. "The Uncanny Portraits: Sanders, Arbus, Samaras," in *Photography and Fascination.* Danbury, N.H., Addison House, 1979.
Kramer, Hilton. "A Fresh Look at Photos," *New York Times*, March 30, 1974.
Kramer, Hilton. "Inspired Transformations," *New York Times*, November 26, 1972.
Kramer, Hilton. "The Photograph Assumes a New 'Artiness,'" *New York Times*, December 21, 1980.
Kurtz, Bruce. "Samaras Autopolaroids," *Arts*, January 1972.
Levin, Kim. "Eros, Samaras and Recent Art," *Arts*, December 1972–January 1973.
Levin, Kim. *Lucas Samaras.* New York, Abrams, 1975.
Licht, Ira. *Bodyworks.* Chicago, Museum of Contemporary Art, 1975.

Lifson, Ben. "Samaras' Nudist Colony," *Village Voice*, December 17, 1980.
Lopes-Cardozo, Judith. "Reviews," *Artforum*, March 1977.
Normile, Ilke. "Instant Samaras," *Afterimage*, March 1977.
Ratcliff, Carter. "New York Letter," *Art International*, January 20, 1971.
Ratcliff, Carter. *Samaras: Sittings 8 x 10*, New York, Pace Gallery, 1980.
Rathbone, Belinda, ed. *One of a Kind.* Boston, Godine, 1979.
Rose, Barbara. "Lucas Samaras: The Self as Icon and Environment," *Arts*, February 1978.
Samaras, Lucas. "The Other Tradition," *New York*, December 11, 1972.
Samaras, Lucas. *Samaras Album.* New York, Whitney Museum and Pace Editions, 1971.
SX-70 Art. New York, Lustrum, 1979.
Szarkowski, John. *Mirrors and Windows.* New York, Museum of Modern Art, 1978.
Van Baron, Judith. "Reviews," *Arts*, March 1974.
Zimmer, William. "The Tribe Stripped Bare," *SoHo News*, December 23, 1980.

MARK SCHWARTZ

Mark Coffey Schwartz was born in 1956 in Fall River, Massachusetts and now lives in Lakewood, Ohio. He is currently an instructor in photography at Cleveland State University and manager of the art gallery, where he has organized several exhibitions including "We Do the Rest" (Diana camera images) and "Alternatives 1980" (nonsilver processes). Both shows were covered by such popular and scholarly publications as *Popular Photography*, *Modern Photography*, *Afterimage*, and *Dialogue*. Schwartz has also received attention for his work with platinum prints and is included in *The Contemporary Platinotype* by John Haffey (Graphic Arts Research Center–Rochester Institute of Technology). In 1979 and 1980 he received fellowships from the Ohio State Arts Council.

Schwartz began photographing in 1975 while studying political science and American history at Rutgers University. After studying for two years with Emmet Gowin, Schwartz received his B.A. in photography and art in 1977. In 1979

he received his M.F.A. from Ohio University, Athens.

Schwartz always works on several projects in several media simultaneously. Besides color and black-and-white, he draws, paints, experiments with platinum materials and the Photo Booth machine. "Everything feeds off of something else," he says, "and although dissimilar in appearance and concept, linkages do occur."

Of his color photographic technique, Schwartz writes, "For the past two years I have been using a vintage 5 x 7" Deardorff field view camera. My lens consists of a 90mm Super Angulon, a very wide lens for the format. The film is always Vericolor II Type S. Its ASA is 100, but I rate it at 25, as I prefer a very dense negative for contact printing to insure that I have information in all parts of the image. My exposures range from one half second all the way to 22 seconds. I find that the film is very true at short exposures but has a tendency to shift at longer times. This is not a problem as I have no problem filtering out these shifts as they occur. Overall, it seems more responsive to my needs than the recommended film for my applications, Type L Vericolor. I print all of my contact prints myself on Kodak Ektacolor 37N surface. Kodak used to make a color paper—Ektacolor 74 which was much truer to the negative. Like nearly all its products, and especially with paper, the introduction of something new usually means a drastic cut in quality, contrast, and tonal range. But, I have no choices."

Selected Solo Exhibitions
1978 Midtown Y Gallery, New York
1979 Princeton University, Princeton, New Jersey
1980 Light Gallery, New York
 Gallery for Photographic Arts, Cleveland, Ohio

Selected Group Exhibitions
1977 "American Photography," United States Information Services, Novosibersk, USSR
1978 "International Invitational of Photography," French Embassy, New York
1979 "Perception: Field of View," Los An-geles Center for Photographic Studies
1980 "Segments of Series," Los Angeles Center for Contemporary Art
 "U.S. Eye," XIII Olympics, Lake Placid, New York; traveling exhibition

STEPHEN SHORE

Stephen Shore was born in New York City in 1947, and now lives in Boseman, Montana. He began photographing at the age of eight because a favorite television program, *Love that Bob*, featured Bob Cummings as a successful commercial photographer surrounded by a bevy of beautiful women. Shore's sole photographic training was in 1970 at a 10-day workshop given by Minor White.

At the age of 15, Shore worked with Andy Warhol at The Factory and later published black-and-white photographs in the book *Andy Warhol* (Moderna Museet, Stockholm, 1968). Shore's first major solo exhibition was of black-and-white photographs at the Metropolitan Museum of Art, when he was 24. Soon after, he began working in color, first with a 4 x 5" and later 8 x 10" view camera. His first major color exhibition was at the Museum of Modern Art, New York in 1976. That same year, the Metropolitan Museum of Art published a limited-edition portfolio of 12 of his photographs.

Shore has worked on assignment for *Fortune*, *Architectural Digest*, and important institutions. In 1977 he photographed Monet's gardens at Giverny for the Metropolitan Museum of Art, and in 1978 he photographed the Yankees at Spring Training for the *New York Times Magazine* and A.T. and T.'s "American Images" project.

Shore received a National Endowment for the Arts fellowship in 1974, and a Guggenheim fellowship in 1975.

Selected Solo Exhibitions
1971 Metropolitan Museum of Art, New York
1972 Thomas Gibson Fine Arts, London
 Light Gallery, New York
1973 Light Gallery, New York
1975 Light Gallery, New York
 Phoenix Gallery, San Francisco
 Galerie Lichttropfen, Aachen, Germany
1976 Museum of Modern Art, New York
 Renwick Gallery, National Collection of Fine Arts, Washington, D.C.
1977 Light Gallery, New York
 Kunsthalle, Düsseldorf
 Galerie Lichttropfen, Aachen
1978 Light Gallery, New York
 Robert Miller Gallery, New York
1980 Light Gallery, New York

Selected Group Exhibitions
1970 "Foto-Portret," Haags Gemeentemuseum, The Hague
1972 "Sequences," Photokina, Cologne
1973 "Landscape/Cityscape," Metropolitan Museum of Art, New York
1974 "New Images in Photography," Lowe Art Museum, University of Miami, Coral Gables, Florida
1975 "New Topographics," International Museum of Photography at George Eastman House, Rochester, New York; traveling exhibition
 "Color Photography: Inventors and Innovators, 1850–1975," Yale University Art Gallery, New Haven, Connecticut
1976 "100 Master Photographs," Museum of Modern Art, New York; traveling exhibition
 "Aspects of American Photography 1976," University of Missouri, St. Louis
 "American Photography: Past into Present," Seattle Art Museum, Washington
1977 "Court House," Museum of Modern Art, New York
 "Documenta," Kassel, Germany
 "The Second Generation of Color Photographers," Arles Festival, France
 "The Great West: Real/Ideal," University of Colorado at Boulder; traveling exhibition
1978 "Mirrors and Windows," Museum of Modern Art, New York; traveling exhibition
 "Amerikanische Landschaftsphotographie," Neue Sammlung, Munich.
1979 "American Photography in the '70s," Art Institute of Chicago

Selected Bibliography

Danese, Renato, ed. *American Images*. New York, McGraw-Hill, 1979.

Davis, Douglas. "New Frontiers in Color," *Newsweek*, April 19, 1976.

Davis, Douglas. "The Ten 'Toughest' Photographs of 1975," *Esquire*, February 1976.

Grundberg, Andy, and Julia Scully. "Currents: American Photography Today," *Modern Photography*, September 1978.

Hiss, Tony. "The Framing of Stephen Shore," *American Photographer*, February 1979.

Hume, Sandy, Ellen Manchester and Gary Metz, ed., *The Great West: Real/Ideal*. Boulder, University of Colorado; distributed by Light Impressions, 1977.

Jenkins, William. *New Topographics*. Rochester, International Museum of Photography at George Eastman House, 1975.

Kozloff, Max. "The Coming of Age of Color," in *Photography and Fascination*. Danbury, N.H., Addison House, 1979.

Lifson, Ben. "Taking All the Way," *Village Voice*, June 19, 1978.

Morris, Maria. "Stephen Shore," *Camera*, January 1977.

Pare, Richard, ed. *Court House*. New York, Horizon, 1978.

Patton, Phil. "Captured Pictures, Pictured Captions," *ARTnews*, January 1977.

Ratcliff, Carter. "Route 66 Revisited," *Art in America*, January/February 1976.

Sembach, Klaus-Jürgen. *Amerikanische Landschaftsphotographie*. Munich. Neue Sammlung, 1978.

"Signs of Life: Symbols in the American City," *Aperture 77*, 1976.

Skoggard, Ross. "Stephen Shore," *Artforum*, January 1977.

Squiers, Carol. "Color Photography: The Walker Evans Legacy and the Commercial Tradition," *Artforum*, November 1978.

Szarkowski, John. *Mirrors and Windows*. New York, Museum of Modern Art, 1978.

Thornton, Gene. "The New Photography: Turning Traditional Standards Upside Down," *ARTnews*, April 1978.

Time-Life Books, eds. *Photography Year/1977*. New York, Time-Life Books, 1977.

West, Stephen. "Report from the Provinces," *Village Voice*, February 10, 1977.

SANDY SKOGLUND

Sandy Skoglund was born in Boston in 1946. She received her B.A. from Smith College in 1968, and her M.A. and M.F.A. from the University of Iowa in 1972. After a year teaching high school art in Batavia, Illinois, Skoglund moved east where she taught at the University of Hartford from 1973 to 1976. Since 1976 she has been on the faculty of Rutgers University.

While a graduate student Skoglund was a conceptual artist working with Ritz and Saltine crackers which she lined up, chewed up, Xeroxed, and so forth. After moving to Connecticut, she was a minimal artist who built elaborate philosophical rationales to back up her lightly sketched dots and lines on canvas. By 1976 she concluded that such art was "so self-reflexive, so self-referential that I thought I'd have to stop altogether."

Skoglund next made a documentary film with Al Bacilli about the Newark health services. Realizing that documentary filmmakers inevitably, even if unintentionally, reconstruct events according to their preconceptions, Skoglund decided to seek the "innocence of art" again.

Skoglund first used the camera to document her conceptual artworks. Her first self-sufficient photographs were of contact paper stuck in the corners of rooms so that the patterns and colors would defy their actual spatial positions while asserting themselves anew on the picture plane. Skoglund's current work in the directorial vein encompasses her past interests in sculpture and filmmaking. By fabricating ceramic fish, papier maché cats, and other objects to be photographed, Skoglund hopes to return "to a more permissive, personal art."

Skoglund exhibits the photographs either independently or with recreations of the scenes photographed. By refabricating the fabrications in the gallery Skoglund adapts her sets for the natural eye, which sees the scenes far differently from the wide-angle, monocular vision of the camera.

In 1980 Skoglund received an emerging artist's fellowship from the National Endowment for the Arts.

Selected Solo Exhibitions

1973 Joseloff Gallery, Hartford Art School, Connecticut

1974 University of Connecticut, Storrs

1976 Rutgers University, Newark, New Jersey

1980 "Radioactive Cats," Real Art Ways Gallery, Hartford, Connecticut

1981 "Revenge of the Goldfish," Castelli Photographs, New York

Selected Group Exhibitions

1979 "Pictures: Photographs," Castelli Graphics, New York

1980 "First Move," Interactive Arts Foundation, New York

"Interiors," Gladstone Gallery, New York

"Likely Stories," Castelli Graphics, New York

"Contemporary Photographs," Fogg Art Museum, Harvard University, Cambridge, Massachusetts

Selected Bibliography

Grundberg, Andy. "Artbreakers: New York's Emerging Artists," SoHo News, September 17, 1980.

Time-Life Books, eds. *Photography Year/1980*, New York, Time-Life Books, 1980.

NEAL SLAVIN

Neal Slavin was born in New York City in 1941. He studied painting at Cooper Union and in 1961 won a scholarship to Lincoln College, Oxford University to study Renaissance painting and sculpture. Slavin's interest in photography developed at Oxford. When he returned to New York and to Cooper Union, where he received his B.A. in 1962, he worked as a photographer's assistant recording artworks at the Guggenheim Museum. After a time on a publisher's staff, Slavin became a freelance photographer and graphic designer, and spent a year traveling extensively throughout the United States for a commercial postcard concern.

In 1964 Slavin began his personal photogra-

phy by documenting the black rural poor of the South. In 1968 he received a Fulbright Fellowship to go to Portugal where he photographed the images that appeared in the 1971 book, *Portugal*. He began working in color in 1972 after he received a photographer's fellowship from the National Endowment for the Arts. Slavin began photographing groups in 1973, and in 1976 his book *When Two or More Are Gathered Together* was published.

In 1977 Slavin received a Creative Artists Public Service Grant from the New York State Council on the Arts. That same year he received a National Endowment for the Arts grant through the Mexican-American Legal Defense and Educational Fund to document Mexican-Americans in the United States.

Slavin has taught at Cooper Union, the School of Visual Arts, Manhattanville College, and Queens College, and participated in Cornell Capa's "concerned photographers" series at New York University.

Selected Solo Exhibitions (Color)
1976 Light Gallery, New York
 Center for Creative Photography, University of Arizona, Tucson
 Photokina, Cologne
 Wadsworth Atheneum, Hartford, Connecticut
 Oakland Museum, California
 Frederick S. Wright Gallery, University of California, Los Angeles
1978 Photokina, Cologne
 Galerie Spectrum, Hanover
 Galerie Gothar, Cologne

Selected Group Exhibitions (color)
1976 Basel Art Fair
 Düsseldorf Art Fair
 "Rooms," Museum of Modern Art, New York
1977 "Documenta," Kassel, West Germany
 Beauborg Museum, Paris
1978 Chicago Center for Contemporary Photography, Columbia College, Chicago

Selected Bibliography
Bentowski, Tom. "Who's in Charge Here," *New York*, October 11, 1976.
Davis, Douglas. "New Frontiers in Color," *Newsweek*, April 19, 1976.
Davis, Douglas. "The Ten 'Toughest' Photographs of 1975," *Esquire*, February 1976.
Du, January 1976.
Dubivsky, Barbara. "Groupees," *New York Times Magazine*, September 26, 1976.
Eauclaire, Sally. "After Ninety and Two or More," *Democrat and Chronicle* (Rochester, N.Y.), April 9, 1978.
Ffrench-Frazier, Nina. "Redder than Red," *ARTnews*, January 1977.
Jorden, Bill. "Book Reviews," *Photograph*, vol. 1, #2, 1976.
Kozloff, Max. "The Coming of Age of Color," in *Photography and Fascination*. Danbury, N.H., Addison House, 1979.
Murray, Joan. "Looking at Groups, Defining America," *Artweek*, October 9, 1976.
Nochlin, Linda. "In Detail: Courbet's A Burial at Ornans," *Portfolio*, November/December 1980.
Photo magazine (French and Italian editions), May 1976.
Porter, Allan, ed. "A Contemporary Compendium, Part II," *Camera*, December 1975.
Porter, Allan, ed. "New American Imagery," *Camera*, May 1974.
Porter, Allan, ed. "The Second Generation of Color Photographers," *Camera*, July 1977.
Rice, Shelley. "One is Not Enough," *Village Voice*, October 19, 1976.
Slavin, Neal. *Portugal*. New York, Lustrum, 1968.
Slavin, Neal. *When Two or More Are Gathered Together*. New York, Farrar-Straus, 1976.
Time-Life Books, eds. *Photography Year/1974*. New York, Time-Life Books, 1974.
Upton, Barbara and John. *Photography*. Boston. Little-Brown, 1976.
Zucker, Barbara. "Neal Slavin," *Zoom*, August/September 1977.

WILLIAM E. SMITH

William Edward Smith was born in 1952 in Greenwich, Connecticut and now lives in Cambridge, Massachusetts. In 1977 he graduated from the New England School of Photography, where he now instructs and directs both the adult education and research and development programs. He tutored the first deaf students to enter the school, and in 1977 designed a photography program for delinquent youths at Boston State Hospital. Smith also works as a commercial freelance photographer and has played the guitar professionally. He plays tournament chess and studies Shao-Lin Kung Fu.

Smith's personal work, whether black-and-white or color, centers on places built for people's entertainment, such as amusement parks, miniature golf courses, or picture parks. Among his influences: M. C. Escher's incongruities and paradoxes, René Magritte's absurdities, and Elliot Erwitt's humor sans derision.

Smith obtained his first 35mm camera in 1971 and still sticks with the format. He uses Kodacolor II film, because, in his words, "the amateur film's rendition, bastardization of color, and saturation fits my subject matter. The clean, realistic representation offered by 'professional films' is not the response I desire. The Kodacolor provides a saturation without the contrast of slide film onto paper, that fits what I shoot." Smith began working in color because color could be sent out to a lab while he caught up on a backlog of black-and-white negatives that needed printing.

Smith has had annual one-man shows at the Carl Siembab Gallery, Boston, since 1977.

EVE SONNEMAN

Eve Sonneman was born in Chicago, Illinois, in 1946 and now lives in New York City. She received her B.F.A. from the University of Illinois, Champaign, in 1967; and her M.F.A. from the University of New Mexico, Albuquerque, in 1969. Since 1971 she has taught at the School of Visual Arts, New York City. Sonneman has also done freelance commercial work for *Esquire*, *Life*, *New York Times Magazine*, and other publications.

From 1969 to 1974 Sonneman worked on the black-and-white diptychs published in *Real Time* (Printed Matter, 1976). Subsequently, she placed color and black-and-white photographs in quadrants, before moving back to the diptych format using color photographs alone.

Sonneman is also a filmmaker whose work has been shown at Castelli Graphics, New York City; the Art Institute of Chicago; the Ann Arbor Film Festival, Michigan; and at the Whitney Museum's Art and Resource Center, New York City.

Sonneman has received grants from the National Endowment for the Arts in 1971 and 1978; the Institute for Art and Urban Resources in New York in 1977; and from the Boskup Foundation in 1969.

In 1980 Sonneman had a retrospective exhibition at the Minneapolis Institute of Art. She has had numerous solo exhibitions in galleries in the U.S. and Europe since 1970. Regular showings have been at Castelli Graphics, New York City; Texas Gallery, Houston; and Galérie Farideh Cadot, Paris.

Selected Group Exhibitions
1975 "Not Photography: Photography," Fine Arts Building, New York
 "Lives," Fine Arts Building, New York
1976 "Works, Words 2," P.S. 1, Long Island City, New York
 "Portraits," Castelli Graphics, New York
1977 "Locations in Time," International Museum of Photography at George Eastman House, Rochester, New York
 "The Extended Frame," Visual Studies Workshop, Rochester, New York; traveling exhibition
 "Documenta VI," Kassel, Germany
 "Biennale," Paris
1978 "Mirrors and Windows," Museum of Modern Art, New York; traveling exhibition
1979 "American Photography of the '70s," Art Institute of Chicago
 "Attitudes: Photography in the '70s," Santa Barbara Musem of Art, California
 "The Altered Photograph," P.S. 1, Long Island City, New York
 "One of a Kind;" traveling exhibition circulated by Polaroid Corporation
1980 "Sequence Photography," Santa Barbara Museum of Art, California
 "Photography: Recent Directions," De Cordova Museum, Lincoln, Massachusetts
 "Biennale," Venice

Selected Bibliography
Bell, Tiffany. "Eve Sonneman's Progressions in Time," *Artforum*, October 1979.
Crary, Jonathan. "Reviews," *Arts*, November 1978.
Deitch, Jeffrey. "Reviews," *Arts*, December 1976.
Gilbert-Rolfe, Jeremy. "Reviews," *Artforum*, February 1974.
Foster, Hal. "Reviews," *Artforum*, September 1980.
Kurtz, Bruce. "Reviews," *Art in America*, January/February 1977.
Lifson, Ben. "Eve Sonneman, Eve Sonneman," *Village Voice*, April 24, 1978.
Lifson, Ben. "Out of Time," *Village Voice*, June 9, 1980.
Lippert, Werner. "Alternative from New York," *Heute Kunst*, February–April 1977.
Malcolm, Janet. "Photography: Two Roads," in *Diana and Nikon*. Boston, Godine, 1980.
Nuridsany, Michel. "Eblouissante Eve Sonneman," *Le Figaro*, January 23, 1980.
Patton, Phil. "Reviews," *Artforum*, February 1977.
Perlberg, Deborah. "Reviews," *Artforum*, Summer 1978.
Ratcliff, Carter. "Words and Images," Rev. of *Real Time*. *Art in America*, November/December 1977.
Rathbone, Belinda, ed. *One of a Kind*. Boston, Godine, 1979.
Rice, Shelley. "All the World's a Trade, Says Sonneman," *Village Voice*, December 27, 1976.
Rice, Shelley. "A Step in the Right Direction," *Village Voice*, June 27, 1977.
Rubinfien, Leo. "Reviews," *Artforum*, May 1977.
Sonneman, Eve. *Eve Sonneman: Works from 1968–1976*. Minneapolis Institute of Art, 1980.
Sonneman, Eve. *Real Time*. New York, Printed Matter, 1976.
Szarkowski, John. *Mirrors and Windows*. New York, Museum of Modern Art, 1978.
Yucikas, Bob. "The Younger Generation: A Cross Section," *Art in America*, September/October 1977.

WAYNE SORCE

Wayne Sorce was born in 1946 in Chicago. He received his B.F.A. and M.F.A. at the Art Institute of Chicago in 1969 and 1971. From 1965 to 1973 Sorce worked part-time as a liturgical artist, designing and executing works in mosaic, stained glass, and bronze. Photography overtook his interest in painting in 1966, and in 1971 he began using color film to record people and their homes.

Sorce has taught photography part-time at Columbia College and the School of the Art Institute of Chicago. As a freelance photographer, he specializes in photographic essays. Sorce's photographs of the environment of Aldo Piacenza and other work has been featured in *Chicago Magazine*. Recently, Sorce has been on assignments for *Life*.

In 1972 Sorce had a one-man show at the Art Institute of Chicago. He received National Endowment for the Arts photographer's grants in 1976 and 1978. In 1978 he moved from Chicago to New York City, and in 1980 photographed in the Philippines.

Selected Solo Exhibitions
1972 Art Institute of Chicago
1976 Elmhurst College, Elmhurst, Illinois

Selected Group Exhibitions
1974 "Fragments of a City," Art Institute of Chicago
1977 "The Photographer and the City," Museum of Contemporary Art, Chicago
1978 "Mirrors and Windows," Museum of Modern Art, New York; traveling exhibition
1979 "American Photography in the '70s," Art Institute of Chicago
 "Nine Contemporary Photographers," Witkin Gallery, New York
 "Color: A Spectrum of Recent Photography," Milwaukee Art Center, Wisconsin

Selected Bibliography
"Albany Park," *Chicago Magazine*, June 1974.
Desmarais, Charles. "Local Color, Chicago Style," *Modern Photography*, November 1980.

Elliot, David. "Six Rainbow Masters," *Chicago Sun-Times*, March 19, 1978.
"Lens is More; The Photographer in The City," *Chicago Magazine*, January 1977.
Porter, Allan, ed. "Wayne Sorce," *Camera*, November 1973.

CARLA STEIGER-MEISTER

Carla Steiger-Meister was born in Chicago in 1951. She received her B.A. in studio arts/art history from Oberlin College, Oberlin, Ohio, in 1974; and her M.F.A. in photography from the University of Minnesota, Minneapolis, in 1977. She worked for a time as a photographer/researcher in San Francisco and as an editorial assistant, photographer, and reporter in Pine Bluff, Arkansas. She has taught photography at Oberlin College, the College of Art and Design in Minneapolis, and Kenyon College, Gambier, Ohio. Steiger-Meister currently lives in Elkhart, Indiana and is an adjunct instructor at Indiana University, South Bend.

Steiger-Meister's involvement with photography arose in 1971 when she needed to make inter negatives for a silk screen class. Her first mature photographs were made in graduate school with a Duaflexes, a primitive camera with a soft lens. Subsequently, she began using a Hasselblad and completed a series of rigorously formal, yet narratively whimsical, still lifes, entitled "Inner Design." In 1978 she began fabricating fantasy collages and assemblages from postcards, magazine images, and objects such as ribbons, flowers, and paper weights. She then photographs these, creating the illusion of three-dimensional space through the use of cutouts, distortion-producing lenses, and layers of plexiglas. The original assemblages are usually about 3 x 5" and the final print sizes either 8 x 10" or 11 x 14". Steiger-Meister now uses a 35mm camera and prints the images so they will have a blue or mauve cast.

The interest in fantasy and dreams derives from earliest childhood when Steiger-Meister played with "dusty but cherished relics" from her grandmother's trunks. Photographs of "my mother and grandmother in their lace dresses and seeded pearl slippers were the earliest characters in a half-real, half-fantasy world I created for them. This world was enriched by voracious reading of fantasy, fable, and heroic biography, then and now."

Selected Solo Exhibitions
1978 International Museum of Photography at George Eastman House, Rochester, New York
 Silver Image Gallery, Ohio State University, Columbus, Ohio
1980 Foto Gallery, New York
 Dobrick Gallery, Chicago

Selected Group Exhibitions
1978 "Small Objects," Robert Freidus Gallery, New York
1979 "130 Years of Ohio Photography," Columbus Gallery of Fine Arts, Columbus, Ohio
 "Photography Invitational," Purdue University, West Lafayette, Indiana

Selected Bibliography
Eauclaire, Sally. "Tackling Range of Still Lifes," *Democrat and Chronicle* (Rochester, N.Y.), July 9, 1978.
Hawkins, Margaret. "Carla Steiger-Meister," *New Art Examiner*, April 1980.
Livingston, Kathryn. "Gallery," *American Photographer*, September 1980.

JOEL STERNFELD

Joel Sternfeld was born in New York City in 1944 and educated at Dartmouth College. Since 1978 he has been pursuing an American odyssey, traveling alone in a Volkswagen camper bus and photographing the natural and social landscape with an 8 x 10" view camera. For his first year's itinerary, Sternfeld followed a course inspired by Edwin Way Teale's books, such as *Autumn across America* and *North with Spring*. During the fall he pushed southward from New England to Texas, then wintered in the Southwest, spent the spring on the Pacific Coast, and summered in the Midwest and the Rocky Mountain regions.

Initially disillusioned upon realizing that the America of myth and legend no longer exists, Sternfeld attempts to reconcile himself to the new America through personal experience. He has met numerous people, whom he says are strikingly dissimilar to the stereotypes perpetrated by the modern media. He also enriches his understanding through wide reading and has been affected by Charles Reich, Lewis Mumford, Joshua C. Taylor, and Leo Marx, among others. Though he began his journey hoping to understand America, he has since learned to accept provocative questions and intriguing contradictions. He is reluctant to pronounce judgments or make declarations.

Sternfeld's essay was begun with a 1979 grant from the Guggenheim Foundation and continues with a 1980 grant from the National Endowment for the Arts and the New York State Council on the Arts. He is on leave from teaching at Stockton College, Pomona, New Jersey.

From 1976 to 1978 he made candid street photographs with a 35mm camera and a 4 x 5" press-view camera. This work, emphasizing the anxiety-ridden faces of commuters and careerists, led to a portfolio in *Camera* magazine, an exhibition at the Pennsylvania Academy of Fine Arts, and the Guggenheim Fellowship. Sternfeld still occasionally works in the street tradition and has photographed people in suburban shopping malls and at theme parks.

Work prior to 1976 includes photographs taken in the Deep South or at Naos Head, North Carolina. These either explore Josef Albers's color theories or are synaesthetic attempts to stimulate nonvisual senses. Sternfeld, who lives in New York City, has worked in color since 1970.

Selected Exhibitions
1976 Pennsylvania Academy of Fine Arts, Philadelphia; solo exhibition
 "The American Landscape," Print Club of Pennsylvania, Philadelphia
1977 "The Second Generation of Color Photographers," Arles Festival, France
1978 "Color Photography," Creative Photography Laboratory, Massachusetts Institute of Technology, Cambridge, Massachusetts
 Photokina, Cologne
1979 "One of a Kind;" traveling exhibition circulated by Polaroid Corporation
 "Fotographie im Alltag Amerikas, Kunstgewerbemuseum, Zurich

1980 Creative Artists Public Service Photography Exhibit; traveling New York State

Selected Bibliography

Grundberg, Andy. "How to Go Slow," *Modern Photography*, February 1976.

Grundberg, Andy. "Inhabited Terrain: Joel Sternfeld's American Landscapes," *Modern Photography*, March 1980.

Grundberg, Andy. "Some Fare over the Rainbow," *SoHo News*, May 21, 1980.

Grundberg, Andy and Mary O'Grady. "Direct Flash Zaps Back," *Modern Photography*, July 1977.

Hughes, Jim, ed. "Recent Landscapes: Photographs by Joel Sternfeld," *Camera Arts*, November/December 1980.

Porter, Allan, ed. "Photographis Interruptus," *Camera*, November 1977.

Porter, Allan, ed. "The Second Generation of Color Photographers," *Camera*, July 1977.

Scully, Julia. "Seeing Pictures," *Modern Photography*, April 1979.

ARTHUR TAUSSIG

H. Arthur Taussig was born in Los Angeles in 1941 and now lives in Costa Mesa, California. He received his B.S. in physics from the University of California, Berkeley in 1962; his M.S. in biophysics from the University of California, Los Angeles in 1969; and his Ph.D in biophysics from U.C.L.A. in 1971.

Taussig began photographing when taking vacations from his work in physics. He first studied with John Upton, who is still a confidante and teacher, then with Minor White. Next, a meeting with Imogen Cunningham proved significant. Upon being told that Taussig had studied with White, she said, "I hope that didn't damage you permanently." For Taussig, "that one sentence, said at the right time and the right place, released me from being a minor Minor and I began doing what I feel is 'my own' work."

Taussig currently feels more influenced by painters, particularly minimal painters, than by photographers. He also makes films, sculpture, 3M Color-in-Color prints, composes music, and instructs dance. He has guest curated exhibitions, been active in the Society for Photographic

Education, and helped found the Los Angeles Center for Photographic Studies. Since 1971 he has been an assistant professor of photography at Orange Coast College, Costa Mesa, California.

Asked to provide information on his technique, Taussig replied, "One of my *favotire* authors is James Joyce. I do not know if he used a typewriter or a pen or pencil. If the latter, I do not know the color of the lead nor its hardness. If the former, I do not know if his typewriter was manual or electric, the type of ribbon, carbon or silk, or its color, nor how fast he could type."

Selected Solo Exhibitions

1977 International Museum of Photography at George Eastman House, Rochester, New York.
Robert Freidus Gallery, New York

1978 Robert Freidus Gallery, New York

1979 Robert Freidus Gallery, New York
Susan Spiritus Gallery, Newport Beach, California

1980 Robert Freidus Gallery, New York

Selected Group Exhibitions

1975 "History Transformed," Friends of Photography, Carmel, California; Orange Coast College, Costa Mesa, California

1976 "Los Angeles Photographers," Los Angeles Institute of Contemporary Art (LAICA)

1977 "Emerging Los Angeles Photographers," International Center of Photography, New York
"Contemporary Color Photography," Indiana University Art Museum, Bloomington
"Cityscapes," De Young Museum of Art, San Francisco

1978 "The Photograph as Artifice," California State University, Long Beach; traveling exhibition

1979 "Attitudes," Santa Barbara Museum of Art, California
"New California Views," International Center of Photography, New York

1980 "Color: A Spectrum of Recent Photography," Milwaukee Art Center, Wisconsin

"Zeitgenossische Amerikanische Farbphotographie," Galerie Rudolf Kicken, Cologne

Selected Bibliography

Buffam, Richard. "Suiting the Words to the Pictures," *Los Angeles Times*, December 30, 1979.

Duke, Shearlean. "Camera Shows More Than Images," *Los Angeles Times*, December 26, 1979.

Eauclaire, Sally. "Color Photography is His Art Form," *Democrat and Chronicle* (Rochester, N.Y.), April 9, 1977.

Fischer, Hal. "Contemporary California Photography: The West is . . . Well, Different," *Afterimage*, November 1978.

Ffrench-Frazier, Nina. "Photography: Beauty in the Ordinary," *ARTnews*, June 1977.

Goodman, Ellen. "Arthur Taussig," *Arts*, February 1979.

Lifson, Ben. "1978 and All That," *Village Voice*, January 8, 1979.

Plagens, Peter. "Collector's Eye," *New West Magazine*, November 1978.

Wooding, Marcia. "Arthur Taussig: An Interview with an Art Person," *35mm Photography*, Spring 1979.

ROCKY THIES

Rocky Thies was born in St. Louis, Missouri in 1947 and has lived in San Diego, California since 1952. He received a B.S. in zoology/chemistry from San Diego State University in 1970. After three years work as a research associate, he became manager of the Lipid Research Clinic of the University of California, San Diego. Since 1978 Thies has pursued photography full-time. In 1980 he was appointed a part-time instructor at Grossmont Community College.

Thies learned the technical aspects of photography during his senior year in college, but did not become seriously interested in the medium until he sought out a man making stereographs of the skull and brain in 1973. Initially only curious about stereography, Thies found himself talking to a man conversant with the works of Walker Evans, Eugène Atget, Robert Frank, and Henri Cartier-Bresson. Once stimu-

lated, he began making his own photographs in earnest.

The photograph in *The New Color*, and others in the "California Portfolio" (1978) were made with a 6 x 9 cm "Siciliano" camera, made by Thies's friend Tom Germano of Brooklyn. Thies uses it because it "is light enough to be hand held allowing the photographer more mobility than with a view camera, while providing a significantly sharper image than 35mm."

Thies has used both Vericolor Type S and Kodacolor 120 films, but had to abandon the former because refrigeration was impossible while traveling. Prints were made by the photographer on both Ektacolor 74 and 78 papers and processed in Kodak's Ektaprint 2-step chemistry.

Selected Exhibitions
1974 "People and this Place," Center for Photographic Arts, La Jolla, California
1979 "Photo as Document," California Institute of the Arts, Valencia
 "Out West," Bertha Urdang Gallery, New York; solo exhibition
1980 "Modern Settlement and the Restoration of Eden," Grossmont College Gallery, El Cajon, California
 "Recent Acquisitions," Corcoran Gallery of Art, Washington, D.C.

STEPHANIE TORBERT

Stephanie Birch Torbert was born in Wichita Falls, Texas in 1945. She was raised in Minneapolis, Minnesota, with a year spent in Europe. She received her B.F.A. in 1968 from the University of New Mexico, Albuquerque.

During the summer of 1967 Torbert studied textile design at the School for American Craftsmen at the Rochester Institute of Technology, Rochester, New York. That summer she attended photography seminars at the George Eastman House, and developed a serious interest in photography. In 1978 Torbert received a grant from Kodak to set up and direct a visual communications department at Monroe Community College. At the same time she enrolled in the Visual Studies Workshop and received her M.F.A. in 1971.

Since 1971 Torbert has lived in Minneapolis, supporting herself through a variety of teaching positions, freelance commercial assignments, consulting jobs, and urban arts programs.

Torbert received grants from the Minnesota State Arts Board in 1974 and 1980; the Bush Foundation in 1976; and from the Minneapolis College of Art and Design in 1978. In 1977 she was one of six photographers commissioned for the Minnesota Survey project funded by the National Endowment for the Arts.

Torbert began working in color in 1969. In 1970 she exhibited color slides and black-and-white prints of people in their underwear at the Minneapolis Institute of Art. Subsequent work dealt with reflections and layers of reality. Most recently Torbert has made portraits. The photographs in *The New Color* were made with a 35mm Pentax and Ektachrome slide film. Her prints are Cibachrome.

Selected Solo Exhibitions
1970 Minneapolis Institute of Art
1073 Walker Art Center, Minneapolis, Minnesota
1978 International Museum of Photography at George Eastman House, Rochester, New York
1979 Friends of Photography, Carmel, California

Selected Color Exhibitions
1973 "Color Light," Light Gallery, New York
1974 "20th Century American Photography," The Photography Gallery Invitational, Kansas City, Missouri
1975 "12 Photographers," Minneapolis Institute of Art, Minnesota; traveling exhibition
1978 "Minnesota Survey," Minneapolis Institute of Art, Minnesota
1979 "Attitudes," Santa Barbara Museum of Art, California

Selected Bibliography
Euaclaire, Sally. "What You See in the Photos Often Isn't What You See," *Democrat and Chronicle* (Rochester, N.Y.), January 8, 1978.
Hartwell, Carroll T. *Minnesota Survey: Six Photographers*. Minneapolis Institute of Art, 1978.

BOYD WEBB

Boyd Webb was born in New Zealand in 1947, and studied sculpture at Canterbury University, New Zealand from 1968 to 1971. In 1972 he entered the Royal College of Art in London and received his M.A. in 1975. Webb currently lives in London.

Webb first used black-and-white photography to record his sculpture. He says, "Gradually the photographs became more important than the sculpture, and as the sculpture was replaced the need for colour became inevitable." Webb reports that his main influences have been Sufi teaching parables, Alfred Jarry, Marcel Duchamp, and Victorian genre painting. He uses half-plate Vericolor film to make Type-C prints using what he calls "the techniques of the mail-order catalogue photographer." Elegant type or tiny hand lettering is used for the titles, and most prints are mounted on tissue paper in pastel shades.

Selected Solo Exhibitions
1976 Robert Self Gallery, London
1977 Graves Art Gallery, Sheffield
 Robert Self Gallery, Newcastle
 Graeme Murray Gallery, Edinburgh
1978 Gray Art Gallery & Museum, Hartlepool
 Konrad Fischer Gallery, Düsseldorf
 Jean & Karen Bernier, Athens
 Arnolfini Gallery, Bristol
 Chapter Art Center, Cardiff
 Whitechapel Art Gallery, London
1979 New 57 Gallery, Edinburgh
 Arts Council Gallery, Belfast
 Sonnabend Gallery, New York
 Galérie Sonnabend, Paris
1980 Gallery t'Venster, Rotterdam
 Museum Hans Lange, Krefeld

Selected Group Exhibitions
1976 Pan Pacific Biennale, Auckland, New Zealand
 "Time Words & the Camera," Innsbruck, Vienna, and Bochum
1979 "Europa '79," Stuttgart

"With a Certain Smile," INK, Zurich
1980 "Artist & Camera;" traveling exhibition
in England
"About 70 Photographs;" traveling exhibition in Europe
"Photography and the Medium;" traveling exhibition in Europe

Selected Bibliography

Grundberg, Andy. "Photography," *SoHo Weekly News*, May 17, 1979.

Webb, Boyd. *Tableaux*, London, Robert Self Gallery, 1978.

Williams, Peter. "Boyd Webb," *Studio International*, March/April 1977.

NOTES

Introduction

1. John Szarkowski, *William Eggleston's Guide* (New York: Museum of Modern Art, 1976), p. 8.

2. Max Kozloff, "The Coming of Age of Color," *Artforum*, January 1975 (reprinted in *Photography and Fascination*; Danbury, N.H: Addison House, 1978).

Chapter 1

1. See the collection of advertisements from Kodak's first publicity campaign in the archive at the International Museum of Photography at George Eastman House, Rochester, N.Y.

2. Laszlo Moholy-Nagy as quoted in Sibyl Moholy-Nagy, *Experiment in Totality* (New York: Harper, 1950), p. 105.

3. Walker Evans, "Test Exposures," *Fortune*, July 1954, p. 80.

4. Edward Steichen, *A Life in Photography* (London: Allen, 1963), n. pag. (chap. 11).

5. Max Kozloff, "The Coming of Age of Color," in *Photography and Fascination* (Danbury, N.H: Addison House, 1978), p. 188.

6. *Ibid.*

7. *Ibid.*, p. 185.

8. Sally Stein, "FSA Color: The Forgotten Document," *Modern Photography*, January 1979, p. 162.

9. Paul Outerbridge, *Photographing in Color* (New York: Random House, 1940), p. 57.

10. Consider the various prescriptions: Sky and interior atmosphere must be described as passive, inhabitable spatial zones, implicitly remote from the picture plane. Principal figures, objects, buildings, etc. must be represented in accordance with concepts of how three-dimensional volumes appear under specific illumination in three-dimensional space. Shaded portions of volumes must seem spatially remote and passive, while their illuminated surfaces should be described with conspicuous concentrations of value contrast and hue saturations. Only selected portions of the pictorial scheme may be visually assertive, and these are appointed in accordance with their comparative positions in three-dimensional space and their narrative and visual roles in overall compositional strategy.

Color photographic solutions tend to generate lamentable results. In-focus and out-of-focus zones create emphases but in a crudely obtrusive manner, for the absence of sharp focus suppresses unwanted information with a prominent, explicit blur. Cast shadows often obscure details completely instead of gently subordinating them, producing spatially flat, conspicuously dark patches, which prevent the image from conveying a persuasive illusion of three-dimensional space. Darkroom manipulation can easily result in disruption of the jewel-like, immaculate color transitions that are among color photography's strengths.

11. Janet Malcolm, "Color," in *Diana and Nikon* (Boston: Godine, 1980), pp. 87–95.

Chapter 2

1. Stephen Shore as quoted in Tony Hiss, "The Framing of Stephen Shore," *American Photographer*, February 1979, p. 35.

2. *Ibid.*

3. Carol Squiers, "Color Photography: The Walker Evans Legacy and the Commercial Tradition," *Artforum*, November 1978, p. 67.

4. John Szarkowski, *Walker Evans* (New York: Museum of Modern Art, 1971), p. 10.

5. Will Grohmann, *Wassily Kandinsky: Life and Work* (New York: Harry N. Abrams, n.d.), p. 180.

6. Colin L. Westerbeck, Jr., "Reviews," *Artforum*, April 1980, p. 80.

7. Joel Meyerowitz in "A Conversation: Bruce K. Macdonald with Joel Meyerowitz," in *Cape Light* (Boston: New York Graphic Society, 1978), n. pag.

8. Kenneth Clark, *Landscape into Art* (1949, rpt. Boston: Beacon, 1963), p. 87.

9. Mark Rothko as quoted in Irving Sandler, *The Triumph of American Painting: A History of Abstract Expressionism* (New York: Praeger, 1970), p. 92.

10. Joel Meyerowitz in "A Conversation: Bruce K. Macdonald with Joel Meyerowitz," in *Cape Light* (Boston: New York Graphic Society, 1978), n. pag.

11. Jan Groover, *American Images*, ed. Renato Danese (New York: McGraw-Hill, 1979), p. 140.

12. Jan Groover, *Outside the City Limits: Landscape by New York City Artists*, exhibition catalogue (Sparkill, N.Y.; Thorpe Intermedia Gallery, 1977), p. 22.

13. Max Kozloff, "Warm Truths and Cool Deceits," in *Photography and Fascination* (Danbury, N.H: Addison House, 1978), pp. 202–203.

14. *Ibid.*

15. Ben Lifson, "Still Lifes Run Deep," *Village Voice*, Feb. 18, 1980, p. 83.

Chapter 3

1. Clement Greenberg, "Modernist Painting," *The New Art*, ed. Gregory Battcock (New York: Dutton, 1973), p. 68.

2. Garry Winogrand as quoted in Janet Malcolm, "Certainties and Possibilities," in *Diana and Nikon* (Boston: Godine, 1980), p. 37.

3. Eugene Ionesco, *Notes and Counter Notes* (New York: Grove, 1964), p. 120.

4. Stuart Liebman, "Making People into Pictures," *SoHo Weekly News*, Dec. 14, 1978.

5. Max Kozloff, "The Territory of Photographs," in *Photography and Fascination* (Danbury, N.H: Addison House, 1978), p. 107.

6. Joel Meyerowitz in "A Conversation: Bruce K. Macdonald with Joel Meyerowitz," in *Cape Light* (Boston, New York Graphic Society, 1978), n. pag.

7. *Ibid.*

8. Joel Meyerowitz as quoted by Andy Grundberg in "Joel Meyerowitz Gets His View," *SoHo Weekly News*, July 26, 1979, p. 32.

9. Max Kozloff, "The Coming of Age of Color," in *Photography and Fascination* (Danbury, N.H: Addison House, 1978), p. 195.

10. Personal interview with Joel Meyerowitz, March 16, 1979.

11. Max Kozloff, "New Japanese Photography," in *Photography and Fascination* (Danbury, N.H: Addison House, 1978), p. 175.

12. Sally Stein, *Harry Callahan: Photographs in*

Color/The Years 1946–1978, exhibition catalogue (Tucson, Center for Creative Photography University of Arizona, 1980), p. 31.

13. *Ibid.*

Chapter 4

1. John Barth, *Lost in the Funhouse* (Garden City, N.Y: Doubleday, 1968), p. 117.

2. Charles Hagen, in *Michael Bishop*, exhibition catalogue (Chicago: Chicago Center of Photography, 1979), n. pag.

3. Personal interview with Michael Bishop, October 17, 1977.

4. Personal interview with John Pfahl, January 24, 1978.

5. Andy Grundberg, "Photography," *SoHo Weekly News*, May 17, 1979, p. 48.

6. Ben Lifson, "Eve Sonneman, Eve Sonneman," *Village Voice*, April 24, 1978, p. 86.

7. Harold Rosenberg, "Defining Art," *Minimal Art*, ed. Gregory Battcock (New York: Dutton, 1968), p. 306.

8. Tom Wolfe, *Marie Cosindas, Color Photographs* (Boston: New York Graphic Society, 1978), p. 14.

9. Personal interview with Arthur Taussig, May 8, 1980.

10. Amy Taubin, "Reel Magic," *SoHo Weekly News*, Dec. 22, 1977.

Chapter 5

1. Max Kozloff, "The Territory of Photographs," in *Photography and Fascination* (Danbury, N.H: Addison House, 1978), p. 102.

2. Jeff Perrone, "Duane Michals: The Self as Apparition," *Artforum*, January 1977, p. 23.

3. Max Kozloff, "The Territory of Photographs," in *Photography and Fascination* (Danbury, N.H: Addison House, 1978), p. 102.

4. Lewis Baltz, review of *The New West* by Robert Adams, *Art in America*, March–April 1975, p. 41.

5. William Jenkins, *New Topographics*, exhibition catalogue (Rochester, N.Y: International Museum of Photography at George Eastman House, 1975), p. 5.

6. Stephen Shore as quoted in *Amerikanische Landschaftsphotographie, 1860–1978* (Munich: Eine Ausstellung der Neuen Sammlung, 1978), p. 19.

7. Susan Sontag, *Against Interpretation* (New York: Oxford University Press, 1966), p. 25.

8. Mark Power, "Washington, D.C.: Capital Photographs at the Corcoran," *Afterimage*, February 1977, p. 19.

9. Allan Sekula, "Dismantling Modernism, Reinventing Documentary (Notes on the Politics of Representation)," *Massachusetts Review*, Winter 1978, p. 859.

10. James Hugunin, "Broken Mirrors and Dirty Windows," *Journal: Southern California Art Magazine*, September 1979, p. 32.

11. John Szarkowski, *Callahan* (Millerton, N.Y: Aperture, 1976), p. 24.

12. David Freund as quoted in Leo Rubinfien, "Reviews," *Artforum*, May 1977, p. 69.

13. Norman Mailer testifying at the trial of the Chicago Seven, quoted in A. D. Coleman, *Light Readings* (New York: Oxford University Press, 1979), p. 258.

14. Shelley Rice, "Essential Differences: A Comparison of the Portraits of Lisette Model and Diane Arbus," *Artforum*, May 1980, p. 71.

15. *Ibid*, p. 69.

16. Neal Slavin, *When Two or More are Gathered Together* (New York: Farrar, Straus and Giroux, 1976), n. pag.

17. Neal Slavin as quoted in Carol Squiers, "Color Photography: The Walker Evans Legacy and the Commercial Tradition," *Artforum*, November 1978, p. 67.

18. Erving Goffman, *The Presentation of Self in Everyday Life* (New York: Doubleday Anchor, 1959).

19. Neal Slavin, *When Two or More are Gathered Together* (New York: Farrar, Straus and Giroux, 1976), n. pag.

20. Carol Squiers, "Color Photography: The Walker Evans Legacy and the Commercial Tradition," *Artforum*, November 1978, p. 65.

21. Max Kozloff, "The Coming of Age of Color," in *Photography and Fascination* (Danbury, N.H: Addison House, 1978), p. 192.

22. Walker Evans, "William Christenberry: Photographs April 13–May 27, 1973," exhibition brochure (Washington, D.C: Corcoran Gallery of Art, 1973), n. pag.

23. Excerpts from early Cirkut advertisements were included in the press release issued by the Visual Studies Workshop, Rochester, N.Y. for an exhibition of panoramic photographs by E.O. Goldbeck held in its gallery March 1979.

24. Colin L. Westerbeck, Jr., "Taking the Long View," *Artforum*, January 1978, p. 56.

25. Gary Metz, "The Landscape as a Photograph," in *The Great West: Real/ Ideal*, eds. Sandy Hume, Ellen Manchester, Gary Metz; exhibition catalogue (Boulder: Department of Fine Arts, University of Colorado, 1977), p. 120.

Chapter 6

1. John Gardner, *On Moral Fiction* (New York: Basic Books, 1978).

2. John Szarkowski, *William Eggleston's Guide* (New York: Museum of Modern Art, 1976), p. 12.

3. Friedrich Nietzsche, "Human, All Too Human," *The Philosophy of Nietzsche*, ed. Geoffrey Clive (New York: Mentor/New American Library, 1965), p. 501.

4. Johann Huizinga, *Homo Ludens* (1938, Eng. trans. 1950, rpt. Boston: Beacon, 1955).

5. James Agee, "A Way of Seeing," in Helen Levitt and James Agee, *A Way of Seeing* (New York: Viking, 1965), p. 74.

6. Ben Lifson, "Dichtung und Wahrheit," *The Village Voice*, May 26, 1980.

7. Leslie Fiedler, "Cross the Border—Close the Gap," *The Collected Essays of Leslie Fiedler*, vol. II (New York: Stein, 1971), pp. 461–485.

8. Joseph Stella as quoted by Joshua C. Taylor in *America as Art* (Washington, D.C: Smithsonian Institution Press, 1976), p. 194.

9. Susan Fromberg Schaeffer, "The Unreality of Realism," *Critical Inquiry*, Summer 1980, p. 730.

10. All information on the beaching of the whales derives from Barry Lopez, "A Presentation of Whales," *Harper's*, March 1980, pp. 68–79.

11. James Agee, *Letters of James Agee to Father Flye* (Boston: Houghton Mifflin, 1971), pp. 228–232.

12. Susan Sontag, *On Photography* (New York: Farrar, Straus and Giroux, 1977), p. 52.

13. Jacques Barzun, *Classic, Romantic, Modern* (New York: Anchor, 1961), pp. 40–41.

14. T. S. Eliot, "Imperfect Critics," in *The Sacred Wood* (1920, rpt. London: Methuen, 1974), p. 31.

15. Frederick J. Hoffman, *The Art of Southern Fiction* (Carbondale and Edwardsville: Southern Illinois University Press, 1967), p. 25.

16. John Szarkowski, *William Eggleston's Guide* (New York: Museum of Modern Art, 1976), pp. 12–13.

17. Thomas Berger as quoted by Richard Schickel, "Interviewing Thomas Berger," *New York Times Book Review*, April 6, 1980, p. 21.

18. Leo V. Marx, *The Machine in the Garden* (1964, rpt. New York: Oxford University Press, 1979), p. 27.

19. Flannery O'Connor, "Some Aspects of the Grotesque in Southern Fiction," in *Mystery and Manners* (New York: Farrar, Straus and Giroux, 1969), p. 50.

20. Willem de Kooning as quoted by Joshua C. Taylor in *America as Art* (Washington, D.C: Smithsonian Institution Press, 1976), p. 271.

Chapter 7

1. Harold H. Jones, III, *Figure in Landscape*, exhibition catalogue (Rochester, N.Y: George Eastman House, 1971), n. pag.

2. T. S. Eliot, "Of Tradition and the Individual Talent," *The Sacred Wood* (1920, rpt. London: Methuen, 1974), pp. 54–59.

3. Ben Lifson, "Ariel Rising," *Village Voice*, April 28, 1980, p. 83.

4. Oscar Wilde, "The Picture of Dorian Gray," in *The Portable Oscar Wilde*, ed. Richard Aldington (New York: Viking, 1973), p. 358.

5. Joyce Culver, "The Secret Soul of Things," Diss., Rochester Institute of Technology, 1980, p. iv.

6. Ben Lifson, "Voice Vanguard, '79—Innovators to Watch," *Village Voice*, Dec. 18, 1978, p. 54.

7. Carter Ratcliff, "Making an Art of Holiday Snaps," *Modern Photography*, April 1978, p. 110.

Chapter 8
1. Eugenia Parry Janis, "A Still Life Instinct," Introd., *One of a Kind*, ed. Belinda Rathbone (Boston: Godine, n.d.), p. 15.

2. Max Kozloff, *SX-70 Art* (New York: Lustrum Press, 1979), p. 10.

3. Owen Edwards, "SX-70: Land's Painless Epiphany Machine," *Saturday Review*, July 22, 1978, p. 28.

LIST OF PLATES

1 William Eggleston
Memphis, ca. 1972
Dye transfer, 12 x 17 in
Courtesy Caldecot Chubb

2 William Eggleston
Memphis, Tennessee, 1971
Dye transfer, 11½ x 17¾ in
Courtesy Caldecot Chubb

3 William Eggleston
Tallahatchie County, Mississippi, 1971
Dye transfer, 11¾ x 18 in
Courtesy Caldecot Chubb

4 William Eggleston
Memphis, Tennessee, ca. 1971
Dye transfer, 12 x 17¾ in
Courtesy Caldecot Chubb

5 William Eggleston
Marks, Mississippi, ca. 1971
Dye transfer, 12½ x 18½ in
Courtesy Caldecot Chubb

6 Stephen Shore
El Paso Street, El Paso, Texas, July 5, 1975
Ektacolor type-c print, 14 x 17 in
Courtesy Light Gallery, New York

7 Stephen Shore
Beverly Boulevard and LaBrea Avenue, Los Angeles, California, June 21, 1975
Ektacolor type-c print, 16 x 20 in
Courtesy Light Gallery, New York

8 Stephen Shore
West Market Street and North Eugene Street, Greensboro, North Carolina, January 23, 1976
Ektacolor type-c print, 8 x 10 in
Courtesy Light Gallery, New York

9 Stephen Shore
West 15th Street and Vine Street, Cincinnati, Ohio, May 15, 1974
Ektacolor type-c print, 8 x 10 in
Courtesy Light Gallery, New York

10 Stephen Shore
U.S. 10, Post Falls, Idaho, August 25, 1974
Ektacolor type-c print, 14 x 17 in
Courtesy Light Gallery, New York

11 Stephen Shore
Marland Street, Hobbs, New Mexico, February 19, 1975
Ektacolor type-c print, 8 x 10 in
Courtesy Light Gallery, New York

12 Stephen Shore
U.S. 93, Kingman, Arizona, July 2, 1975
Ektacolor type-c print, 8 x 10 in
Courtesy Light Gallery, New York

13 Rocky Thies
Untitled, Near Lost Hills, California, 1978
Ektacolor 74 type-c print, 8⅜ x 12⁷⁄₁₆ in
Courtesy the artist

14 Emmet Gowin
Near Assisi, Italy, 1978
Type-c print, 8 x 10 in
Courtesy Light Gallery, New York

15 Emmet Gowin
Arizona (desert), 1978
Type-c print, 8 x 10 in
Courtesy Light Gallery, New York

16 Allen Hess
M.V. Butch Alario, Harvey Canal, Louisiana, June 24, 1979
Ektacolor 74 type-c print, 8 x 11¾ in
Courtesy the artist

17 Joanne Mulberg
Cedarhurst, Long Island, 1978
Ektacolor 74, type-c print, 8¼ x 8¼ in
Courtesy the artist

18 Joel Sternfeld
Nag's Head, North Carolina, July 1975
Ektacolor 74, type-c print, 9 x 13½ in
Courtesy the artist

19 Joel Meyerowitz
Law Office
Ektacolor 74 type-c print, 10 x 8 in
Courtesy the artist

20 Joel Meyerowitz
Porch, Provincetown, 1977
Ektacolor 74 type-c print, 20 x 16 in
Courtesy the artist

21 Joel Meyerowitz
Provincetown, 1976
Ektacolor 74 type-c print, 16 x 20 in
Courtesy the artist

22 Joel Meyerowitz
Bay/Sky, Provincetown, 1977
Ektacolor 74 type-c print, 16 x 20 in
Courtesy the artist

23 Joel Meyerowitz
Provincetown, 1976
Ektacolor 74 type-c print, 16 x 20 in
Courtesy the artist

24 Joel Meyerowitz
4th and Market
Ektacolor 74 type-c print, 8 x 10 in
Courtesy the artist

25 Joel Meyerowitz
4th and Walnut

Ektacolor 74 type-c print, 8 x 10 in
Courtesy the artist

26 Joel Meyerowitz
The Arch
Ektacolor 74 type-c print, 8 x 10 in
Courtesy the artist

27 Joel Meyerowitz
Parking Lot at 4th and Walnut
Ektacolor 74 type-c print, 8 x 10 in
Courtesy the artist

28 Joel Meyerowitz
Provincetown, 1977
Ektacolor 74 type-c print, 8 x 10 in
Courtesy the artist

29 Larry Babis
Colorado, 1977
Ektacolor 74 type-c print, 11 x 14 in
Courtesy the artist

30 Jan Groover
Untitled, 1978
Ektacolor 74 type-c print, 16 x 20 in
Courtesy Sonnabend Gallery, New York

31 Jan Groover
Untitled, 1978
Ektacolor 74 type-c print, 16 x 20 in
Courtesy Sonnabend Gallery, New York

32 Jan Groover
Untitled, 1979
Ektacolor 74 type-c print, 16 x 20 in
Courtesy Sonnabend Gallery, New York

33 Jan Groover
Untitled #6319, 1975
3 color photographs type-c prints, each 6 x 9 in
Courtesy Sonnabend Gallery, New York

34 Jan Groover
Untitled #7556, 1977
3 color photographs type-c prints, each 14½ x
 14½ in
Courtesy Sonnabend Gallery, New York

35 Jan Groover
Untitled, 1979
Ektacolor 74 type-c print, 16 x 20 in
Courtesy Sonnabend Gallery, New York

36 Jan Groover
Untitled, 1978
Ektacolor 74 type-c print, 16 x 20 in
Courtesy Sonnabend Gallery, New York

37 Jan Groover
Untitled #9526, 1979
Ektacolor 74 type-c print, 16 x 20 in
Courtesy Sonnabend Gallery, New York

38 Mark Cohen
Untitled, April 1975
Ektacolor 37 type-c print, 12⅛ x 18¼ in
Courtesy the artist

39 Mark Cohen
Untitled, March 31, 1975
Ektacolor 37 type-c print, 12⅛ x 18¼ in
Courtesy the artist

40 Mark Cohen
Untitled, 1977
Type-c print, 13⅙ x 19¾ in
Courtesy the artist

41 Mark Cohen
Untitled, 1977
Type-c print, 13⅙ x 19¾ in
Courtesy the artist

42 Mark Cohen
Untitled, 1977
Type-c print, 13⅙ x 19¾ in
Courtesy the artist

43 Joel Meyerowitz
Malaga, Spain (fallen horse), 1967
Dye transfer print, 15 x 23⅜ in
Courtesy the artist

44 Joel Meyerowitz
New York City, 1975
Dye transfer print, 15 x 23⅜ in
Courtesy the artist

45 Joel Meyerowitz
New York City, 1975
Dye transfer print, 15 x 23⅜ in
Courtesy the artist

46 Joel Meyerowitz
New York City, 1976
Dye transfer print, 15 x 23⅜ in
Courtesy the artist

47 Harry Callahan
Providence, 1977
Dye transfer, 8½ x 12¾ in
Courtesy Light Gallery, New York

48 Harry Callahan
Providence, 1977
Dye transfer, 8½ x 12¾ in
Courtesy Light Gallery, New York

49 Joe Maloney
Paramus, New Jersey, 1977
Ektacolor 74 print, 16 x 20 in
Courtesy the artist

50 Joe Maloney
Westwood, New Jersey, 1977
Ektacolor 74 print, 16 x 20 in
Courtesy the artist

51 Joe Maloney
*Route 80, Pennsylvania (grain elevator, sweep-
 ing road)*, 1979
Ektacolor 74 type-c print, 16 x 20 in
Courtesy the artist

52 Langdon Clay
Couch, New York, 1977
Ektacolor 74 type-c print, 10 x 8 in
Courtesy the artist

53 Roger Mertin
Boston, Massachusetts, 1978
Polacolor print, 9½ x 7½ in
Courtesy the artist

54 Roger Mertin
Rochester, New York, 1979
Type-c print, 7⅝ x 9¹¹⁄₁₆ in
Courtesy the artist

55 Roger Mertin
Rochester, New York, 1979
Type-c print, 9¹¹⁄₁₆ x 7⅝ in
Courtesy the artist

56 Barbara Karant
Untitled, 1978
Ektacolor 74 type-c print, 9⅛ x 13½ in
Courtesy the artist

57 William Eggleston
Outskirts of Morton, Mississippi, Halloween,
 1971

Dye transfer print, 11⅝ x 17½ in
Courtesy Caldecot Chubb

58 William Eggleston
Thomasville, Georgia, ca. 1977
Ektacolor 74 photograph, 10 x 14¾ in
Courtesy Caldecot Chubb

59 William Eggleston
St. Simon's Island, Georgia, ca. 1978
Dye transfer print, 9¾ x 14⅞ in
Courtesy Caldecot Chubb

60 Michael Bishop
#1108, 1974
16 x 20 in
Courtesy the artist

61 Michael Bishop
#2805, 1977
16 x 11 in
Courtesy the artist

62 Michael Bishop
#7519, 1976
16 x 20 in
Courtesy the artist

63 Michael Bishop
#634, 1979
16 x 11 in
Courtesy the artist

64 Michael Bishop
#705, 1979
23 x 16 in
Courtesy the artist

65 Michael Bishop
#2720, 1979
23 x 16 in
Courtesy the artist

66 Michael Bishop
#1403, 1979
23 x 16 in
Courtesy the artist

67 Eve Sonneman
"The Instant and the Moment" Greece (Parthenon), 1977
Cibachrome type-r prints, 20 x 30 in (diptych)
Courtesy Castelli Photographs, New York

68 Eve Sonneman
"Boat Building," Samos Greece, 1977
Cibachrome type-r prints, 20 x 30 in (diptych)
Courtesy Castelli Photographs, New York

69 Eve Sonneman
"Dusk," New York (World Trade Center), 1976
Cibachrome type-r prints, 20 x 30 in (diptych)
Courtesy Castelli Photographs, New York

70 Eve Sonneman
"Landscape/Cloud," Nevada, 1978
Cibachrome type-r prints, 20 x 30 in (diptych)
Courtesy Castelli Photographs, New York

71 Stephanie Torbert
Wall with Smoke, Berkeley, California, 1975
Cibachrome type-r print, 9 x 13½ in
Courtesy the artist

72 Stephanie Torbert
Sunbather, London, England, 1976
Cibachrome type-r print, 9 x 13½ in
Courtesy the artist

73 Arthur Taussig
Irvine, California, 1978
Ektacolor 74 type-c print, 11 x 14 in
Courtesy Robert Freidus Gallery, New York

74 Arthur Taussig
Guerrero, Mexico, 1979
Ektacolor 74 type-c print, each panel 20 x 24 in (diptych)
Courtesy Robert Freidus Gallery, New York

75 David Haxton
Side Light on Torn Yellow over Violet, 1979
Ektacolor 74 type-c print, 23 x 34 in
Courtesy Sonnabend Gallery, New York

76 David Haxton
Various Colored Rolls and Blue Paper, 1980
Ektacolor 74 type-c print, 23 x 34 in
Courtesy Sonnabend Gallery, New York

77 Joel Sternfeld
Chicago, Illinois July/August 1976
Ektacolor 74 type-c print, 16 x 20 in
Courtesy the artist

78 John Pfahl
Red Rock Wall Repeat (Capitol Reef National Park, Utah) October 1977
Ektacolor type-c print, 8 x 10 in
Courtesy Robert Freidus Gallery, New York, and Visual Studies Workshop, Rochester, New York

79 John Pfahl
Triangle, Bermuda, August 1975
Ektacolor type-c print, 8 x 10 in
Courtesy Robert Freidus Gallery, New York, and the Visual Studies Workshop, Rochester, New York

80 John Pfahl
Australian Pines (Fort DeSoto, Florida), February 1977
Ektacolor type-c print, 8 x 10 in
Courtesy Robert Freidus Gallery, New York, and the Visual Studies Workshop, Rochester, New York

81 John Pfahl
Great Salt Lake Angles (Great Salt Lake, Utah), October 1977
Ektacolor type-c print, 8 x 10 in
Courtesy Robert Freidus Gallery, New York, and the Visual Studies Workshop, Rochester, New York

82 John Pfahl
Pink House (White House Ruins, Canyon de Chelly, Arizona), December 1977
Ektacolor type-c print, 8 x 10 in
Courtesy Robert Freidus Gallery, New York, and the Visual Studies Workshop, Rochester, New York

83 John Pfahl
1390 South Dixie Highway, Coral Gables, Florida, March 1979
Ektacolor type-c print, 16 x 20 in
Courtesy Robert Freidus Gallery, New York, and the Visual Studies Workshop, Rochester, New York

84 John Pfahl
2 Balanced Rock Drive, Springdale, Utah, June 1980
Ektacolor type-c print, 16 x 20 in
Courtesy Robert Freidus Gallery, New York, and the Visual Studies Workshop, Rochester, New York

85 William E. Smith
Picture Park, September 1978
Ektacolor 78 type-c print, 8 x 10 in
Courtesy the artist

86 William E. Smith
Picture Park, September 1978
Ektacolor 78 type-c print, 8 x 10 in
Courtesy the artist

87 Neal Slavin
Sarasota County Angeles Club, n.d.
Type-c print, 10½ x 10½ in
Courtesy the artist

88 Bill Ravanesi
*Irrigated Field–Desert Farming—Mojave Desert,
 California*, 1977
Type-c print, 11 x 14 in
Courtesy the artist

89 Bill Ravanesi
*Shade Tobacco Crew—Pioneer Valley, Whately,
 Massachusetts*, 1977
Type-c print, 11 x 14 in
Courtesy the artist

90 Wayne Sorce
Aldo Piacenza's Foyer, 1976–77
Type-c print, 9 x 7¼ in
Courtesy the artist

91 Wayne Sorce
Dr. Soter's Pink Couch, 1976
Type-c print, 10 x 33 in
Courtesy the artist

92 Douglas Hill
Costa Mesa, California, 1977
Cibachrome type-r print, 10¾ x 13½ in
Courtesy the artist

93 Douglas Hill
Huntington Beach, California, 1977
Cibachrome type-r print, 13½ x 10¾ in
Courtesy the artist

94 Neal Slavin
The Associated Blind, Inc., n.d.
Type-c print, 10½ x 10½ in
Courtesy the artist

95 Neal Slavin
Society for Photographic Education n.d.

Type-c print, 15½ x 15¼ in
Courtesy the artist

96 Neal Slavin
National Cheerleaders Association, n.d.
Type-c print, 15½ x 15¼ in
Courtesy the artist

97 Jerry Dantzic
East River Bridges, 1975
Type-c print, 8 x 60 in
Courtesy the artist

98 Jerry Dantzic
Monument Valley, Utah, 1977
Type-c print, 10 x 74 in
Courtesy the artist

99 William Christenberry
Church, Sprott, Alabama, 1971
Ektacolor 74 type-c print, 3 x 5 in
Courtesy Caldecot Chubb

100 William Christenberry
*Bathtub Used as Water Trough outside Greens-
 boro Alabama*, 1977
Ektacolor 74 type-c print, 3 x 5 in
Courtesy Caldecot Chubb

101 William Christenberry
*Corn Sign Under Storm Cloud, near Greensboro,
 Alabama*, 1977
Ektacolor 74 type-c print, 3 x 5 in
Courtesy Caldecot Chubb

102 William Christenberry
Child's Grave with Roses, Hale County, Alabama,
 1975
Ektacolor 74 type-c print, 3 x 5 in
Courtesy Caldecot Chubb

103 Helen Levitt
Untitled, New York, 1972
Dye transfer print, 9 x 13 in
Courtesy the artist

104 Helen Levitt
Untitled, New York, 1974
Dye transfer print, 9 x 13 in
Courtesy the artist

105 Joel Sternfeld
After a Flash Flood, Rancho Mirage, California,
 July 1979

Ektacolor 74 type-c print, 13½ x 17 in
Courtesy the artist

106 Joel Sternfeld
Tucson, Arizona, April 1979
Ektacolor 74 type-c print, 13½ x 17 in
Courtesy the artist

107 Joel Sternfeld
Houston, Texas, December 1978
Ektacolor 74 type-c print, 13½ x 17 in
Courtesy the artist

108 Joel Sternfeld
*The Space Shuttle Lands at Kelly Air Force Base,
 San Antonio, Texas*, March 1979
Ektacolor 74 type-c print, 13½ x 17 in
Courtesy the artist

109 Joel Sternfeld
McLean, Virginia, December 4, 1978
Ektacolor 74 type-c print, 13½ x 17 in
Courtesy the artist

110 Joel Sternfeld
*Approximately 17 of a pod of 41 whales which
 beached near Florence, Oregon*, June 1979
Ektacolor 74 type-c print, 13½ x 17 in
Courtesy the artist

111 William Eggleston
Puddle (from *Troubled Waters*), ca. 1971
Dye transfer, 17¼ x 11⅜ in
Courtesy Caldecot Chubb

112 William Eggleston
Blue Pipes (from *Troubled Waters*), ca. 1971
Dye transfer, 11⅜ x 17¼ in
Courtesy Caldecot Chubb

113 William Eggleston
Neon Flag (from *Troubled Waters*), ca. 1971
Dye transfer, 10¾ x 17¼ in
Courtesy Caldecot Chubb

114 William Eggleston
Pinball Machine (from *Troubled Waters*), ca.
 1971
Dye transfer, 17¼ x 11 in
Courtesy Caldecot Chubb

115 William Eggleston
Memphis, ca. 1977
Ektacolor 74 color photograph, 10 x 14⅞ in
Courtesy Caldecot Chubb

116 William Eggleston
Morton, Mississippi, ca. 1971
Dye transfer, 13⅛ x 8¾ in
Courtesy Caldecot Chubb

117 Kenneth McGowan
Paris Fire, 1976
Cibachrome type-r print, 14 x 14 in
Courtesy Castelli Photographs, New York

118 Kenneth McGowan
Steak Billboard, 1977
Cibachrome type-r print, 14 x 14 in
Courtesy Castelli Photographs, New York

119 Kenneth McGowan
Yoga, 1976
Cibachrome type-r print, 14 x 14 in
Courtesy Castelli Photographs, New York

120 Kenneth McGowan
Float, 1977
Cibachrome type-r print, 14 x 14 in
Courtesy Castelli Photographs, New York

121 Kenneth McGowan
Azaleas, 1976
Cibachrome type-r print, 14 x 14 in
Courtesy Castelli Photographs, New York

122 Leo Rubinfien
Ruthin, Wales, 1980
Ektacolor type-c print, 16 x 20 in
Courtesy Castelli Photographs, New York

123 Leo Rubinfien
Barmouth, Wales, 1980
Ektacolor type-c print, 16 x 20 in
Courtesy Castelli Photographs, New York

124 Leo Rubinfien
Tokyo, Japan, 1979
Ektacolor type-c print, 16 x 20 in
Courtesy Castelli Photographs, New York

125 Adam Bartos
Column with Doorway, Alexandria, 1980
Ektacolor 74 type-c print, 13½ x 19⅛ in
Courtesy the artist

126 Joyce Culver
Fencepost and Leaves, Bethlehem, Pennsylvania, 1978
Ektacolor 74 type-c print, 9½ x 9½ in
Courtesy the artist

127 Joyce Culver
Two Mailboxes, Boca Raton, Florida, 1978
Ektacolor 74 type-c print, 9½ x 9½ in
Courtesy the artist

128 Len Jenshel
The Harkness Estate, Waterford, Connecticut, 1977
Type-c print, 16 x 20 in
Courtesy Castelli Photographs, New York

129 Len Jenshel
South San Francisco, California, 1978
Type-c print, 16 x 20 in
Courtesy Castelli Photographs, New York

130 Len Jenshel
York Beach, Maine, 1977
Type-c print, 16 x 20 in
Courtesy Castelli Photographs, New York

131 Len Jenshel
Pacifica, California, 1978
Type-c print, 16 x 20 in
Courtesy Castelli Photographs, New York

132 Len Jenshel
Popham Beach, Maine, 1979
Type-c print, 16 x 20 in
Courtesy Castelli Photographs, New York

133 Len Jenshel
The Harkness Estate, Waterford, Connecticut, 1977
Type-c print, 16 x 20 in
Courtesy Castelli Photographs, New York

134 Len Jenshel
World Trade Center, New York, New York, 1979
Type-c print, 16 x 20 in
Courtesy Castelli Photographs, New York

135 Mitch Epstein
Pohkara, Nepal, 1978
Ektacolor 74 type-c print, 13 x 19⅛ in
Courtesy Light Gallery, New York

136 Mitch Epstein
Pushkar Camel Fair, India, 1978
Ektacolor 74 type-c print, 13 x 19⅛ in
Courtesy Light Gallery, New York

137 Mitch Epstein
Galta, Rajasthan, India, 1978
Ektacolor 74 type-c print, 13 x 19⅛ in
Courtesy Light Gallery, New York

138 Mitch Epstein
Cheops' Pyramid, Giza, Egypt, 1980
Ektacolor 74 type-c print, 13 x 19⅛ in
Courtesy Light Gallery, New York

139 Mitch Epstein
Joan of Arc Monument, New York City, 1978
Ektacolor 74 type-c print, 13 x 19⅛ in
Courtesy Light Gallery, New York

140 Mitch Epstein
Boboli Gardens I, Florence, 1977
Ektacolor 74 type-c print, 13 x 19⅛ in
Courtesy Light Gallery, New York

141 Mitch Epstein
Jamaica, 1978
Ektacolor 74 type-c print, 13 x 19⅛ in
Courtesy Light Gallery, New York

142 Mitch Epstein
Old Cairo, Egypt, 1980
Ektacolor 74 type-c print, 13 x 19⅛ in
Courtesy Light Gallery, New York

143 David Hockney
Herrenhausen-Hanover (from the portfolio *20 Photographic Pictures*), July 1976
Type-c print, 7⅛ x 9½ in
Courtesy Sonnabend Gallery, New York

144 David Hockney
Still Life with Hats (from the portfolio *20 Photographic Pictures*), July 1976
Type-c print, 9⁷⁄₁₆ x 7¹⁄₁₆ in
Courtesy Sonnabend Gallery, New York

145 David Hockney
Untitled, 1975–76
Type-c print, 4¹¹⁄₁₆ x 7 in
Courtesy Sonnabend Gallery, New York

146 David Hockney
Untitled, 1975–76
Type-c print, 4^{11}/$_{16}$ x 7 in
Courtesy Sonnabend Gallery, New York

147 David Hockney
Peter Washing (from the portfolio *20 Photo-
graphic Pictures*), July 1976
Type-c print, 7^1/$_8$ x 9^1/$_2$ in
Courtesy Sonnabend Gallery, New York

148 David Hockney
The Pines, Fire Island (from the portfolio *20 Pho-
tographic Pictures*), July 1976
Type-c print, 7^1/$_8$ x 9^1/$_2$ in
Courtesy Sonnabend Gallery, New York

149 David Hockney
Untitled, 1975–76
Type-c print, 5 x 7^1/$_{16}$ in
Courtesy Sonnabend Gallery, New York

150 Carla Steiger-Meister
Untitled, 1978
Ektacolor type-c print, 8 x 10 in
Courtesy the artist

151 Olivia Parker
Untitled, 1979
Polacolor print, 10 x 8 in
Courtesy the artist

152 Mark C. Schwartz
Athens, Ohio, 1979
Ektacolor 74 type-c print, 5 x 7 in
Courtesy the artist

153 Mark C. Schwartz
Woodburn, Indiana, 1980
Ektacolor 74 type-c print, 5 x 7 in
Courtesy the artist

154 Jo Ann Callis
Girl on Bed, 1977
Ektacolor 78 type-c print, 16 x 20 in
Courtesy G. Ray Hawkins Gallery, Los Angeles

155 John Divola
from *Zuma* series, #29, 1978
Ektacolor 78 type-c print, 16 x 20 in
Courtesy Robert Freidus Gallery, New York

156 Bernard Faucon
Carnaval, 1979
Fresson Print, 12 x 12 in
Courtesy Castelli Photographs, New York

157 Don Rodan
Tantalus (from the series *The Greek Myths*),
1977
Incorporated color-coupler prints from Polaroid
SX-70 originals on Ektacolor paper, 4^1/$_2$ x 3^1/$_2$
in
Courtesy Castelli Photographs, New York

158 Don Rodan
Hermes (from the series *The Greek Myths*), 1977
Incorporated color-coupler prints from Polaroid
SX-70 originals on Ektacolor paper, 4^1/$_2$ x 3^1/$_2$
in
Courtesy Castelli Photographs, New York

159 Boyd Webb
Untitled #9310 from *Tableaux*, 1978
Type-c print, 23 x 31 in (including frame)
Courtesy Sonnabend Gallery, New York

160 Boyd Webb
Untitled, 1978
Type-c print, 37^3/$_8$ x 27^3/$_8$ in (including frame)
Courtesy Sonnabend Gallery, New York

161 Lucas Samaras
Photo-Transformation, July 16, 1976

SX-70 Polaroid, 3 x 3 in
Courtesy Pace Gallery

162 Lucas Samaras
Photo-Transformation, March 12, 1976
SX-70 Polaroid, 3 x 3 in
Courtesy Pace Gallery

163 Lucas Samaras
Photo-Transformation, July 27, 1976
SX-70 Polaroid, 3 x 3 in
Courtesy Pace Gallery

164 Lucas Samaras
Photo-Transformation, March 31, 1976
SX-70 Polaroid, 3 x 3 in
Courtesy Pace Gallery

165 Lucas Samaras
Untitled Still Life, October 24, 1978
Polacolor, 10 x 8 in
Courtesy Pace Gallery

166 Sandy Skoglund
The Revenge of the Goldfish, 1981
Cibachrome type-r print, 30 x 40 in
Courtesy Castelli Photographs, New York

INDEX TO THE ARTISTS

Text references, set in roman type, refer to page numbers, as do the plate references which are in *italic*.